THE REAL JERSEY SHORE

THE JERSEY SHORE BY JERSEY SHORE PHOTOGRAPHERS

ASBURY PARK PRESS APP.com

Foreword

Dear Jersey Shore Residents and Visitors,

The Asbury Park Press and the Jersey Shore Convention and Visitors Bureau (JSCVB) have partnered to bring you this beautiful coffee-table art book celebrating the best images of the real Jersey Shore. The online photography contest started Memorial Day weekend as we challenged Jersey Shore residents and visitors to upload their favorite photos, share and vote. After a summer full of activity the results were truly amazing – a bounty of exceptional photos that truly represent this unique and special part of the Garden State, the Jersey Shore.

These photos showcase Monmouth and Ocean counties as more than just nearly 90 miles of magnificent world-famous beaches. This area nestled along the east coast of New Jersey is also home to a rich musical heritage, a vibrant arts and culture community, historic treasures, intriguing downtowns and exciting tourist attractions.

The Asbury Park Press, the number one source for local news and information has been a part of the Jersey Shore community for more than 130 years delivering breaking news and award-winning content, and chronicling the lives of Jersey Shore residents and visitors with its daily newspapers, websites and magazines.

The Jersey Shore Convention and Visitors Bureau promotes a positive image of the environmental, cultural and historic assets of the area that increases leisure and business tourism to the region.

Home to one million residents and host to an estimated 35 million visitors annually, the Jersey Shore is a celebration of intriguing people, fascinating places and wonderful sights that are captured in the pages of this book.

Enjoy The Real Jersey Shore.

 The Jersey Shore Convention and Visitors Bureau is funded in part by a grant from the State of New Jersey Division of Travel and Tourism.

Table of Contents

Living .. 4

Landmarks and Architecture 16

Sports, Recreation, Food and Fun 38

Scapes of All Sorts 78

Nature and Wildlife 110

Friends, Family and Pets 128

Stats, Credits and Leaders 141

Sponsors .. 142

Join Us .. 143

Winners ... 144

About This Book

The Real Jersey Shore™ is a unique approach to fine-art book publishing. An online community of local photographers submitted photos to be considered for this book. Then, area residents voted to determine which photos would be published. From 32,301 photo submissions to the pages of this book, 767,087 votes helped shape what you hold in your hands. It's the Jersey Shore through the eyes and lenses of local photographers and enthusiasts. Enjoy.

Join the community.

Every bit of this book was made possible by an active community of users on the Capture Jersey Shore Web site. Whether you're a professional photographer, hobbyist, or just like looking at great Jersey Shore photography, join the community at capturejerseyshore.com.

How to use this book.

Open. Look at the best book of Jersey Shore photography you've ever seen. Repeat. Actually, maybe there's a little more to it. First, be sure to note the credit listed with each photo. Search for your favorite photographer at capturejerseyshore.com and leave your comment or show your appreciation with a vote. Many photographers also sell their photos online so you may be able to buy a print for your wall! Also note, captions are used as submitted by the photographer, mostly verbatim. We do our best to fact check, but captions may not be perfect.

Copyright info.

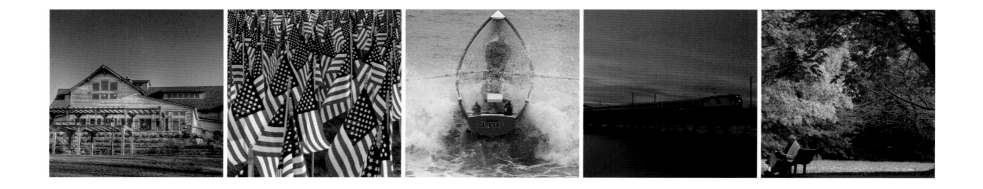

Living

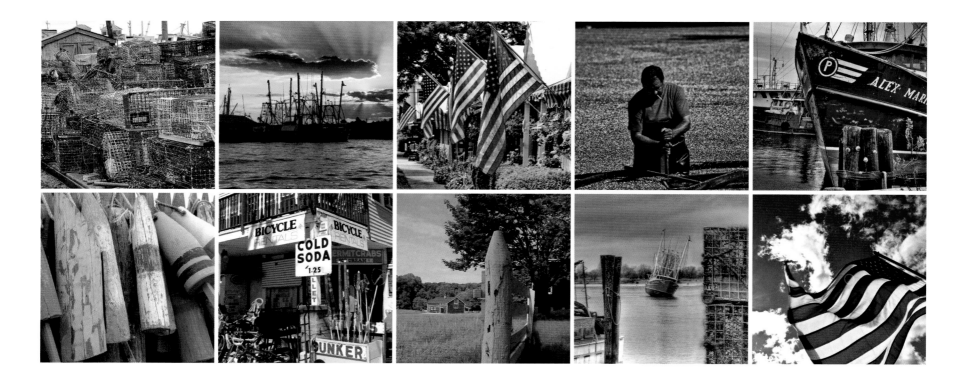

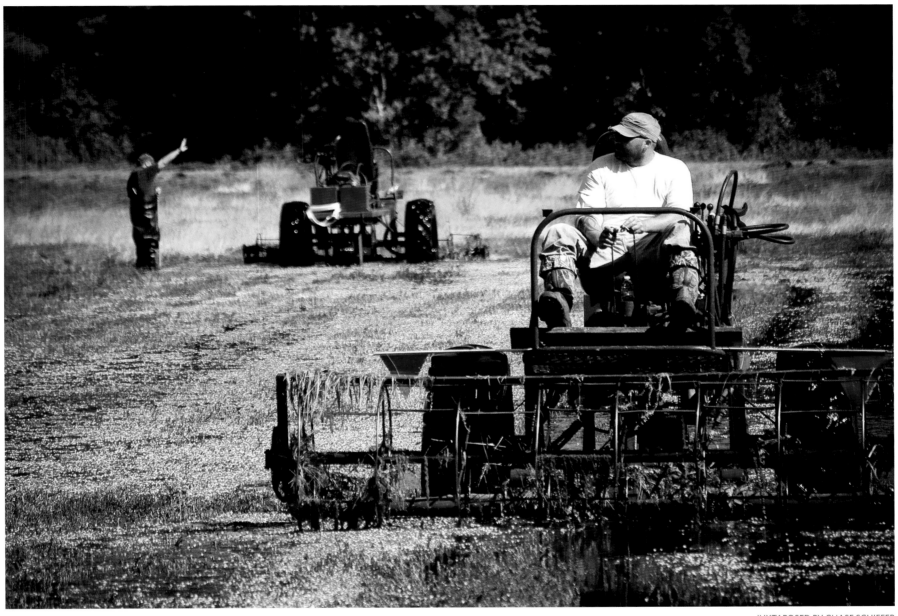

ABOVE: Double Trouble cranberry harvest, Double Trouble State Park. *(Berkeley, Ocean County)*

RIGHT: Lifeguards at work. *(Seaside Park, Ocean County)*

BOTTOM LEFT: Double Trouble cranberry harvest, Double Trouble State Park. *(Berkeley, Ocean County)*

BOTTOM RIGHT: Lady Guards stop for a pose. *(Seaside Park, Ocean County)*

OPPOSITE TOP: Spring Lake lifeguards getting ready for the season. *(Spring Lake, Monmouth County)*

OPPOSITE BOTTOM LEFT: Guard days of Summer. *(Ocean Grove, Monmouth County)*

OPPOSITE BOTTOM RIGHT: Manasquan High School cheerleaders during a football game. *(Manasquan, Monmouth County)*

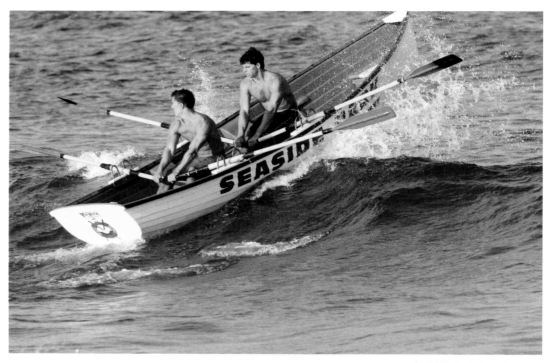

ON DUTY BY FRANK COSTELLO

SO MANY BERRIES BY CHASE SCHIEFER

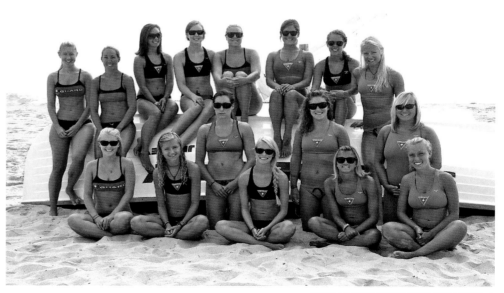

GOOD LOOKIN' GROUP BY FRANK COSTELLO

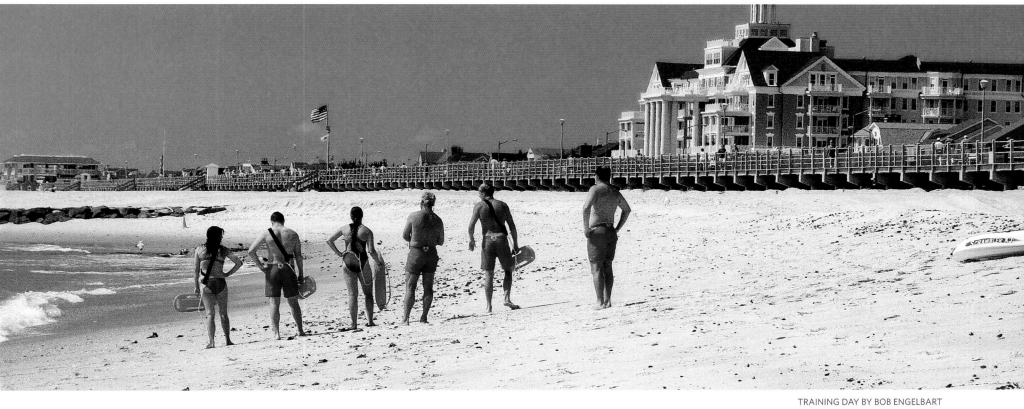

TRAINING DAY BY BOB ENGELBART

SHORE SHOTS BY TRACEY JAMES

UNTITLED BY CATHERINE VAN STOLK

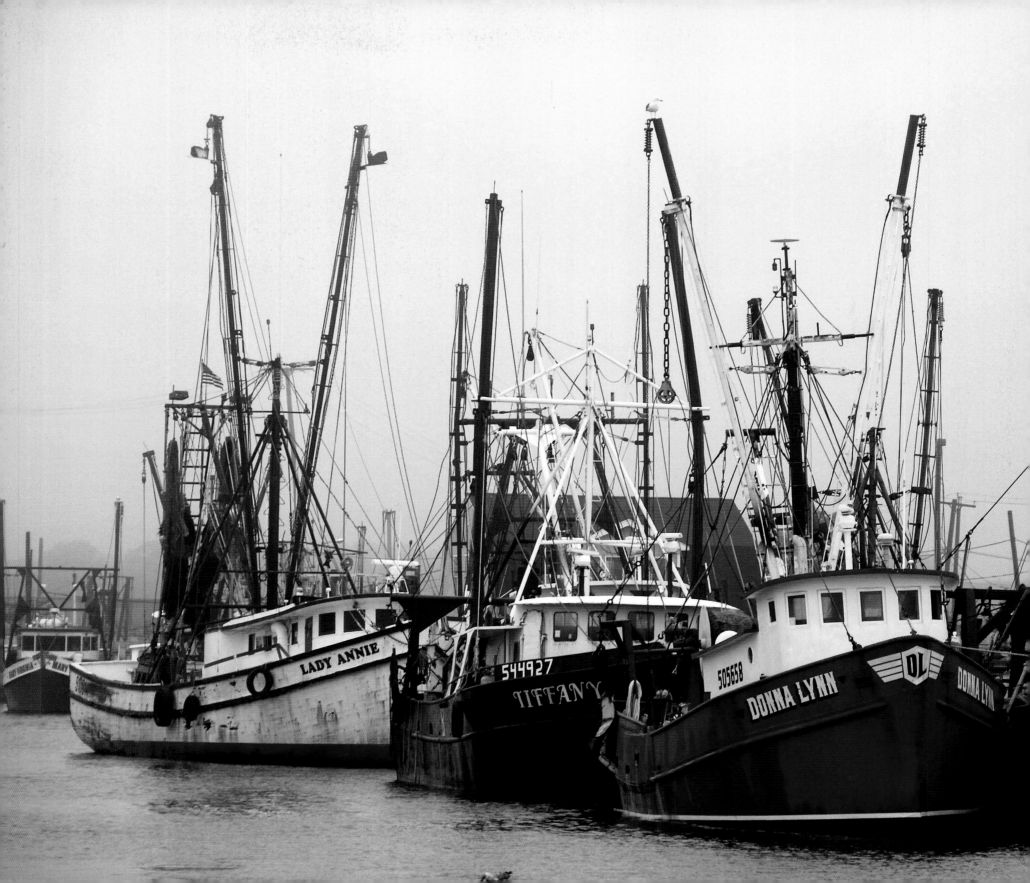

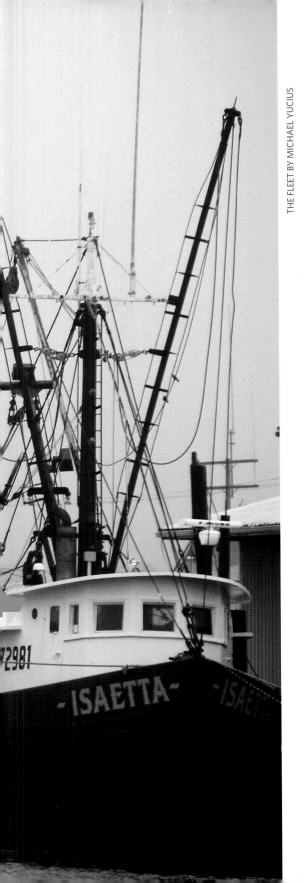

THE FLEET BY MICHAEL YUCIUS

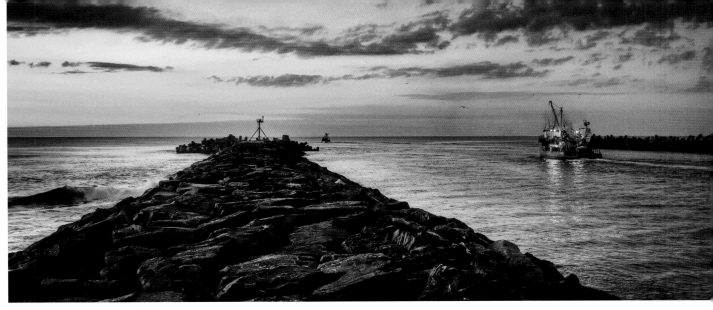

THE JOURNEY. BY MIKE ATTANASIO

JERSEY DEVIL BY DAVID SCELFO

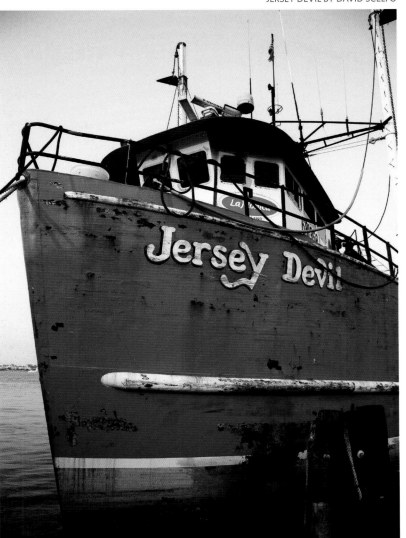

ABOVE: Local fishing boat heading out to the Atlantic at sunrise.
(Manasquan, Monmouth County)

LEFT: The Jersey Devil — a workingman's boat.
(Point Pleasant Beach, Ocean County)

FAR LEFT: The Belford fishing fleet at rest on a foggy day.
(Belford, Monmouth County)

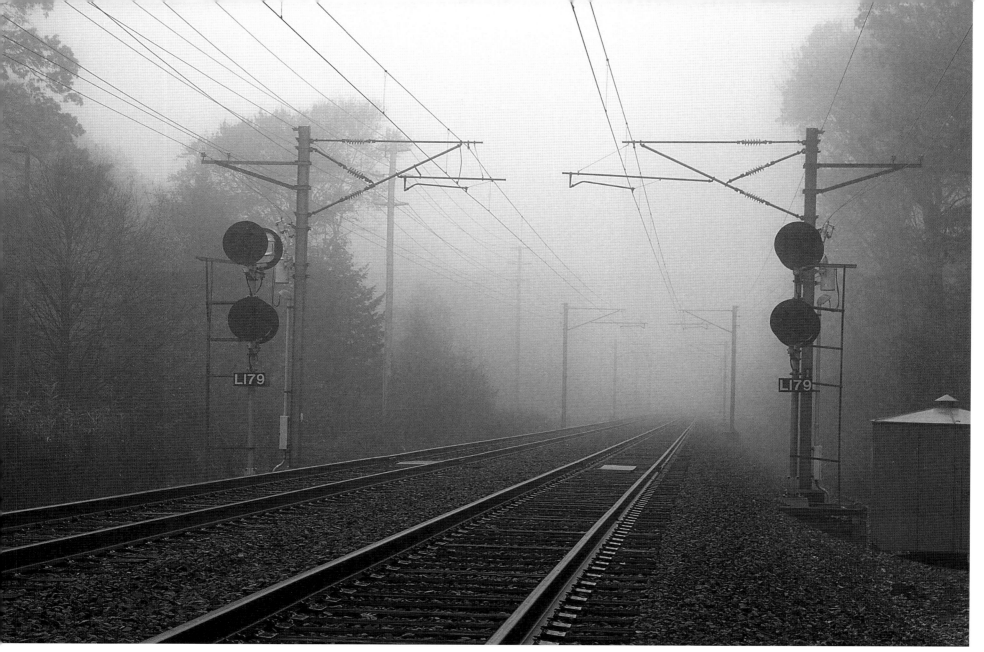

ABOVE: Looking south down railroad tracks on a foggy morning. *(Shrewsbury, Monmouth County)*

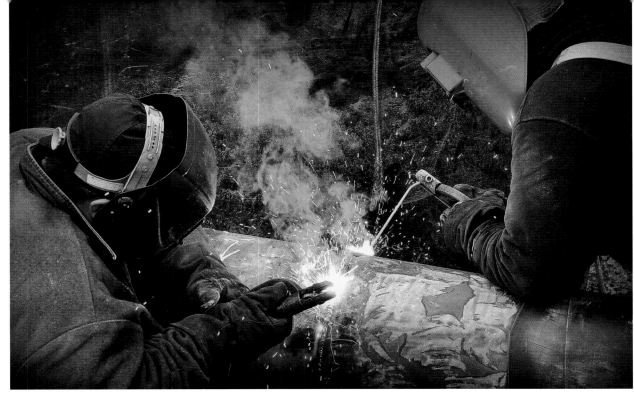

WELDED SCULPTURE BY TOM BERG

LEFT: A welded sculpture.
(Wall, Monmouth County)

BOTTOM LEFT: A garage-sale-type gift shop in Viking Village — a picker's delight.
(Barnegat Light, Ocean County)

BOTTOM RIGHT: The making of salt-water taffy on the boardwalk in Seaside.
(Seaside Heights, Ocean County)

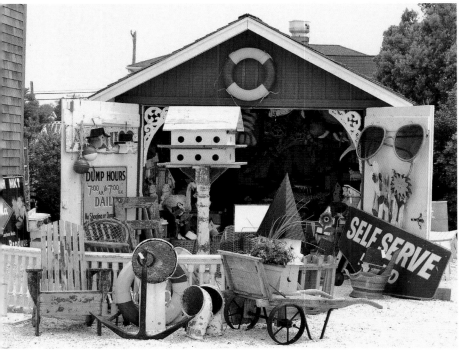

HELP YOURSELF BY GENE NANN

SALT-WATER TAFFY BY DAWN DAVIS

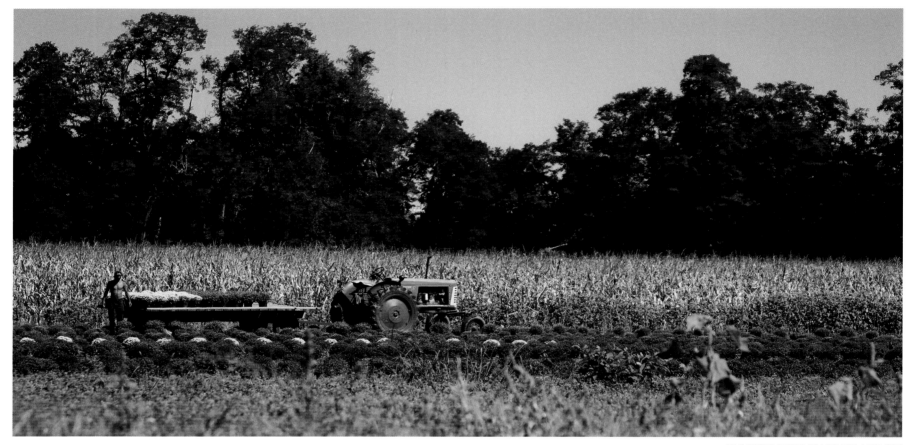

ABOVE: Mum's the word. *(Colts Neck, Monmouth County)*

RIGHT: Mia steals just a moment to lean against Grandpa before running off to find the sweetest strawberries. *(Freehold, Monmouth County)*

OPPOSITE: Barn duties. *(Holmdel, Monmouth County)*

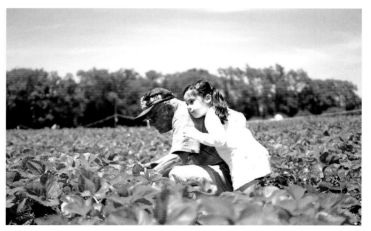

CHORES BY MELISSA MCCLAIN

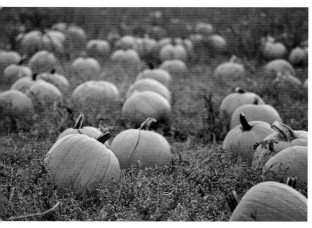

PUMPKIN PATCH BY DIANE STACHURA DESIMINI

ABOVE: Gorgeous orange spots in the field of Eastmont Orchards.
(Colts Neck, Monmouth County)

RIGHT: A scene from a farm in Holmdel.
(Holmdel, Monmouth County)

BELOW: An interior photo of our barn. Each stall has a red heat lamp and I waited until night to turn them all on and close each stall door. I used a 30 second shutter speed and was amazed at the results.
(Colts Neck, Monmouth County)

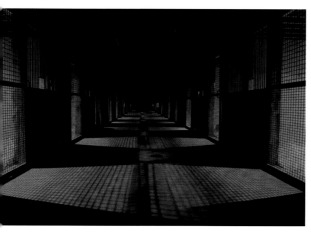

RED BARN ABSTRACT BY MIKE QUINN

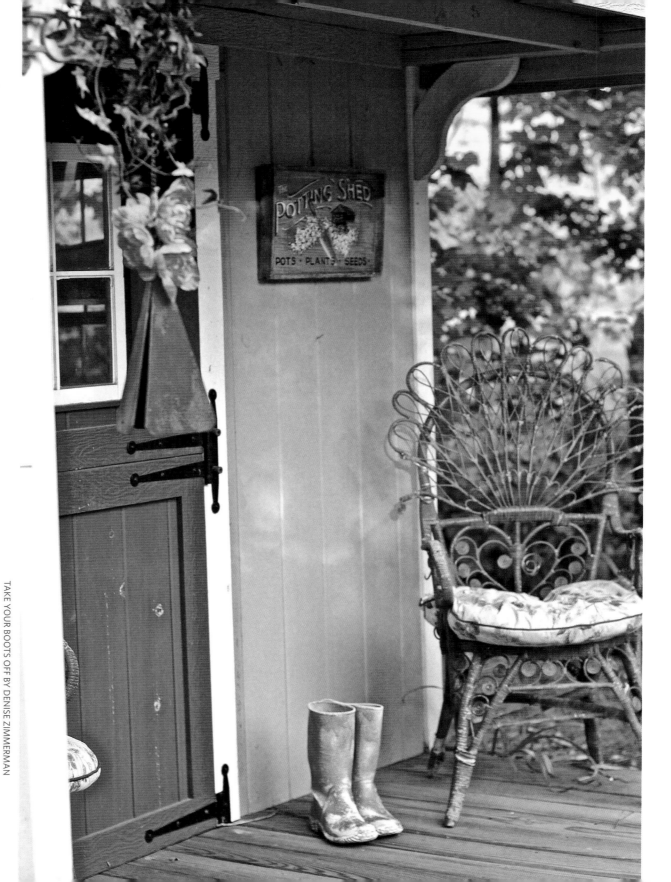

TAKE YOUR BOOTS OFF BY DENISE ZIMMERMAN

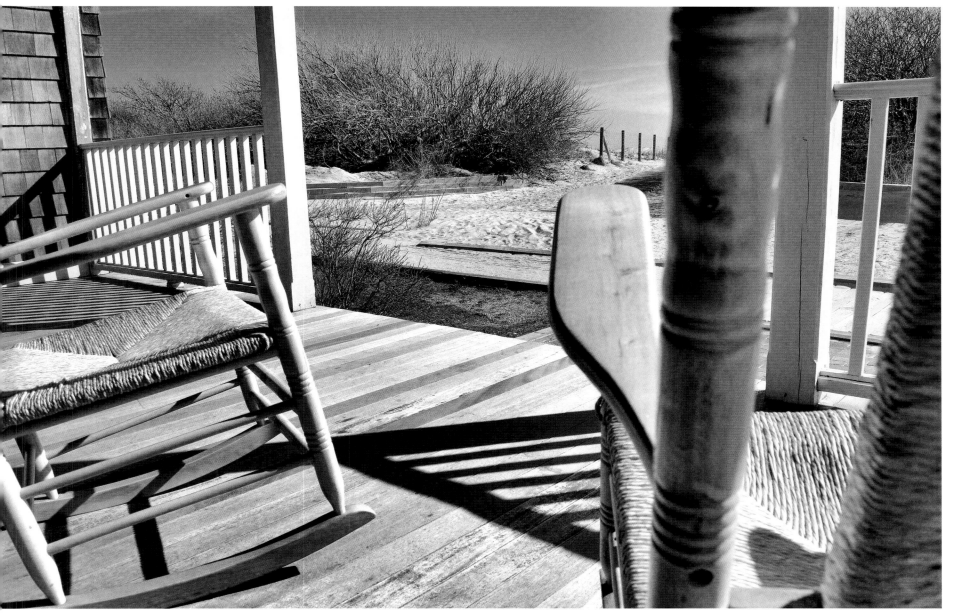

ABOVE: Set back from the beach on Sandy Hook, you can grab a seat and enjoy the view. *(Highlands, Monmouth County)*

Landmarks and Architecture

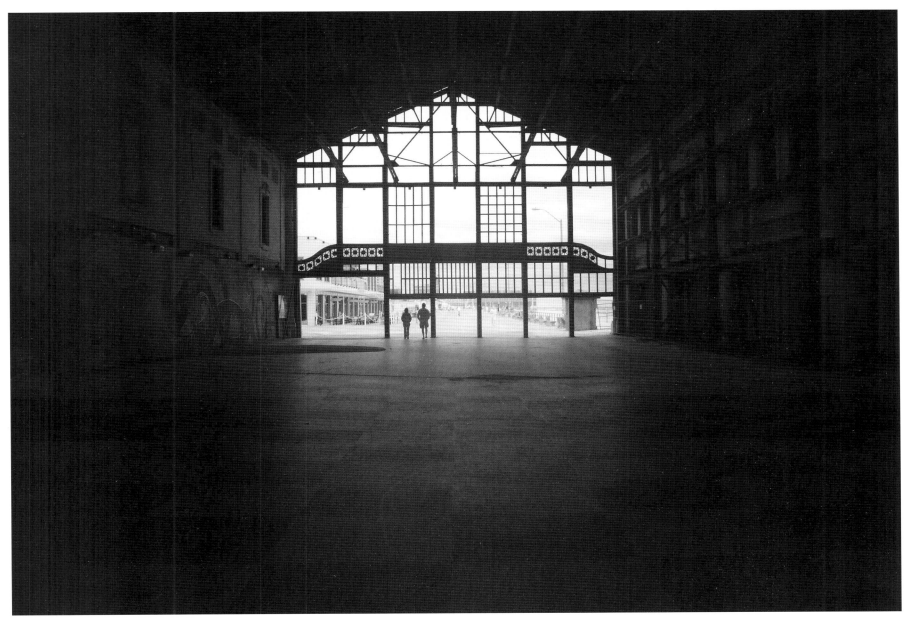

ABOVE: The old casino in Asbury Park, looking north. (*Asbury Park, Monmouth County*)

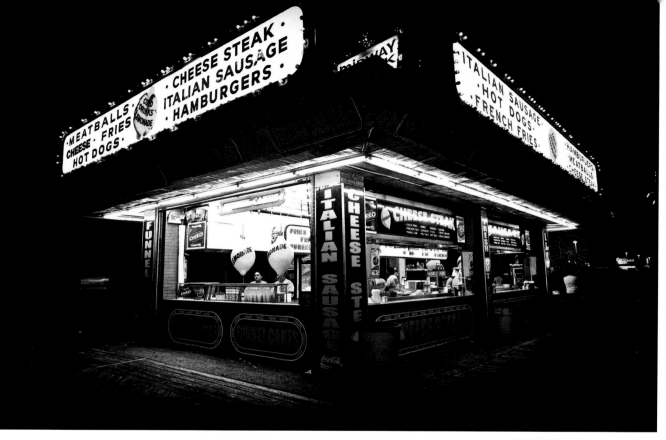

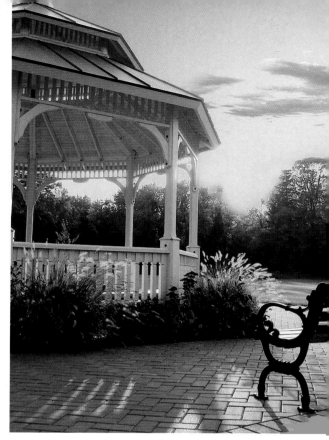

MIDWAY STEAKS BY JAMES LOESCH

CALM BEFORE THE CONCERT BY APRIL MARTINES

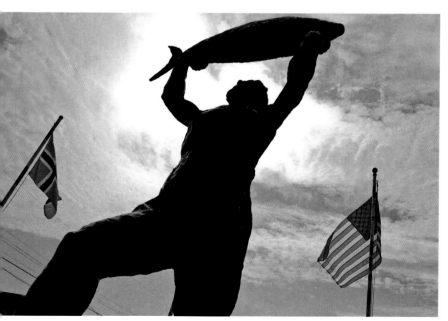

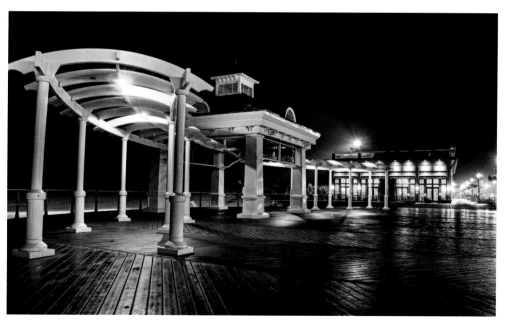

GIVE PRAISE TO THE FISHING GODS BY RYAN MARCHESE

PIER VILLAGE AFTER THE RAINS BY CHASE SCHIEFER

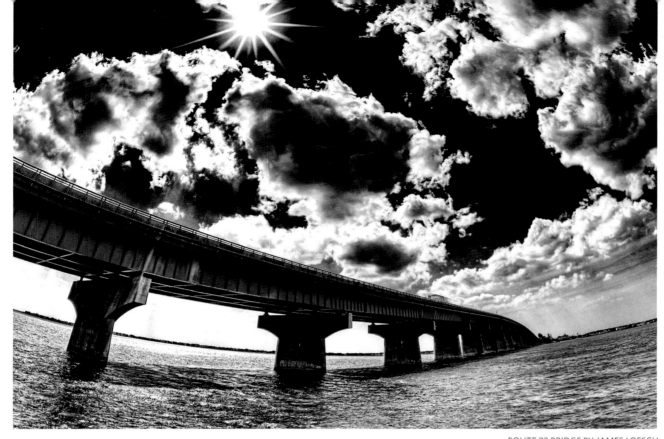

ROUTE 72 BRIDGE BY JAMES LOESCH

LEFT: The bridge across the Barnegat Bay from the main land to Long Beach Island. (*Surf City, Ocean County*)

BOTTOM LEFT: Looking into the descending sun brings out all the character in these row houses at Allaire State Park. (*Allaire, Monmouth County*)

BOTTOM RIGHT: Asbury Park. (*Asbury Park, Monmouth County*)

OPPOSITE TOP LEFT: On the boardwalk midway between Funtown and Casino piers. (*Seaside Heights, Ocean County*)

OPPOSITE TOP RIGHT: The gazebo and lawn in Shrewsbury. (*Shrewsbury, Monmouth County*)

OPPOSITE BOTTOM LEFT: Viking Village statue. (*Barnegat Light, Ocean County*)

OPPOSITE BOTTOM RIGHT: A scene from Long Branch. (*Long Branch, Monmouth County*)

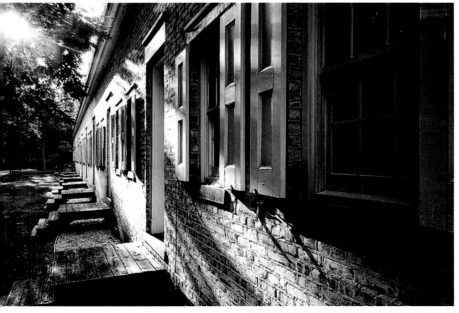

18TH CENTURY CHARACTER BY MIKE ATTANASIO

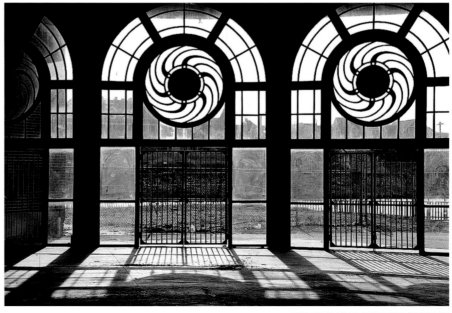

ASBURY PARK BY BRUCE MACDONALD

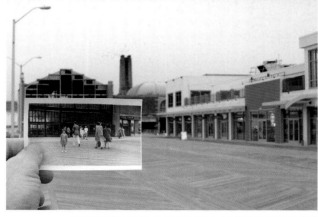

EVERYTHING SEEMED SO CLEAR BACK THEN BY PHIL SMITH

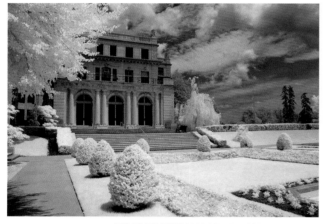

WOODROW WILSON HALL BY JOSEPH PADUANO

ABOVE: Monmouth University. *(West Long Branch, Monmouth County)*

TOP: My grandfather took this picture of my mom on the boardwalk in Asbury Park in 1938. *(Asbury Park, Monmouth County)*

RIGHT: St. Michaels in West End. *(Long Branch, Monmouth County)*

OPPOSITE TOP: St. Catharine's Church.
(Spring Lake, Monmouth County)

OPPOSITE BOTTOM LEFT: Monmouth University Library.
(West Long Branch, Monmouth County)

OPPOSITE BOTTOM RIGHT: Oct-Mermaid by Porkchop in the Casino Building. *(Asbury Park, Monmouth County)*

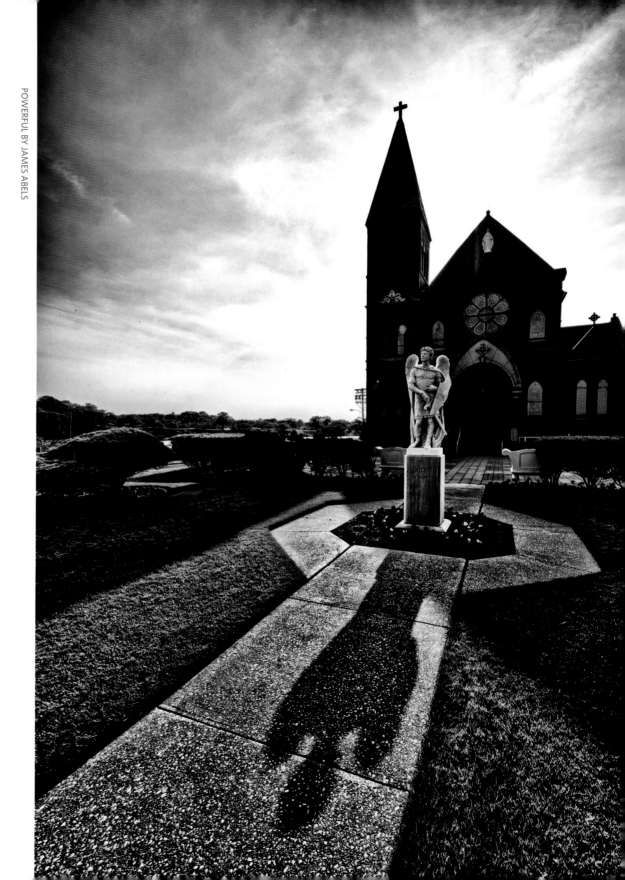

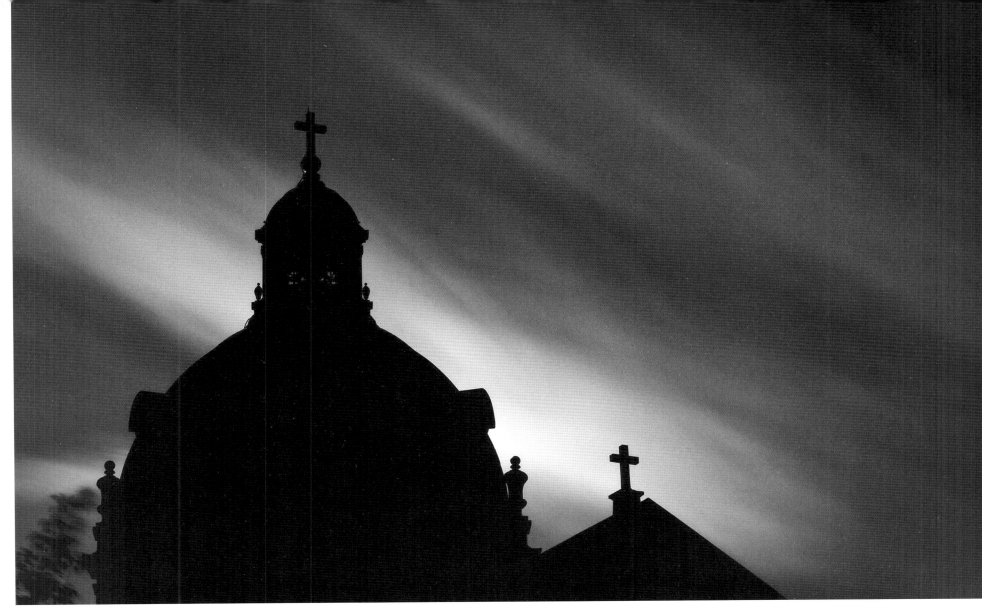

PASSING CLOUDS BY KEN BORDFELD

MONMOUTH UNIVERSITY LIBRARY BY TOM BERG

IN THE CASINO BUILDING BY CATHERINE CONROY

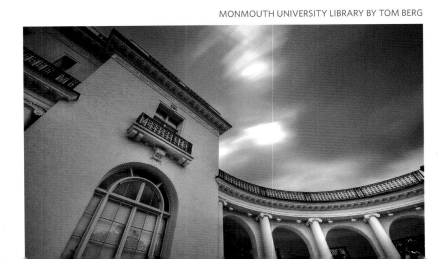

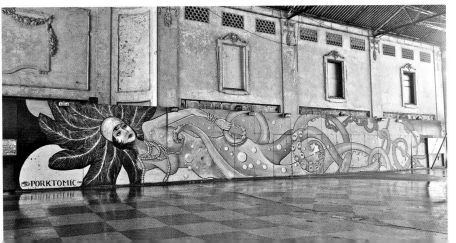

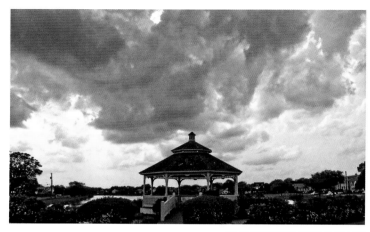

BELMAR GAZEBO BY CARL BEAMS

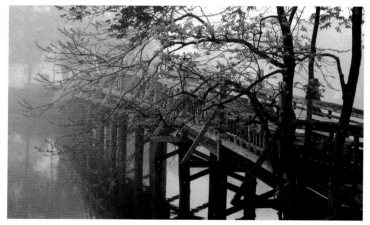

THE FOOT BRIDGE FOG IN SPRING LAKE BY MICHELE FORD

ABOVE: The mysterious beauty of a foggy spring day at the foot bridge in Spring Lake. *(Spring Lake, Monmouth County)*

TOP: This gazebo is located in Ferruggiaro Park, Belmar, and offers a beautiful view of Silver Lake. *(Belmar, Monmouth County)*

RIGHT: Saint Catharine's at night *(Spring Lake, Monmouth County)*

OPPPOSITE: Snow blankets the streets of Freehold Boro. *(Freehold, Monmouth County)*

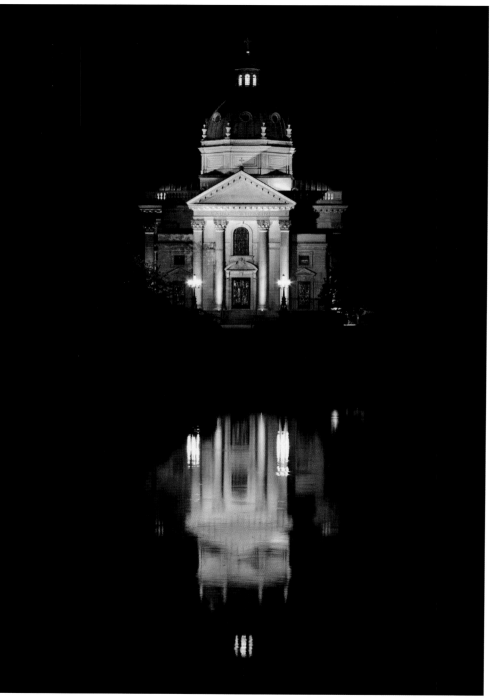

REFLECTION BY KEN BORDFELD

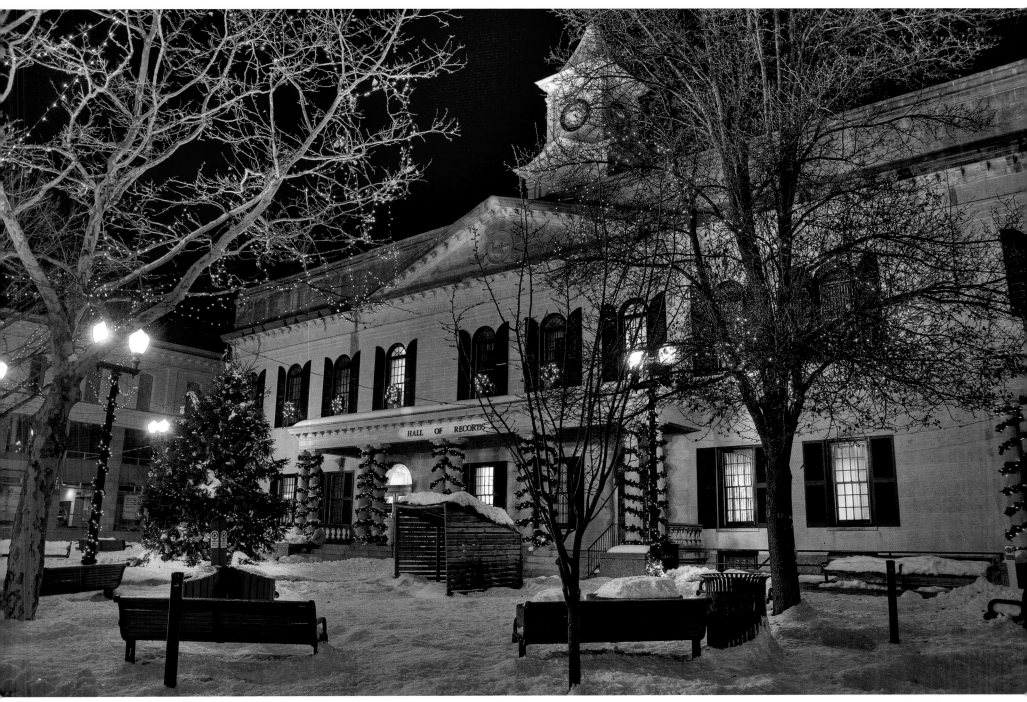

HALL OF RECORDS

BLUE ON WHITE BY MIKE ATTANASIO

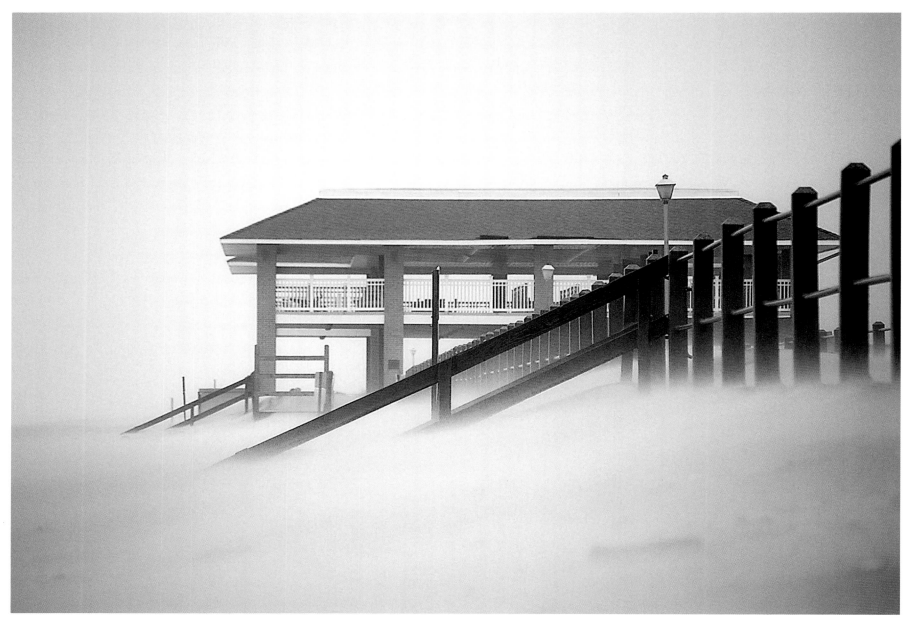

SAND STORM BY RORY BROGAN

ABOVE: South End Pavilion, Spring Lake. *(Spring Lake, Monmouth County)*

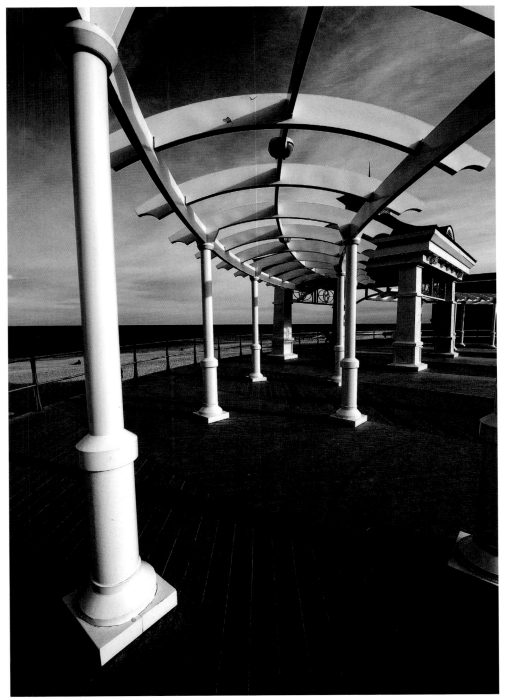

TRESTLE BY JONATHAN VANDUYNE

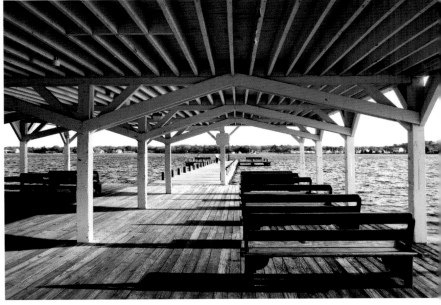

PAVILION LINES BY REGINA VOGLER

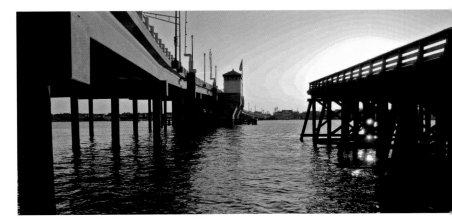

MANTOLOKING CROSSING BY HERB WILEY

ABOVE: The old and the new. *(Bricktown, Ocean County)*

TOP: The Island Heights Pavilion on the Toms River. The view looking into the pavilion is as captivating as the view looking out. The river's beauty is framed by lines of wood, light, and shadow. *(Island Heights, Ocean County)*

LEFT: Trestle to the beach in Pier Village. *(Long Branch, Monmouth County)*

RIGHT: Stars and stripes from the bay to the beach on the Fourth of July. *(Ocean Beach, Ocean County)*

BOTTOM LEFT: Ocean Grove, moonlit. *(Ocean Grove, Monmouth County)*

BOTTOM RIGHT: Summer residents. *(Ocean Grove, Monmouth County)*

OPPOSITE: A typical row of summer beach cabanas decorated in their Caribbean color best. *(Sea Bright, Monmouth County)*

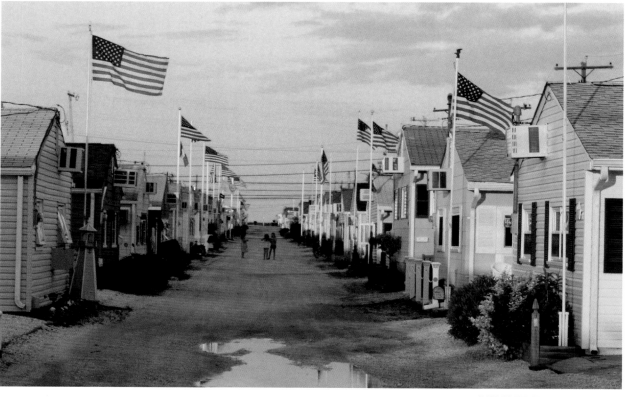

SHORE PATRIOTISM BY KATIE WISZ

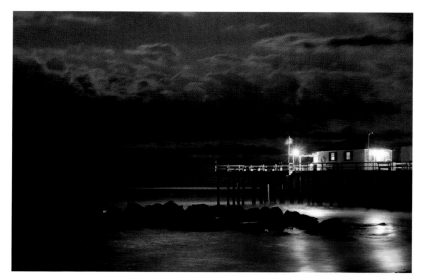

MOONLIT BY ROB NAGY

TENT PEOPLE BY JO HENDLEY

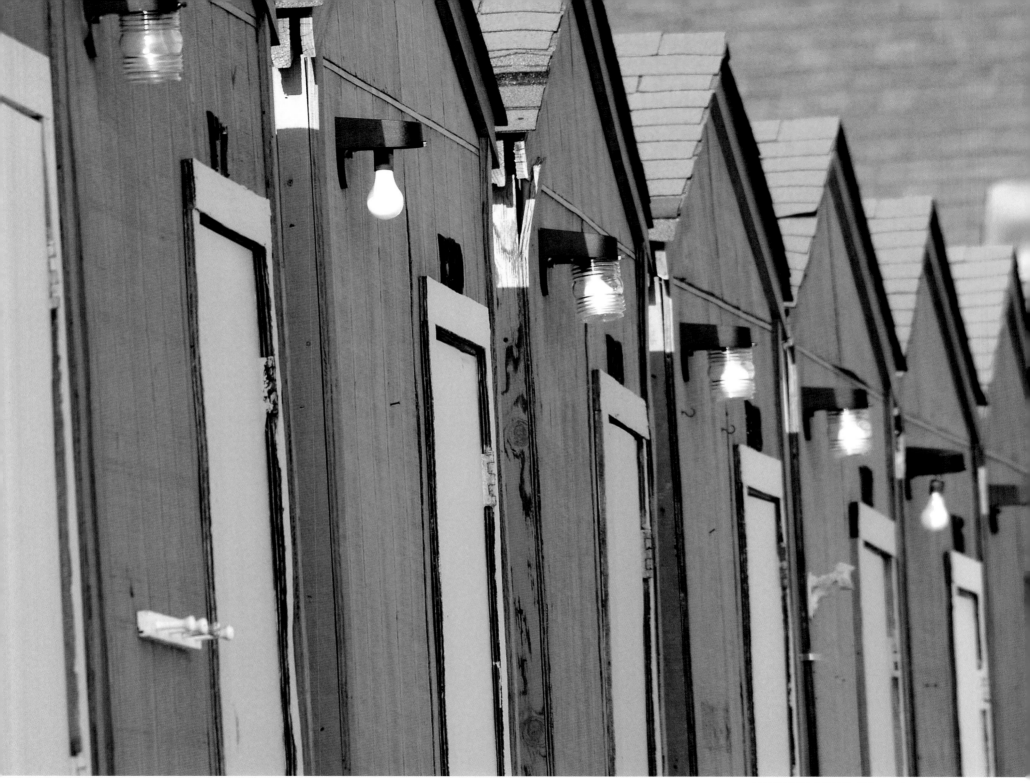

HOME AWAY FROM HOME BY KHRISTI JACOBS

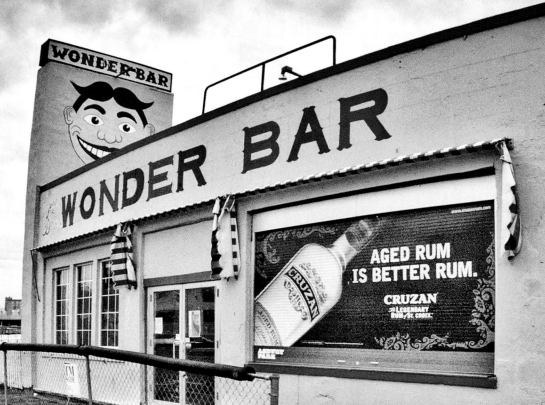

WONDER FISH BY JAMES ABELS

WALL SHARK BY STEVE STANGER

ABOVE: A shark poking out from the wall in Keyport. *(Keyport, Monmouth County)*

LEFT: Detail of Palace Amusements exterior before being torn down. *(Asbury Park, Monmouth County)*

FAR LEFT: An 8mm fisheye shot of The Wonder Bar. *(Asbury Park, Monmouth County)*

PALACE AMUSEMENTS BY HENRY BOSSETT

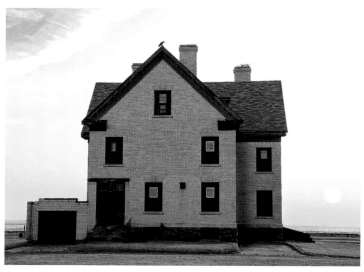

HOUSE OF THE SETTING SUN BY MICHAEL YUCIUS

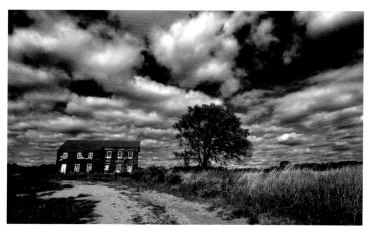

MONMOUTH BATTLEFIELD BY TOM BERG

ABOVE: Monmouth Battlefield. *(Manalapan, Monmouth County)*

TOP: The sun sets on Fort Hancock. *(Fort Hancock, Monmouth County)*

RIGHT: A single house stands outlined. *(Fort Hancock, Monmouth County)*

OPPOSITE: A view of the Quarters at Fort Hancock.
(Fort Hancock, Monmouth County)

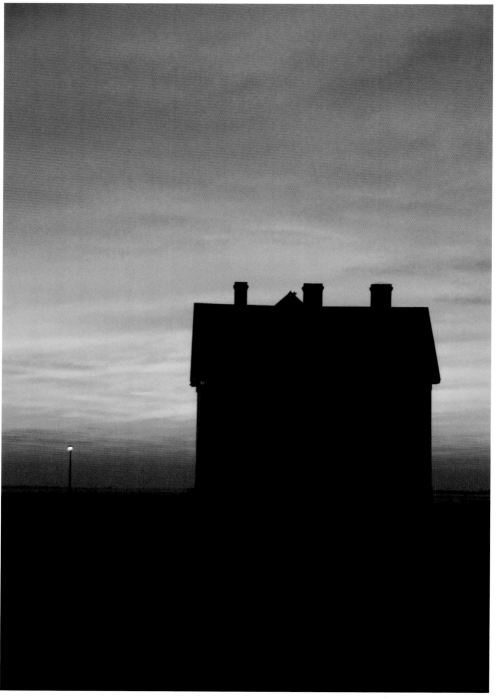

ALONE AT DUSK BY MIKE GALVIN JR

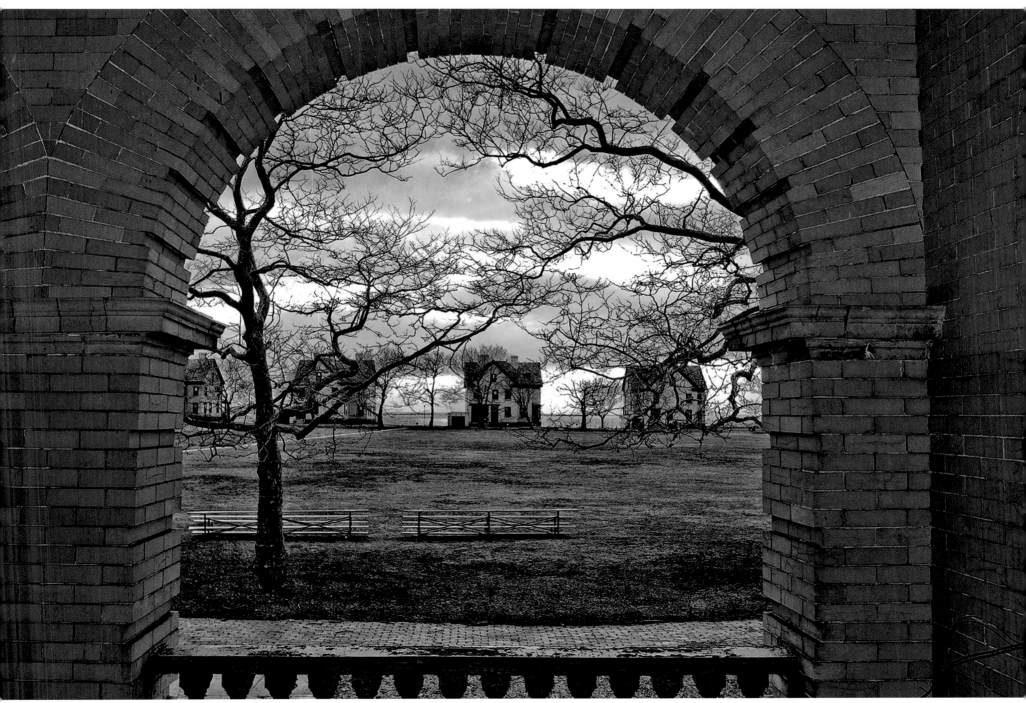

UNTITLED BY ED KULBACK

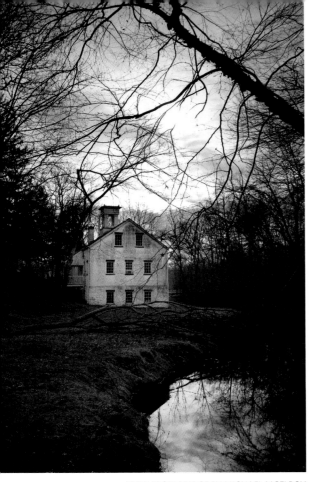

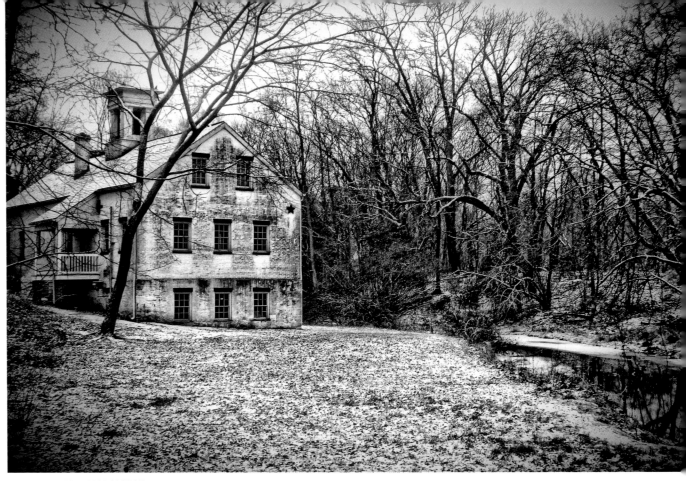

VIEW FROM BRIDGE BY MICHAEL MCELROY

LIKE OLD TIMES BY MARY BARAN

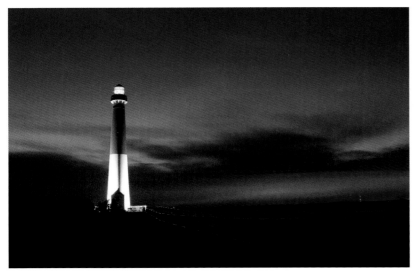

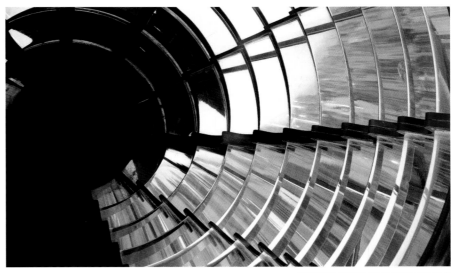

WINTER SUNSET BY MIKE GIANNICO

KEEPING WATCH BY CHERYL SOMERS

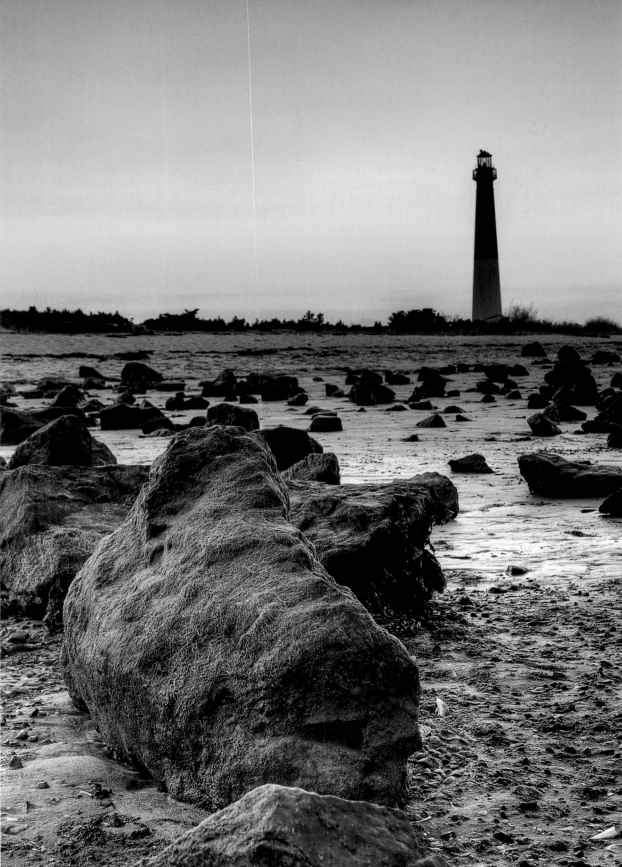

LOW TIDE BY ALEX TUMUSOK

LEFT: Rocks are exposed when the water's gone. *(Barnegat, Ocean County)*

OPPOSITE TOP LEFT: Allaire State Park. *(Allaire, Monmouth County)*

OPPOSITE TOP RIGHT: Allaire Village wrapped in a gentle blanket of snow. *(Allaire, Monmouth County)*

OPPOSITE BOTTOM LEFT: A winter sunset at Barnegat Lighthouse. *(Barnegat Light, Ocean County)*

OPPOSITE BOTTOM RIGHT: Sandy Hook Lighthouse. *(Highlands, Monmouth County)*

FOLLOWING LEFT: Sandy Hook at night. *(Fort Hancock, Monmouth County)*

FOLLOWING RIGHT: A Sandy Hook scene. *(Highlands, Monmouth County)*

BELOW: Barnegat Light House. *(Barnegat, Ocean County)*

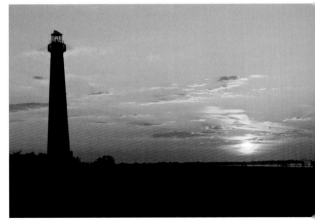

THE SENTINEL BY HARVEY SPINKS

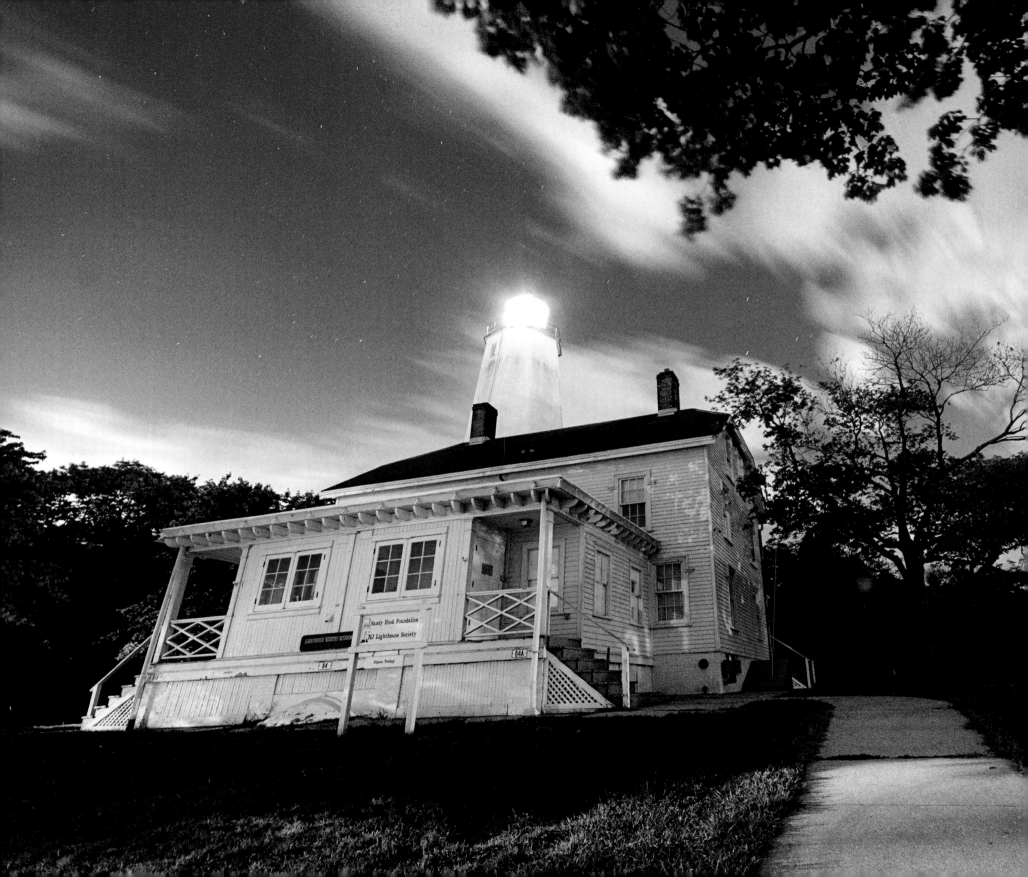

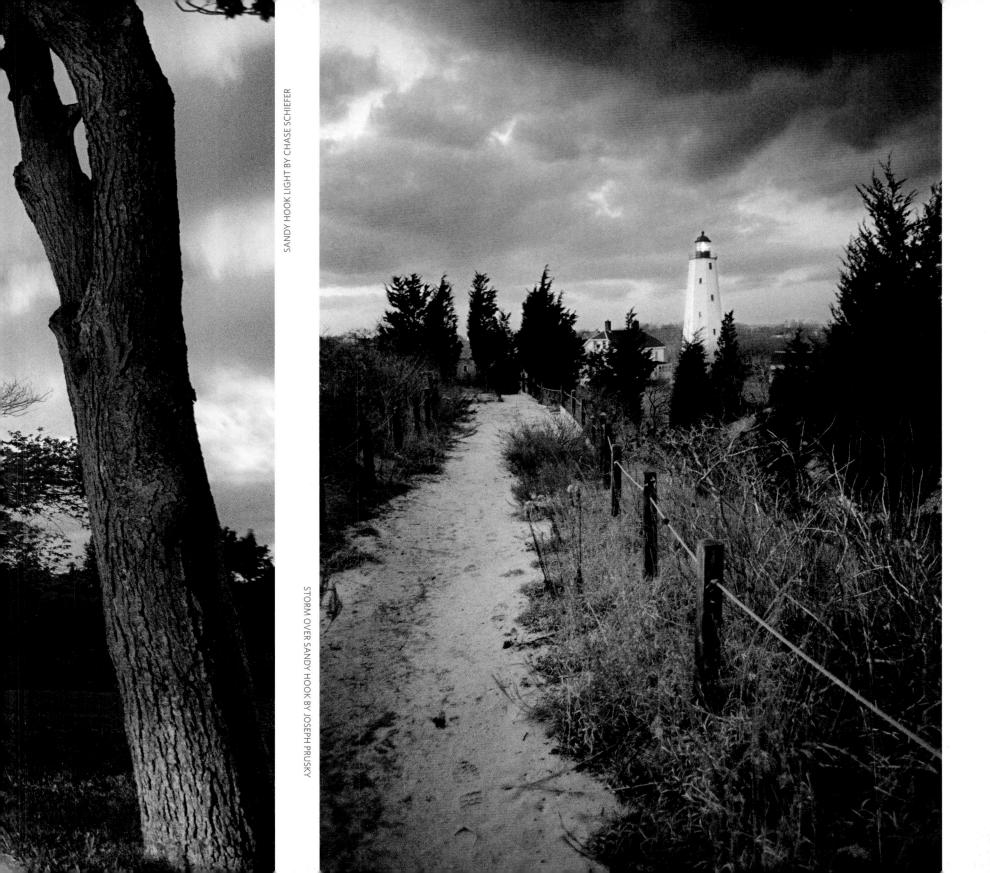

SANDY HOOK LIGHT BY CHASE SCHIEFER

STORM OVER SANDY HOOK BY JOSEPH PRUSKY

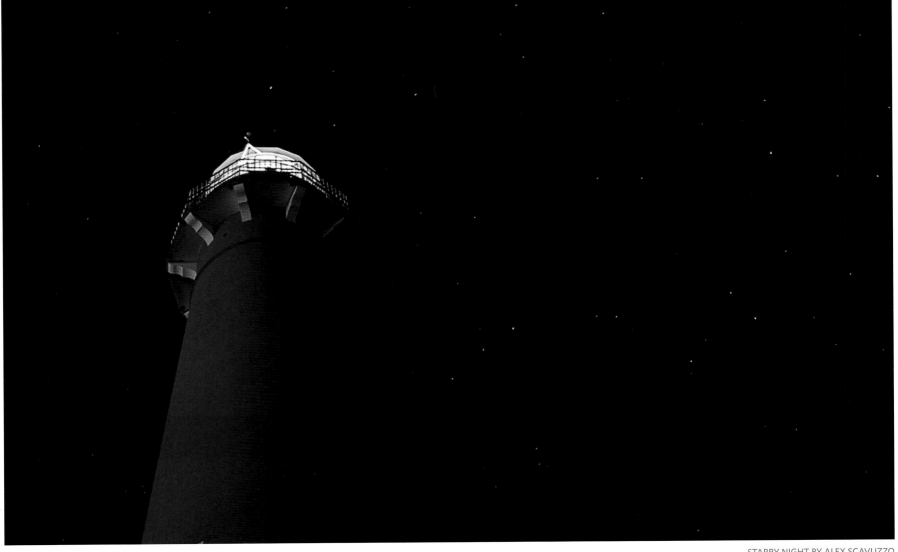

STARRY NIGHT BY ALEX SCAVUZZO

UNTITLED BY CAMILLE NICCOLI

ABOVE: A humid night next to Old Barney.
(Barnegat Light, Ocean County)

RIGHT: Old Barney. *(Barnegat Light, Ocean County)*

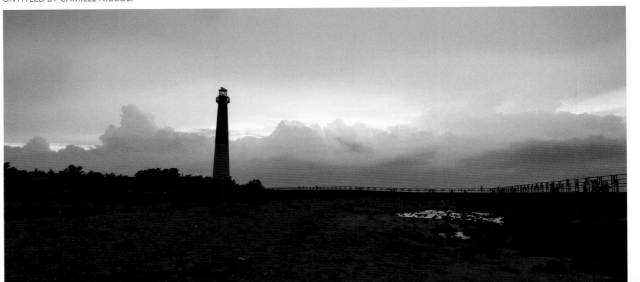

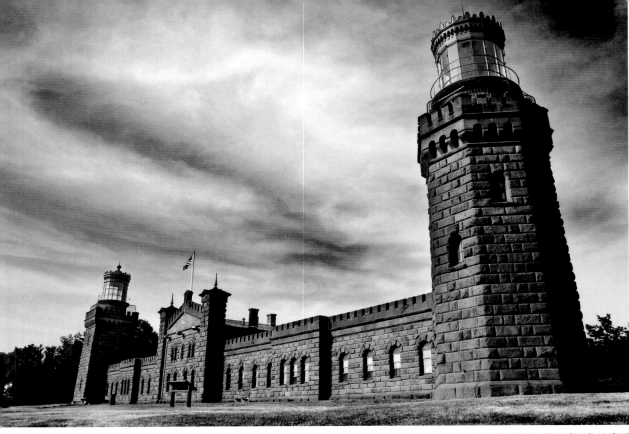

THE GUARDIAN BY MICHAEL YUCIUS

WINTER AT SANDY HOOK BY JOE VARNEKE

REFLECTIONS OF SANDY BY MIKE GALVIN JR

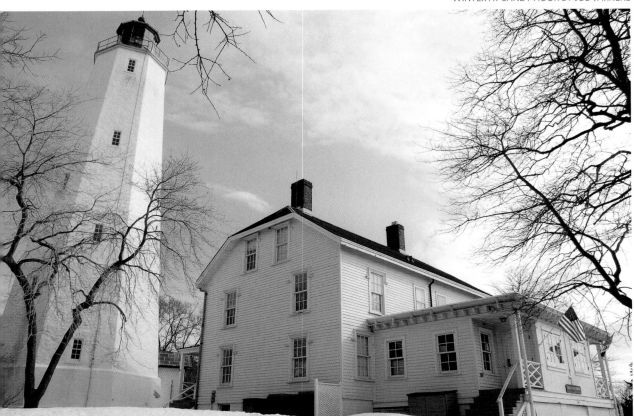

ABOVE: This is one of my favorite subjects to photograph. It never lets me down. *(Fort Hancock, Monmouth County)*

LEFT TOP: The twin lights of Navesink, 250 feet above the Sandy Hook Bay. *(Highlands, Monmouth County)*

LEFT BOTTOM: Sitting at the northern end of the Jersey Shore, the Sandy Hook lighthouse is the oldest operating lighthouse in the country. I like going to the top as you can see the skyline of New York City and the ocean. I also like it because when you're at the top you see how far from the tip of Sandy Hook it actually is and gives one a sense of the currents and tidal force that shape our shoreline. *(Sands Point, Monmouth County)*

Sports, Recreation, Food and Fun

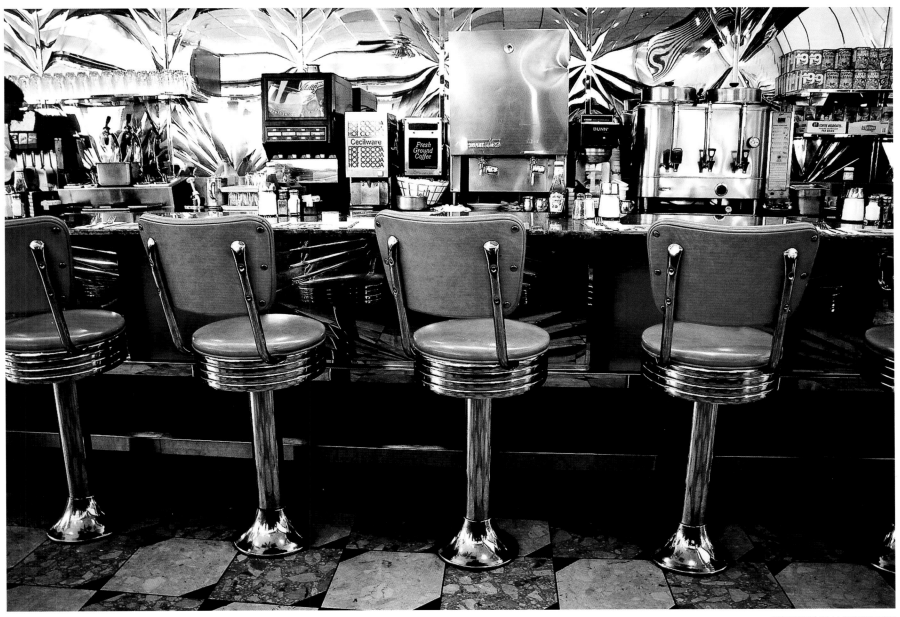

ABOVE: The diner — an icon found throughout the Jersey Shore. *(Shrewsbury, Monmouth County)*

RIGHT: Early morning training run. *(Seaside Heights, Ocean County)*

BOTTOM LEFT: People walking on the boardwalk. *(Seaside Heights, Ocean County)*

BOTTOM RIGHT: Couple enjoying their morning coffee while biking on the boards. *(Lavallette, Ocean County, NJ)*

OPPOSITE TOP: Bringing bed skills to the boardwalk. *(Seaside Heights, Ocean County)*

OPPOSITE BOTTOM LEFT: Having fun on the Himalaya ride at the boardwalk. *(Point Pleasant, Ocean County)*

OPPOSITE BOTTOM RIGHT: Where is everybody? All the fun is waiting on the boardwalk. *(Seaside Heights, Ocean County)*

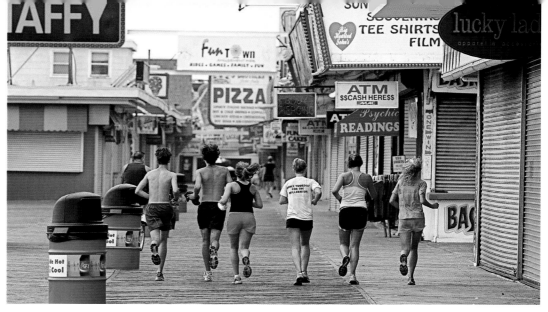

COED RUN BY FRANK COSTELLO

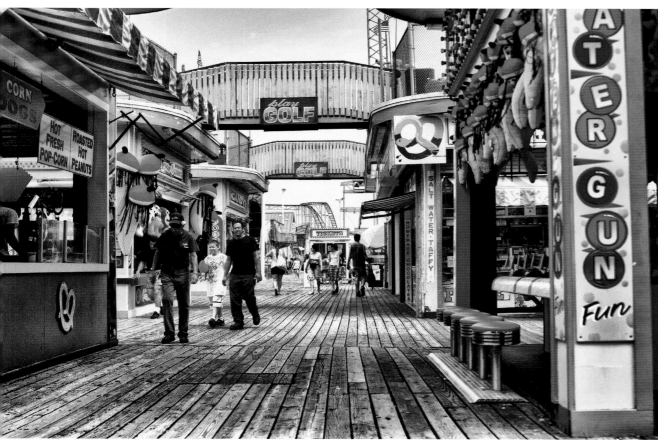

THE BOARDWALK BY DANE SCHMIDT

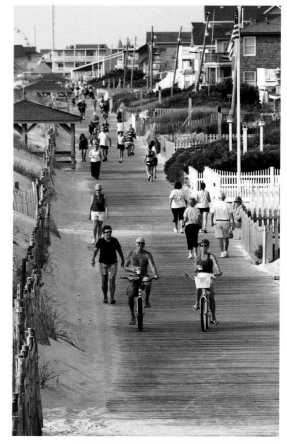

AMERICA RUNS ON DUNKIN BY FRANK COSTELLO

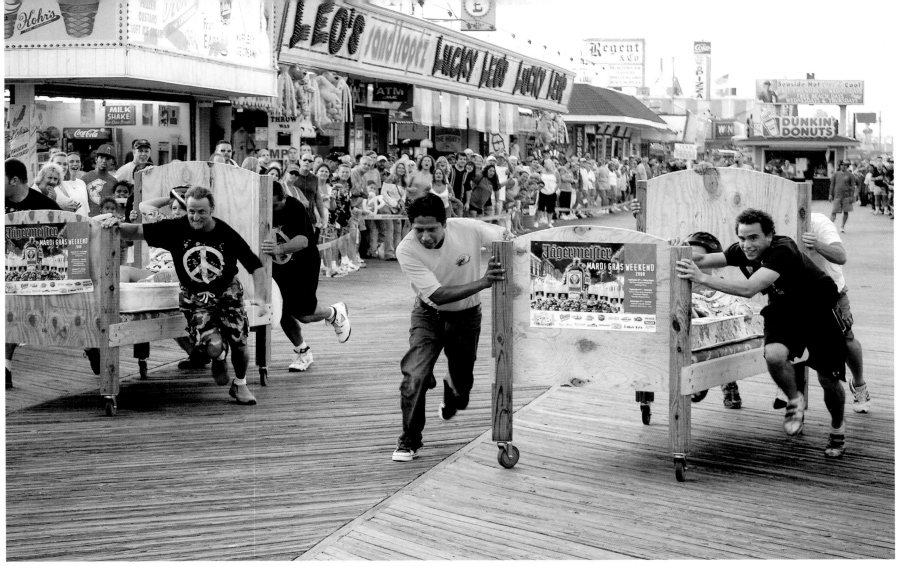

BEDS AND BOARDS BY BOB CUTHBERT

BEST FRIENDS BY STACEY BRUNO · LATE NIGHT BY JUDIT PAPP

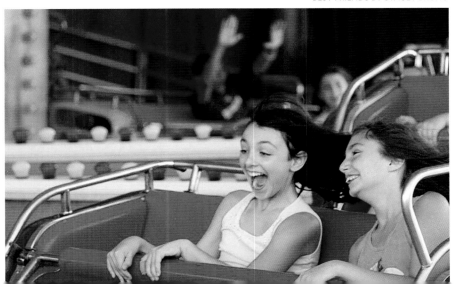

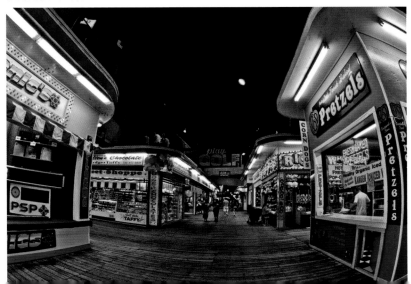

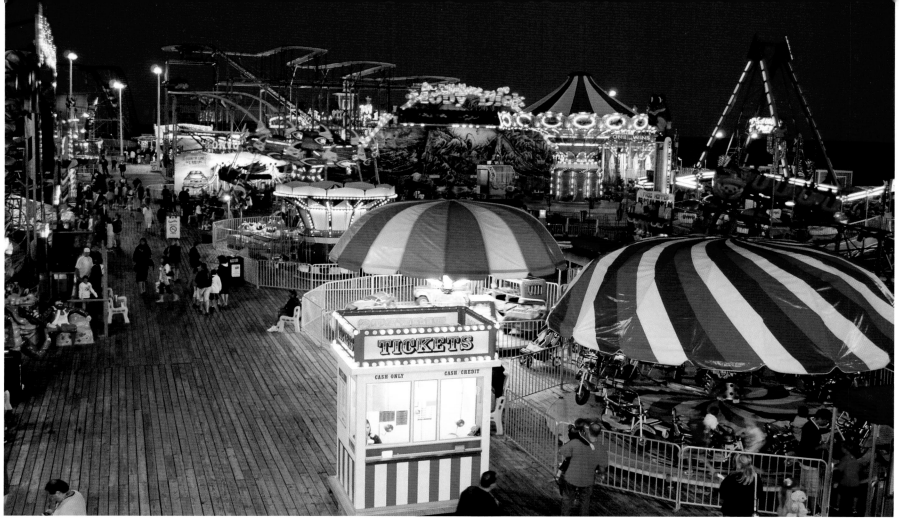

THE COLOR WHEEL BY DAVID SUTTON

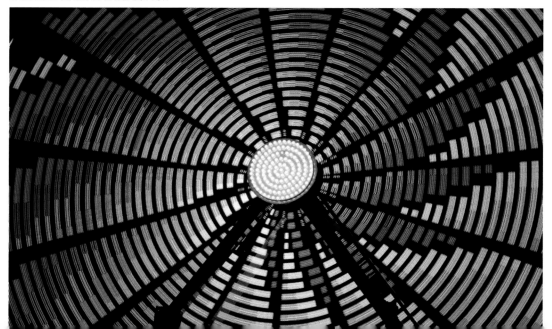

ABOVE: Amusements on Casino Pier. *(Seaside Heights, Ocean County)*

RIGHT: A close-up shot of the Ferris wheel at the Italian Festival. *(Oakhurst, Monmouth County)*

OPPOSITE TOP: A long-exposure photograph taken of both Ferris wheels (regular and kiddie) in Seaside. *(Seaside Heights, Ocean County)*

OPPOSITE BOTTOM LEFT: My nephew enjoying the swings at Point Pleasant. *(Point Pleasant, Ocean County)*

OPPOSITE BOTTOM RIGHT: A long-exposure shot of one of the many crazy rides on the boardwalk. *(Seaside Heights, Ocean County)*

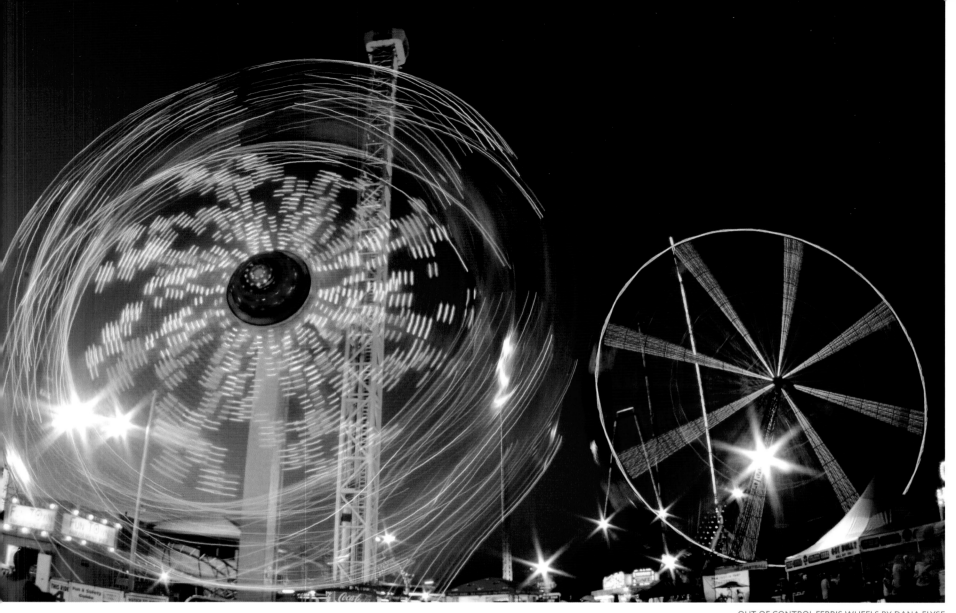

OUT OF CONTROL FERRIS WHEELS BY DANA ELYSE

SWING! BY JACKIE SCARPARI

WHEEEEE BY DANA ELYSE

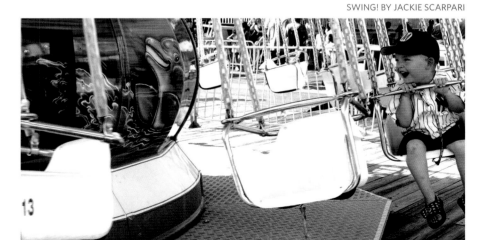

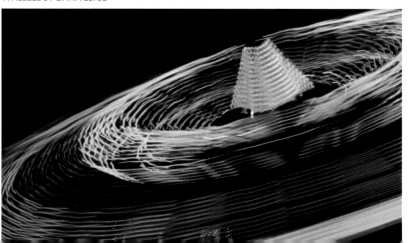

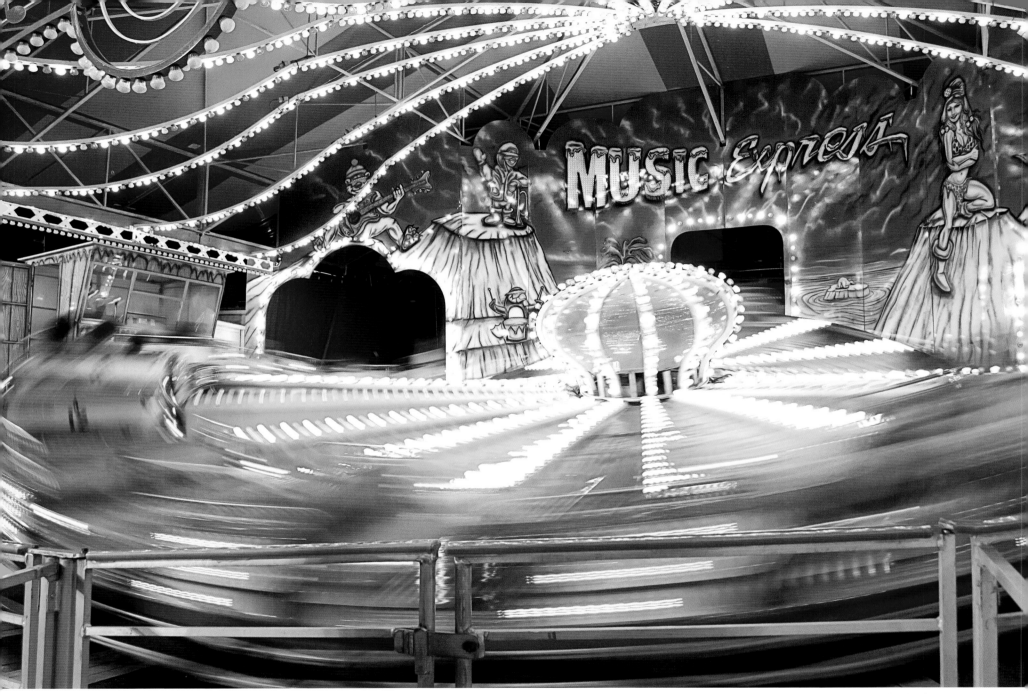

ABOVE: The louder you scream, the faster you'll go. *(Point Pleasant, Ocean County)*

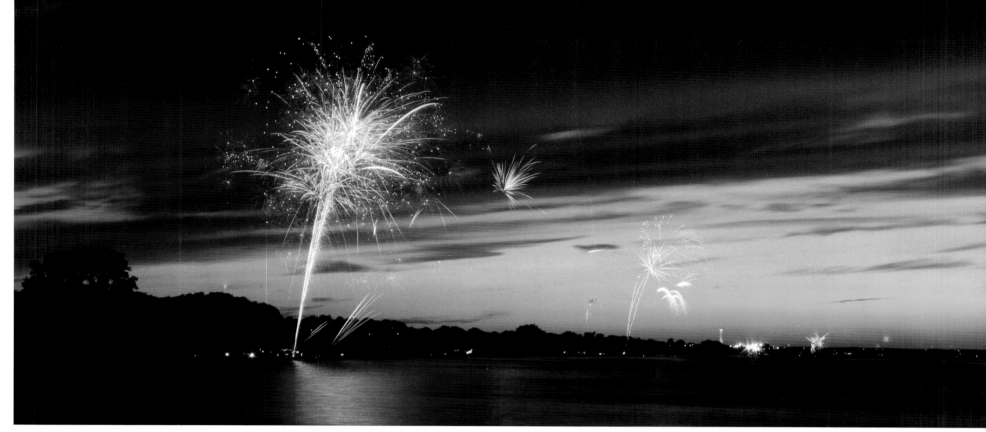

FAIR AND FIREWORKS BY JAMES GOLDSTEIN

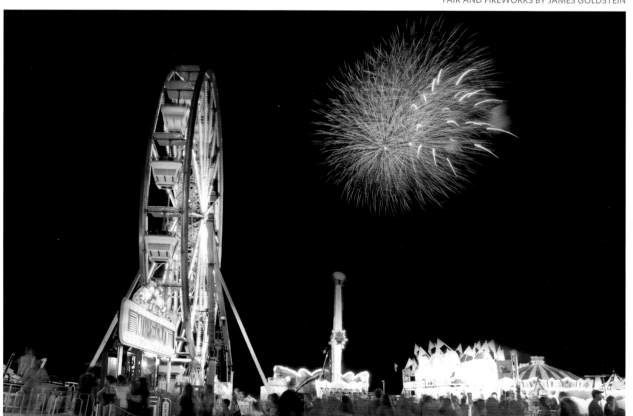

ABOVE: Usually it's really dark when the fireworks start, but some families on the local beach were staring early. *(Port Monmouth, Monmouth County)*

LEFT: Ocean Township festival and fireworks in August. *(Ocean, Ocean County)*

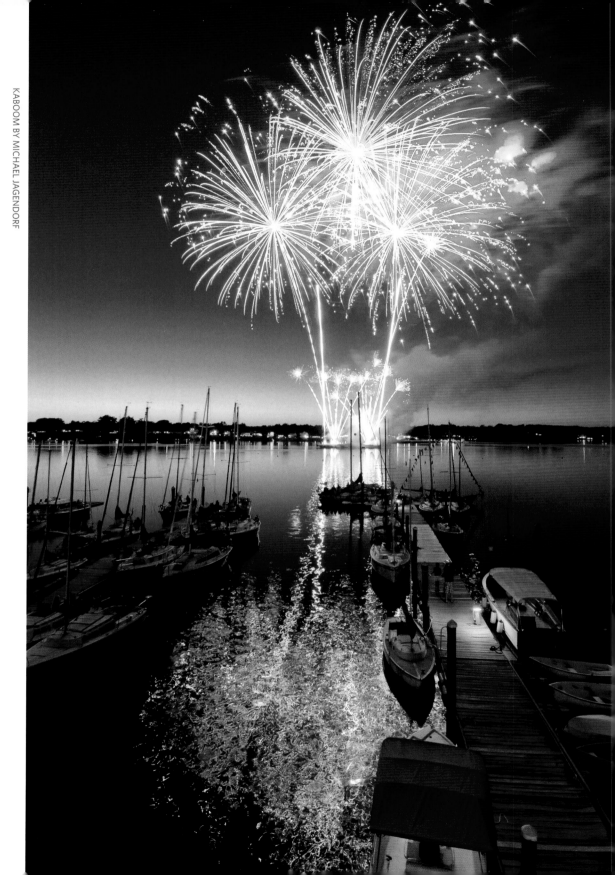

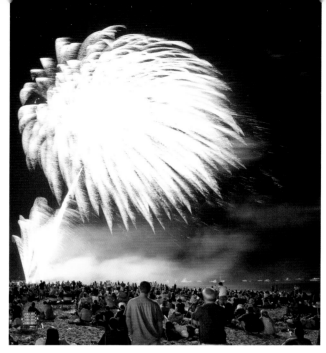

FIREWORKS BY JEREMY WOOD

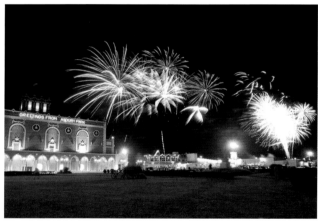

COLOR IN THE SKY BY DOUGLAS RAYNOR

ABOVE: Asbury Park fireworks. (*Asbury Park, Monmouth County*)

TOP: Fireworks mark a happy Fourth of July.
(*Point Pleasant Beach, Ocean County*)

RIGHT: The Kaboom fireworks show over the Navesink
River in Red Bank from the roof of the Monmouth Boat Club.
(*Red Bank, Monmouth County*)

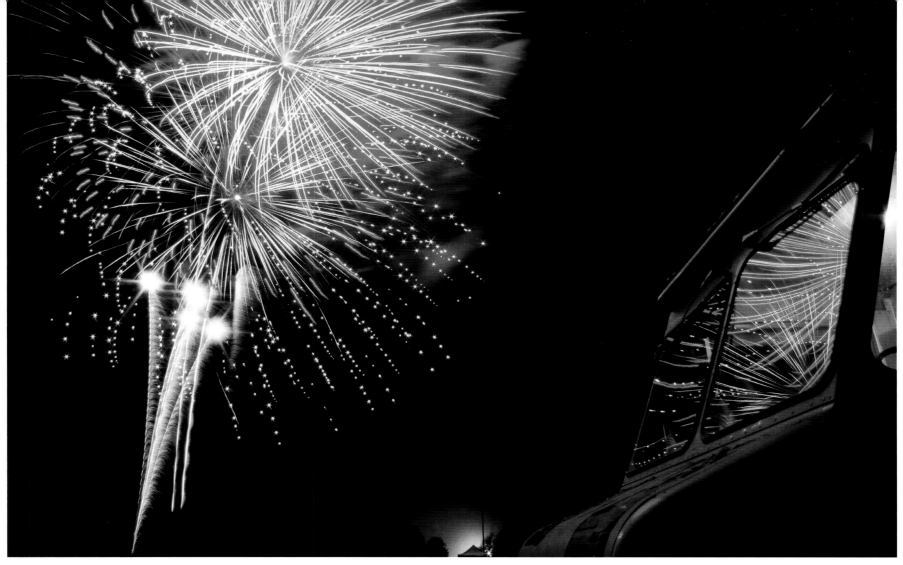

FIREWORK BY KEVIN SMOCK

FUNTOWN BY JONATHAN VANDUYNE

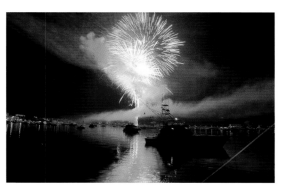

FOURTH OF JULY BY JENNIFER QUINN

ABOVE: Fireworks reflecting. *(Oakhurst, Monmouth County)*

LEFT: Fireworks on the Navesink River. *(Bay Side, Ocean County)*

FAR LEFT: Fourth of July weekend kicks off early at Seaside Heights. *(Seaside Heights, Ocean County)*

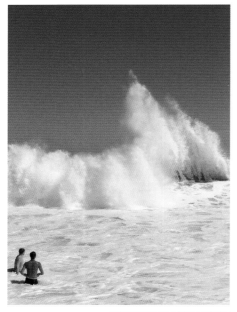

EXPLOSIVE BY JOAN MANZO

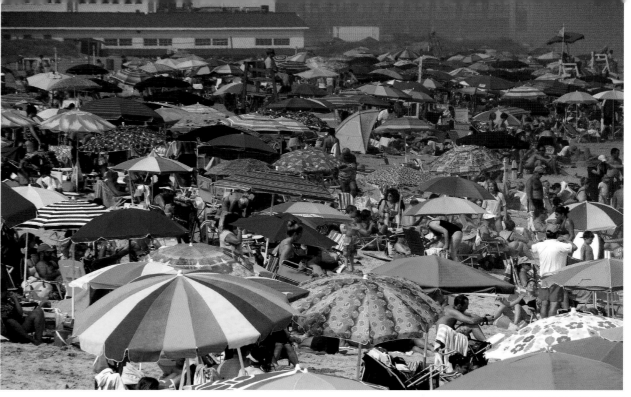

UMBRELLA DAY BY JOHN BASILE

BLUE BEACH CRUISERS BY GREG CUMMINGS

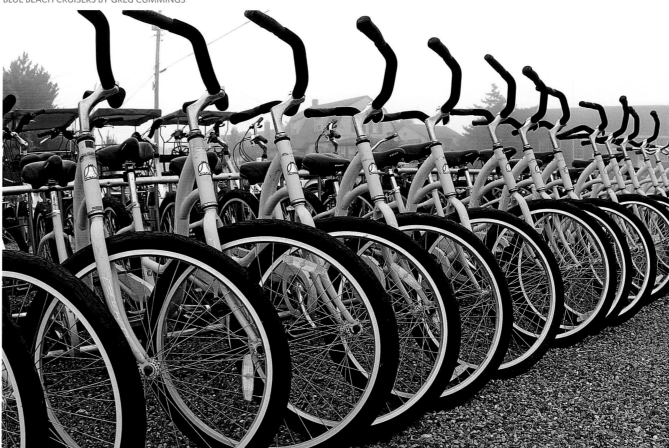

ABOVE: Watching the waves collide after a storm. *(Point Pleasant Beach, Ocean County)*

ABOVE RIGHT: A day at the beach. *(Ocean Grove, Monmouth County)*

RIGHT: Bikes in a row, ready for some fun. *(Surf City, Ocean County)*

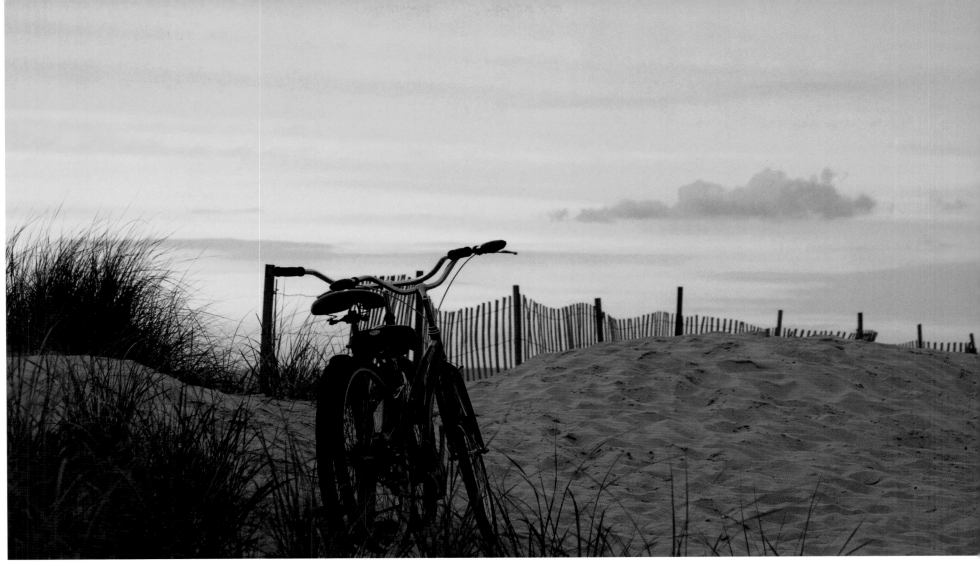

OFF INTO THE SUNSET BY STACEY BRUNO

LONER BY RON SCHILLER

ABOVE: Some cyclists parked their bikes for a walk on the beach.
(*Port Monmouth, Monmouth County*)

LEFT: Late spring in Avon.
(*Avon-by-the-Sea, Monmouth County*)

RIDE HOME BY JAMES LOESCH

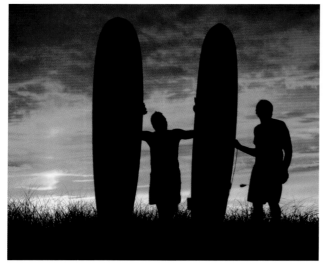

SUNSET SURF BY MICHELLE GRAY

ABOVE: Surfing at Sunset on the Fourth of July. *(Asbury Park, Monmouth County)*

TOP: A surfer on a bike on 9th Avenue in Seaside Park after a day of surfing. *(Seaside Park, Ocean County)*

RIGHT: A long day of surfing comes to an end. *(Holgate, Ocean County)*

OPPOSITE: Ahh — relaxation. *(Surf City, Ocean County)*

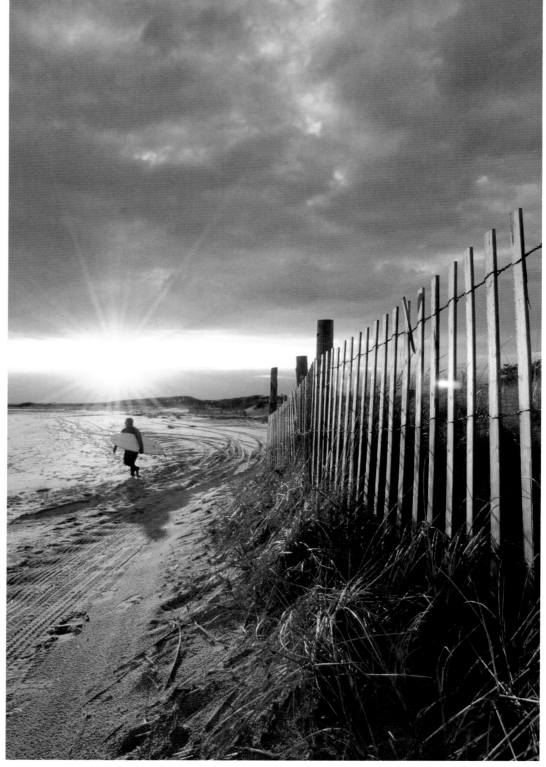

A GOLDEN END BY ALEX SCAVUZZO

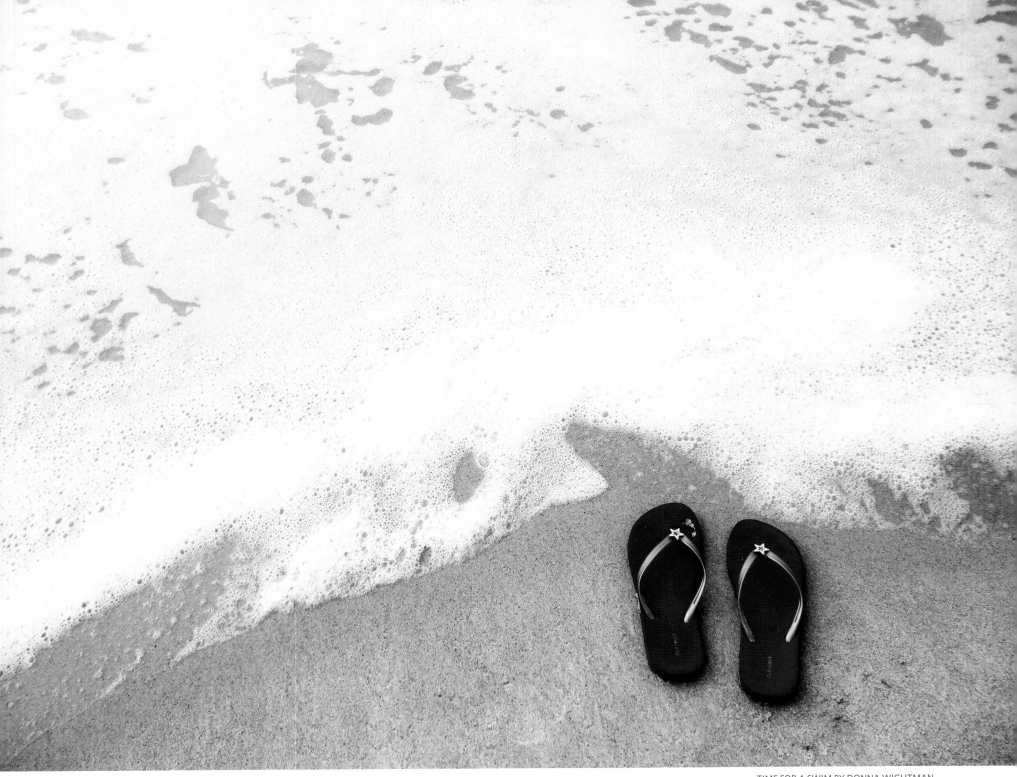

TIME FOR A SWIM BY DONNA WIGHTMAN

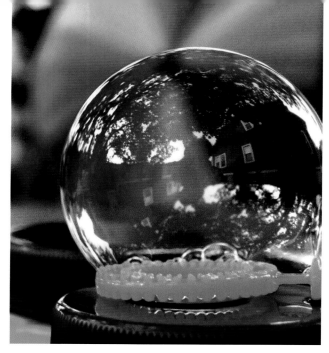

IN A BUBBLE BY JILL WHITLEY

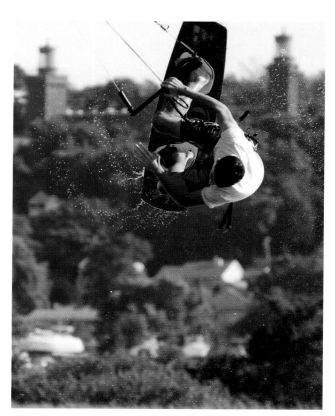

KITEBOARDING BY GONZALO HERRERA

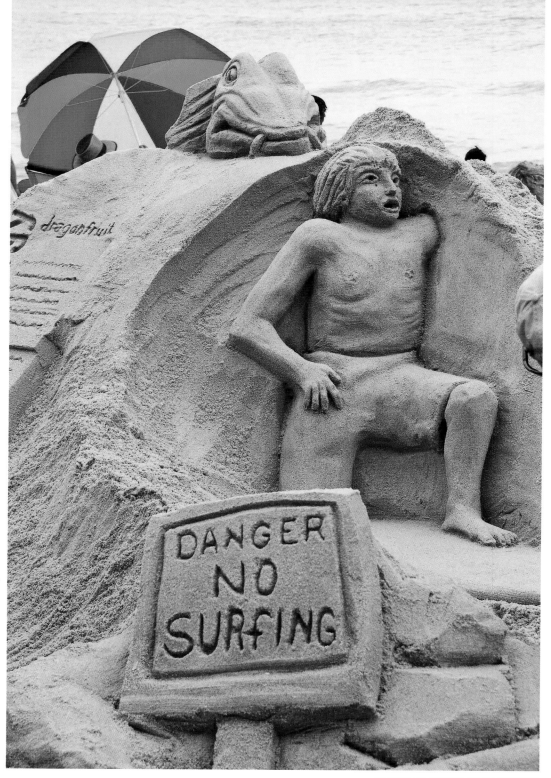

DANGER NO SURFING BY ALAN WIENER

LEFT: Pick your weapon of choice. *(Bay Head, Ocean County)*

OPPOSITE LEFT TOP: Fun with bubbles. *(Bricktown, Ocean County)*

OPPOSITE LEFT BOTTOM: Kiteboarding afternoon at Sandy Hook with the Twin Lights of the Navesink as a background. *(Highlands, Monmouth County)*

OPPOSITE RIGHT: Belmar sandcastle contest. *(Belmar, Monmouth County)*

BOTTOM LEFT: Down by the lake. *(Matawan, Monmouth County)*

BOTTOM RIGHT: Kayak at sunset. *(Red Bank, Monmouth County)*

SUIT UP BY MARTIN MASTERSON

DOWN BY THE LAKE BY STEVE STANGER

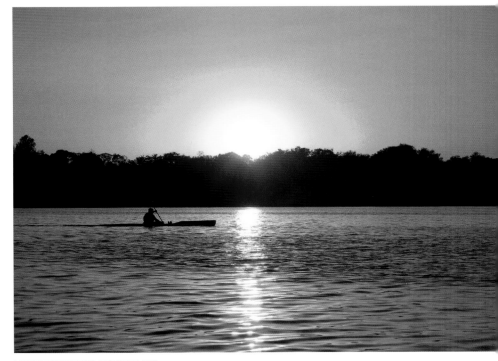

NAVESINK KAYAK BY ERIC THACKE

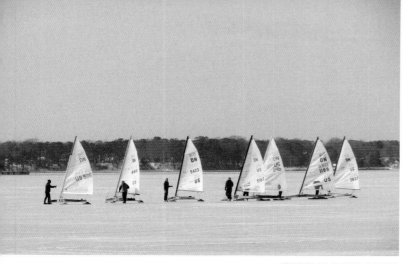

ICY FUN BY DUSTIN GABRIEL

ABOVE: Ice boating on the Toms River.
(Island Heights, Ocean County)

RIGHT: Endless summer on the Jersey Shore.
(Point Pleasant, Ocean County)

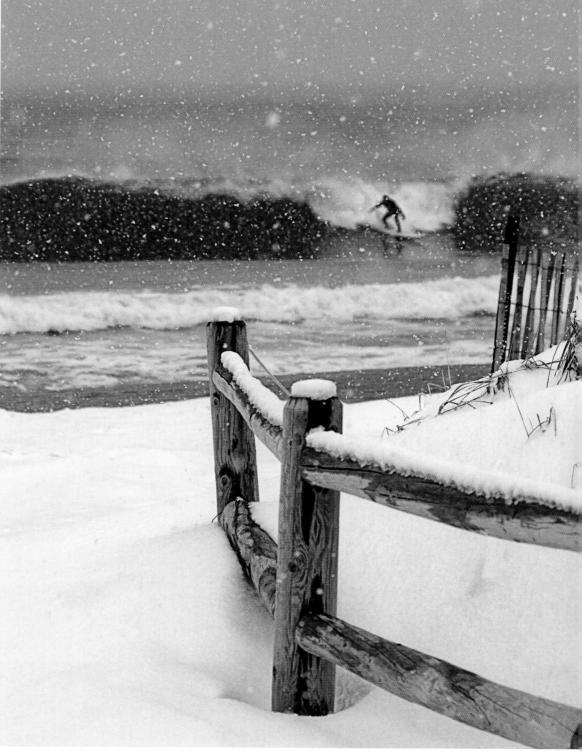

SNOW SURFER BY RON SCHILLER

WINTER SPORTS BY BOB ENGELBART

ABOVE: My backyard shower. *(Bricktown, Ocean County)*

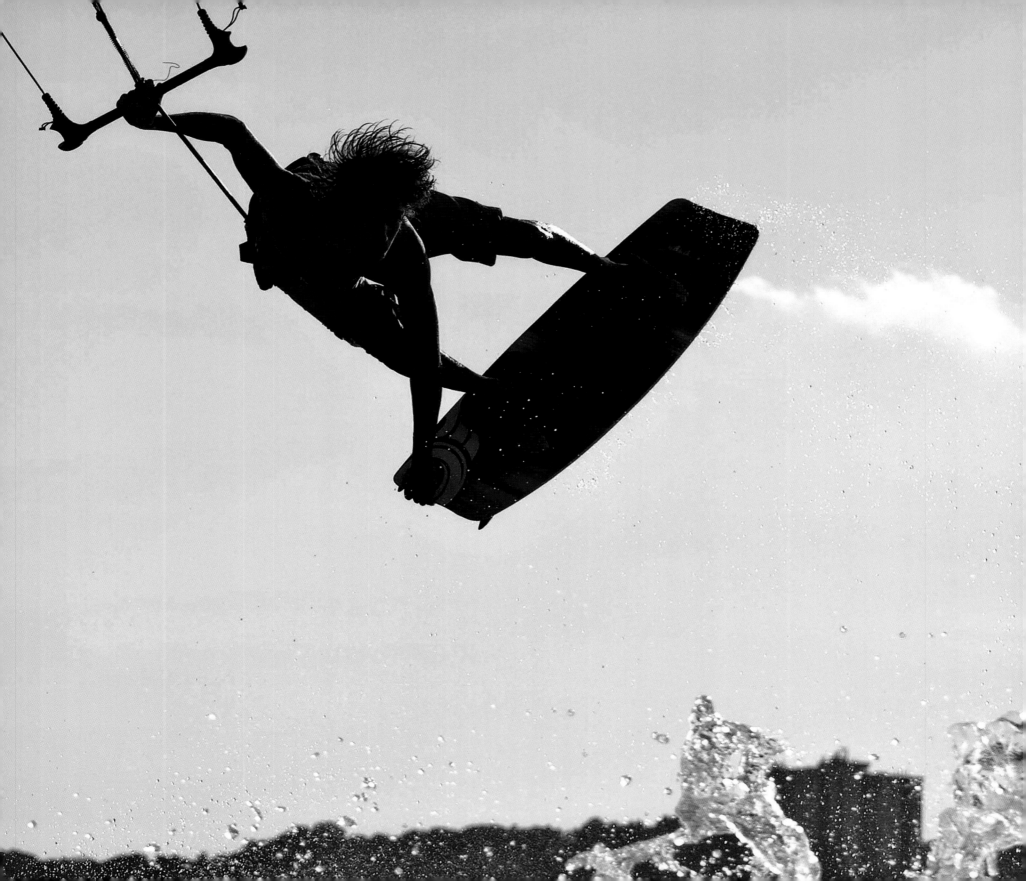

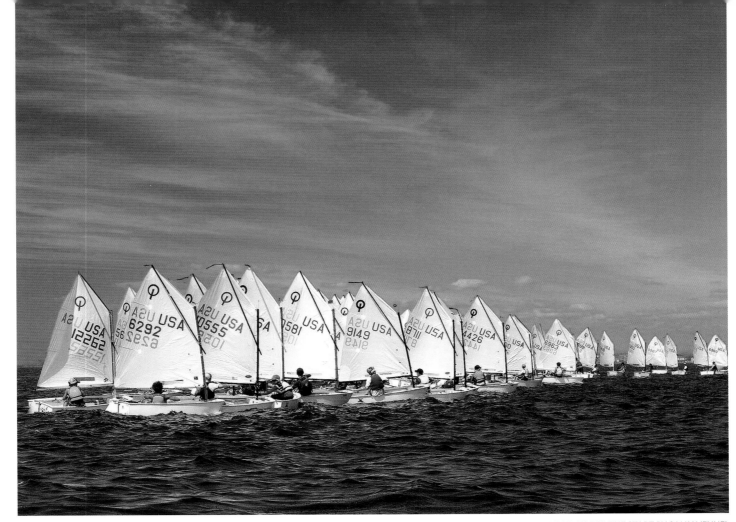

LINED UP FOR THE START BY SALLY VENNEL

SAILBOATS AT DUSK BY RON SCHILLER

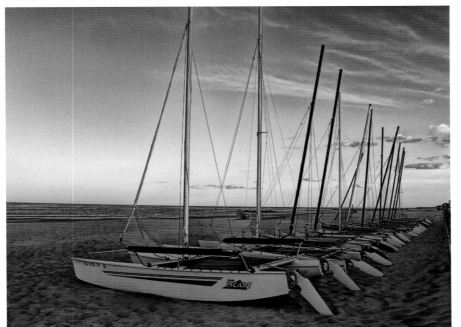

ABOVE: Opti Race at the Surf City Yacht Club. *(Surf City, Ocean County)*

LEFT: Tomorrow is another day for sailing. *(Spring Lake, Monmouth County)*

FAR LEFT: Kiteboarding at The Hook. *(Highlands, Monmouth County)*

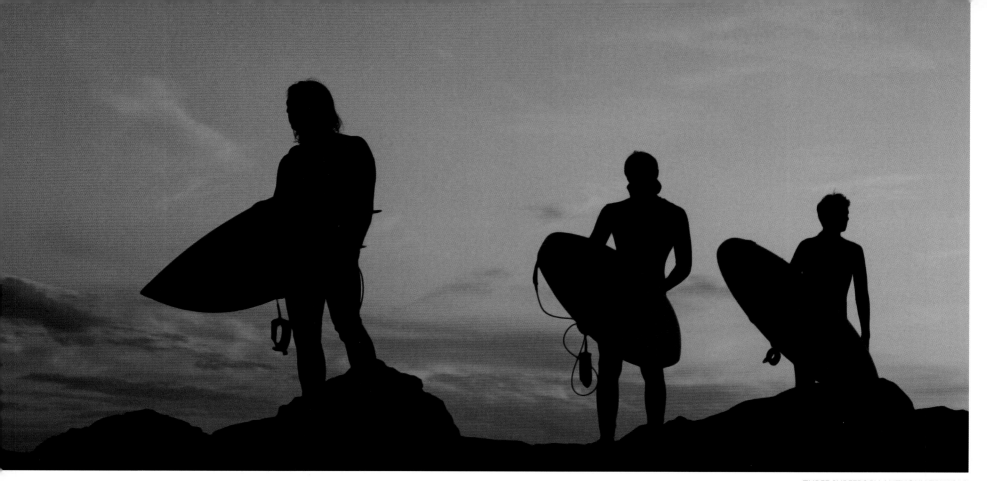

THREE SURFERS BY ANTHONY TRUFOLO

ABOVE: Friends after a day of surfing.
(Deal, Monmouth County)

RIGHT: The first wave we ever catch will stay with us forever. *(Ocean Beach, Ocean County)*

FAR RIGHT: A Seaside surfer.
(Seaside Heights, Ocean County)

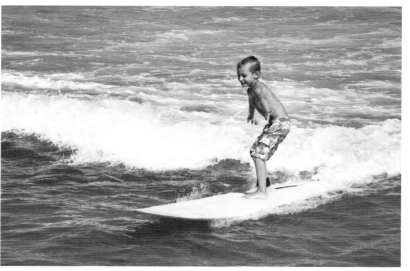

FIRST WAVE BY JENNIFER MALPASS

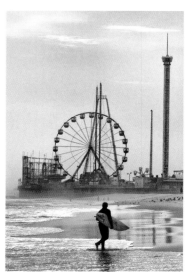

SEASIDE SURFER BY RON SCHILLER

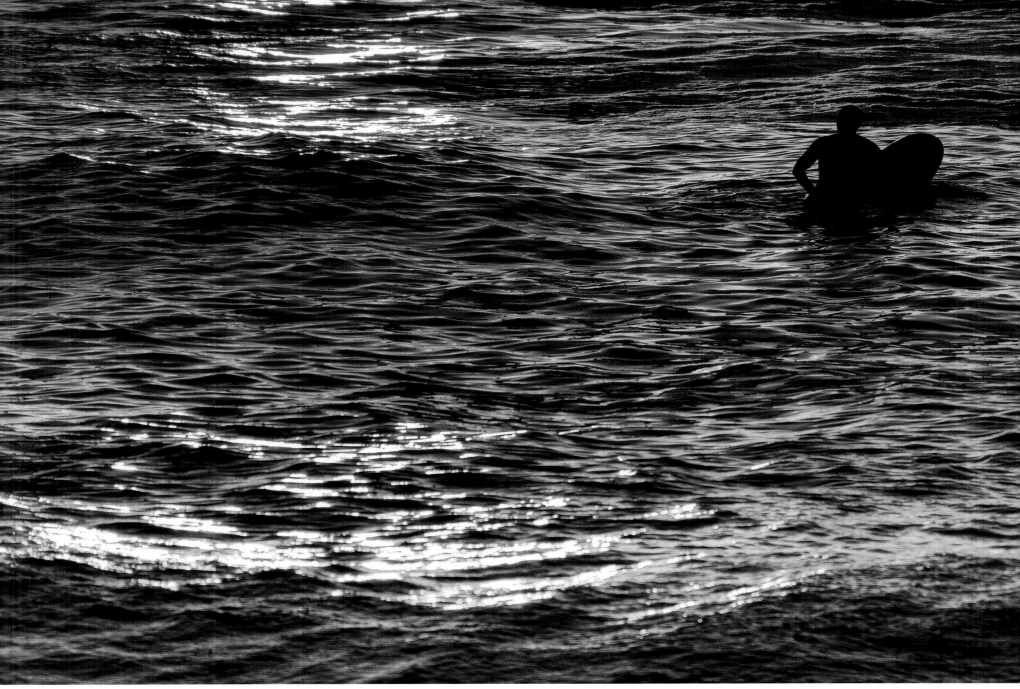

ASBURY PARK SURFING BY TOM BERG

ABOVE: A sunrise surf. *(Asbury Park, Monmouth County)*

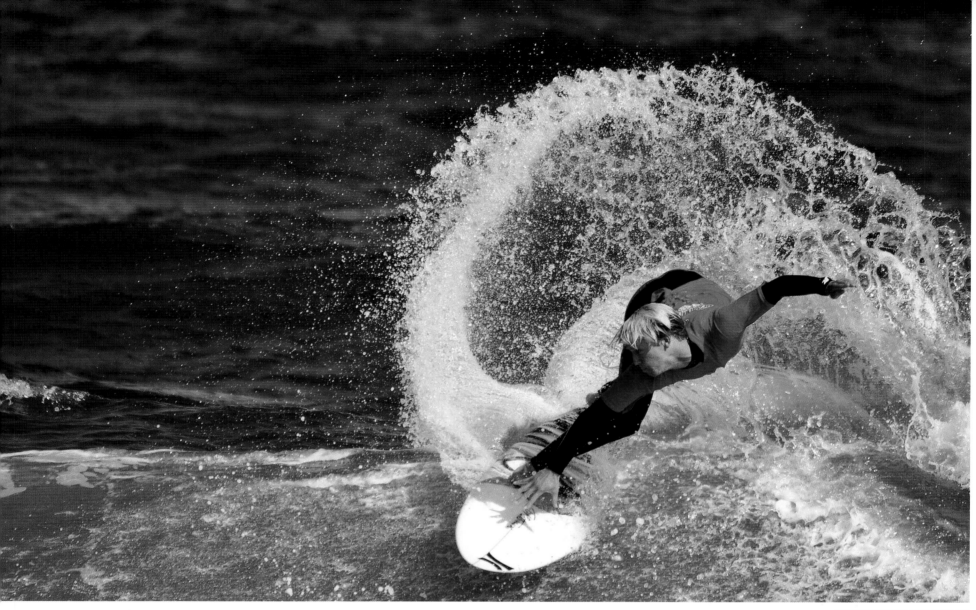

SURFER BY BRUCE MACDONALD

KEITH NOONAN BY STEVE FITZPATRICK

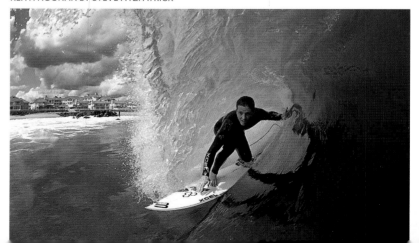

ABOVE: Catching a wave.
(Belmar, Monmouth County)

RIGHT: Keith Noonan travels through the barrel of a wave at the Free Beach in West Long Branch.
(Long Branch, Monmouth County)

OPPOSITE TOP: Going in for a surf.
(Point Pleasant, Ocean County)

OPPOSITE BOTTOM LEFT: A surfer escaping the wave after a good ride.
(Sea Girt, Monmouth County)

OPPOSITE BOTTOM MIDDLE: A surfer catching a wave.
(Manasquan, Monmouth County)

OPPOSITE BOTTOM RIGHT: Up-close in the water. *(Seaside Park, Ocean County)*

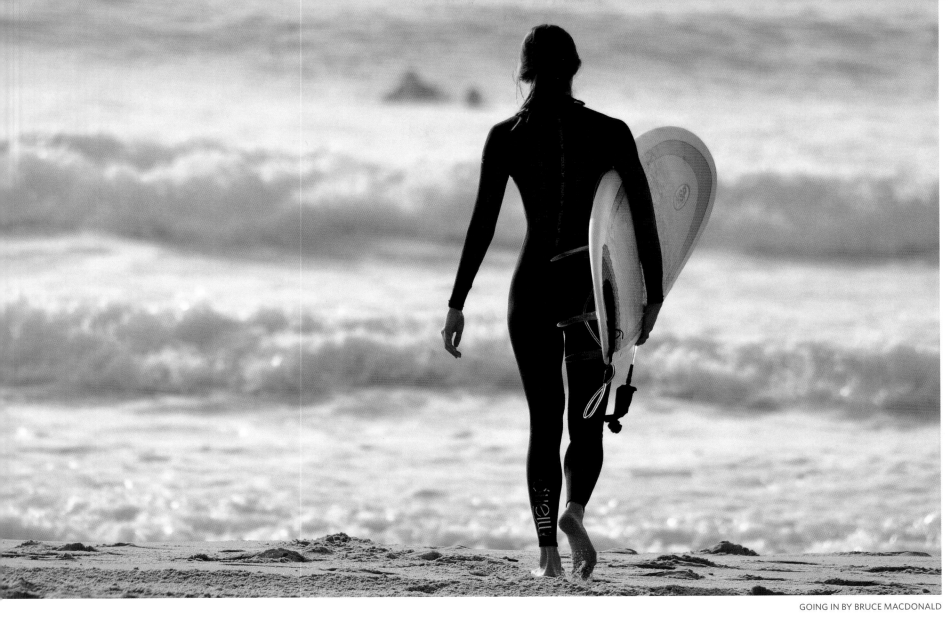

GOING IN BY BRUCE MACDONALD

BEATING THE WAVE BY HENRY BOSSETT

JERSEY STYLE BY MIKE ATTANASIO

BRAD BY JAMES LOESCH

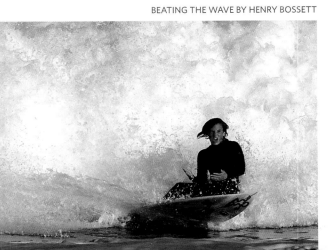

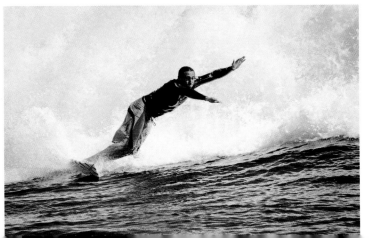

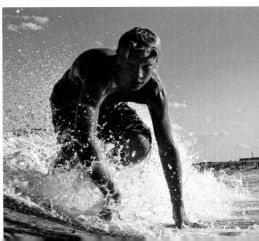

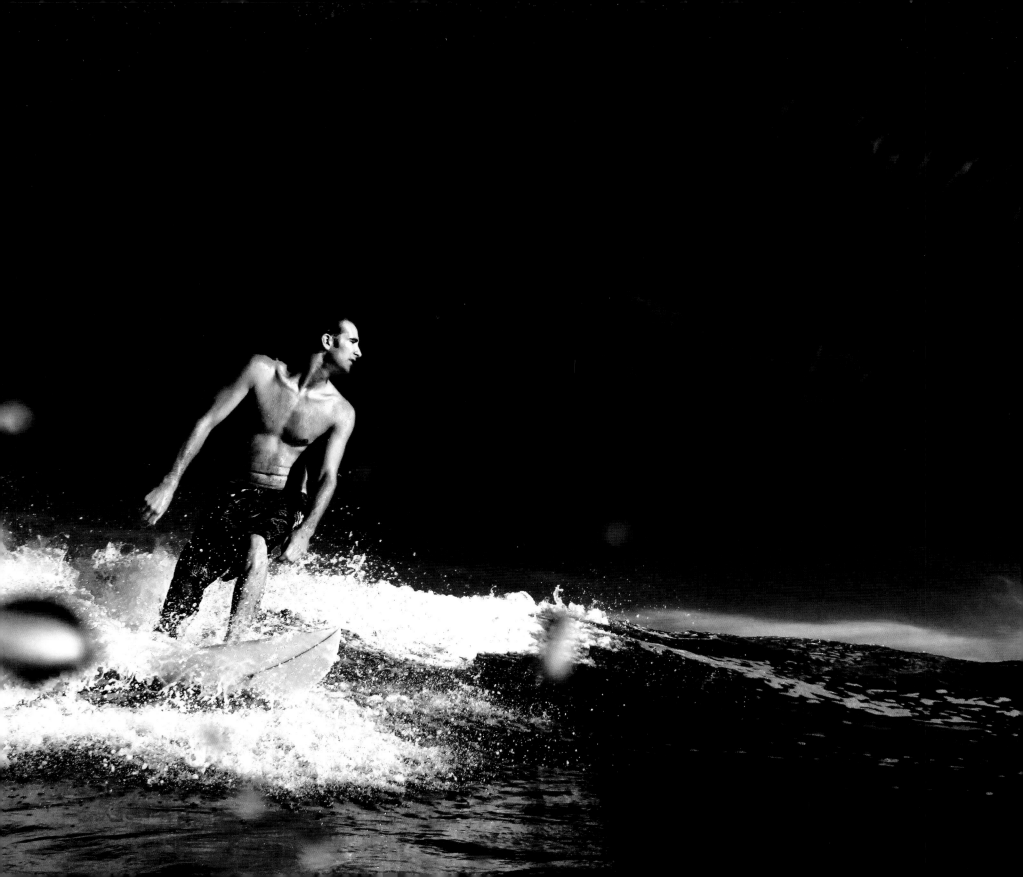

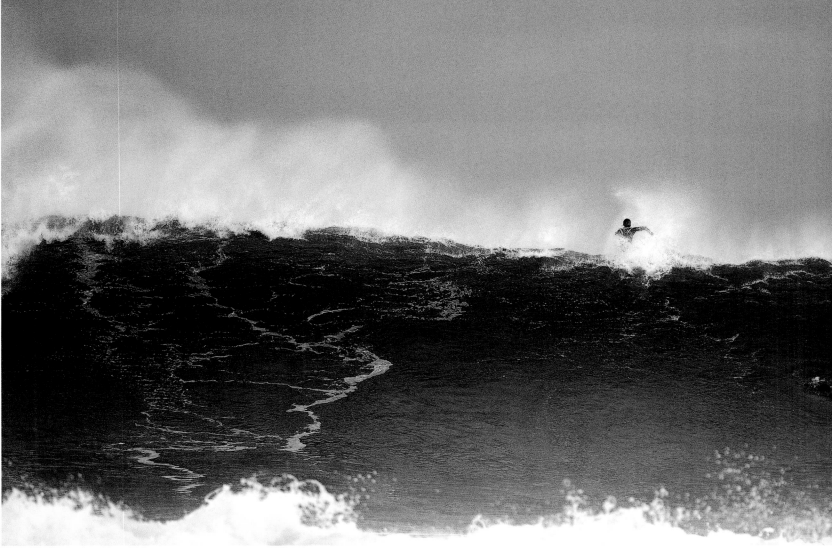

BW SURFER BY JAMES LOESCH

I'LL WAIT FOR THE NEXT WAVE BY HENRY BOSSETT

SURFERS ENTER THE MEGA-FROTH BY CHASE SCHIEFER

ABOVE: A surfer in Hurricane Earl waves.
(*Sea Girt, Monmouth County*)

LEFT: Surfers in Hurricane Earl froth.
(*Deal, Monmouth County*)

FAR LEFT: I caught this surfer in the water using underwater housing for my camera.
(*Seaside Park, Ocean County*)

RIGHT: The Sons of Ireland Polar Bear Plunge, January 2011. *(Asbury Park, Monmouth County)*

BOTTOM LEFT: Fishing for a good time in Beach Haven starts by throwing in the line. *(Beach Haven, Ocean County)*

BOTTOM RIGHT: Fishermen at Manasquan Reservoir. *(Howell, Monmouth County)*

OPPOSITE TOP LEFT: Fishing. *(Bradley Beach, Monmouth County)*

OPPOSITE TOP RIGHT: Crabbing. *(Seaside Heights, Ocean County)*

OPPOSITE BOTTOM LEFT: Early-morning fisherman at first light. *(Howell, Monmouth County)*

OPPOSITE BOTTOM RIGHT: Chillin' on the dock. *(Island Heights, Ocean County)*

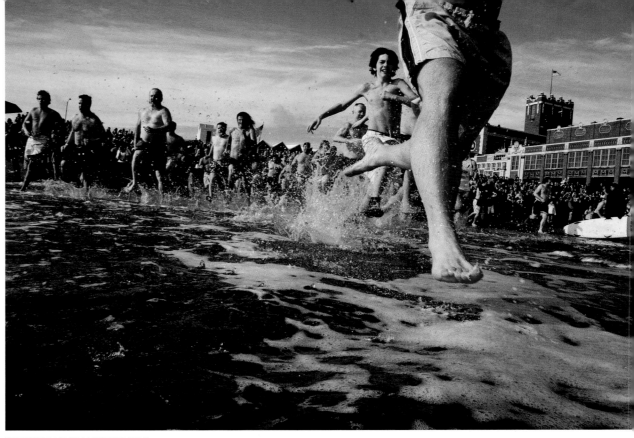

CATCHING AIR BY MARK KRAJNAK

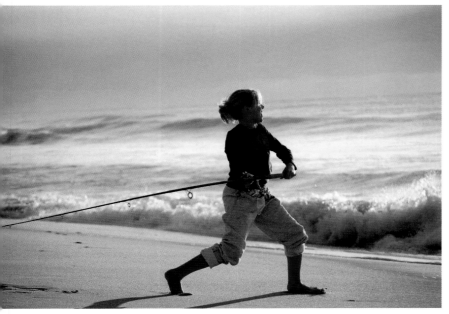

EARLY MORNING FISHING BY BOB CUTHBERT

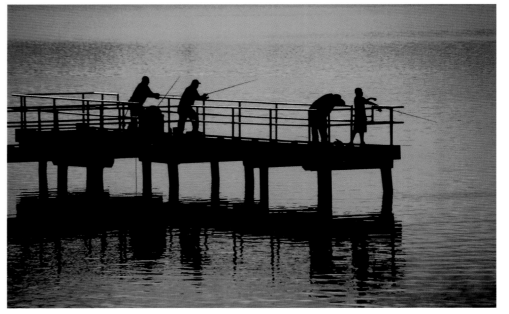

FISHERMEN BY RAYMOND SALANI III

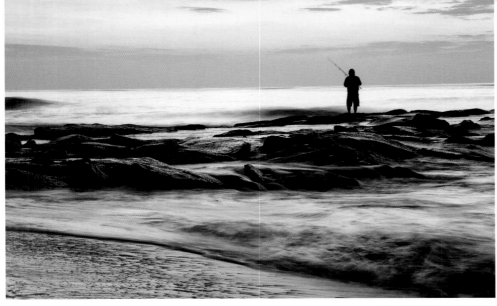

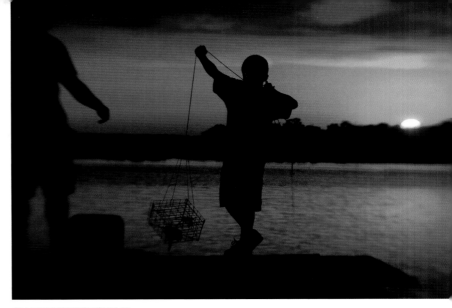

FISHING BY PAUL SHAPPIRIO

CRABBING BY RON SCHILLER

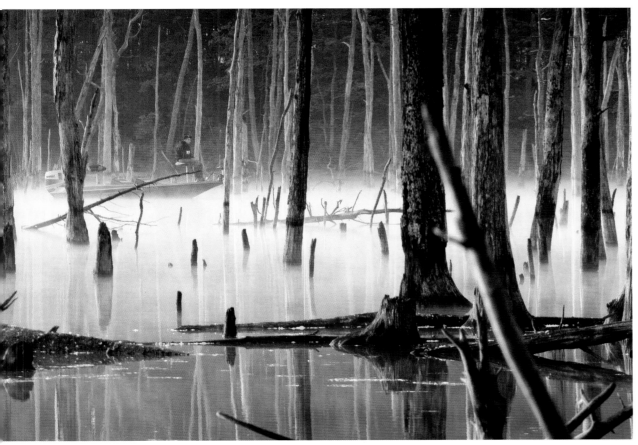

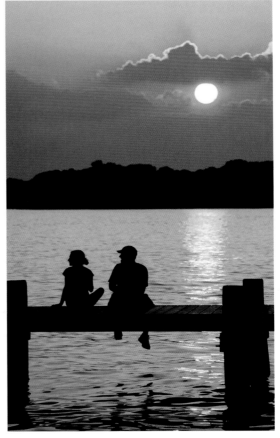

BY DAWN'S EARLY LIGHT BY BOB ENGELBART

END OF THE DAY BY PAUL DANIELCZYK

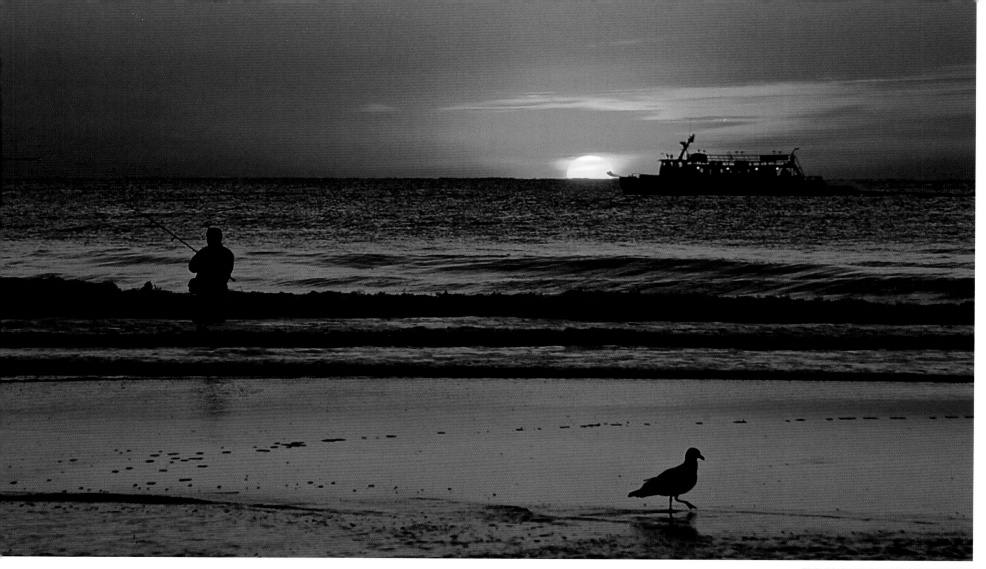

TRIPLE SUNRISE BONUS BY SCOTT MILLER

I'M NOT STOPPING FOR YOU BY ROB FISCHER

UNTITLED BY AMY HALL

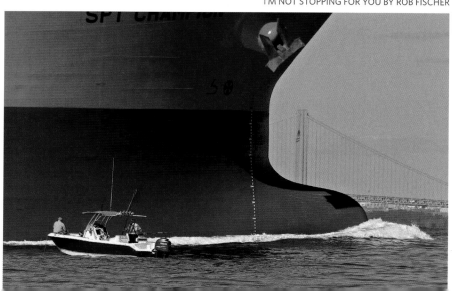

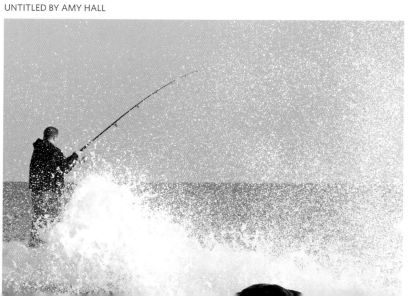

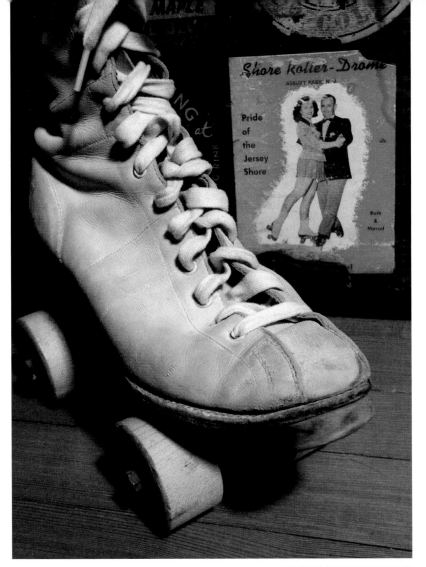

ROLLING BACK BY JILL WHITLEY

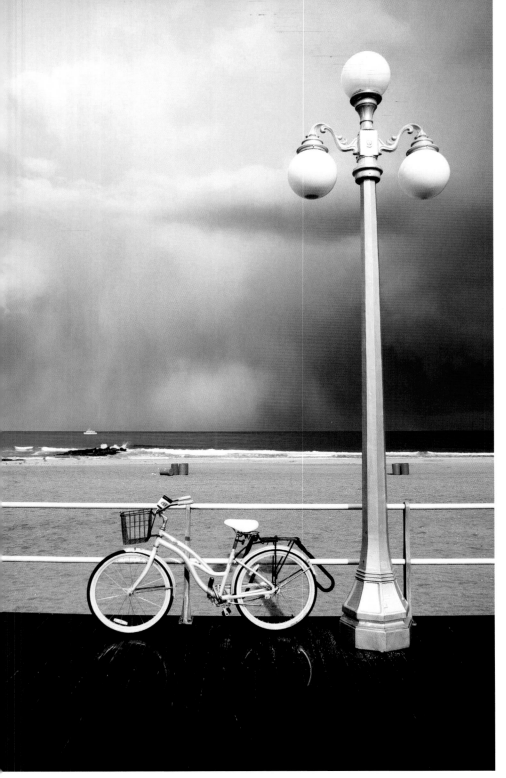

FRIDAY AFTERNOON BIKE BY MATT COLLINS

ABOVE: One of my grandmother's roller skates with wooden wheels and skate box. *(Bricktown, Ocean County)*

LEFT: An afternoon bike ride. *(Avon-by-the-Sea, Monmouth County)*

OPPOSITE TOP: Many interesting subjects at sunrise. *(Belmar, Monmouth County)*

OPPOSITE BOTTOM LEFT: Little boats regularly fish in the channel off of the tip of Sandy Hook. Big boats don't stop — I don't know how many little boats have lost the stare down. *(Fort Hancock, Monmouth County)*

OPPOSITE BOTTOM RIGHT: A soaked fisherman. *(Avon-by-the-Sea, Monmouth County)*

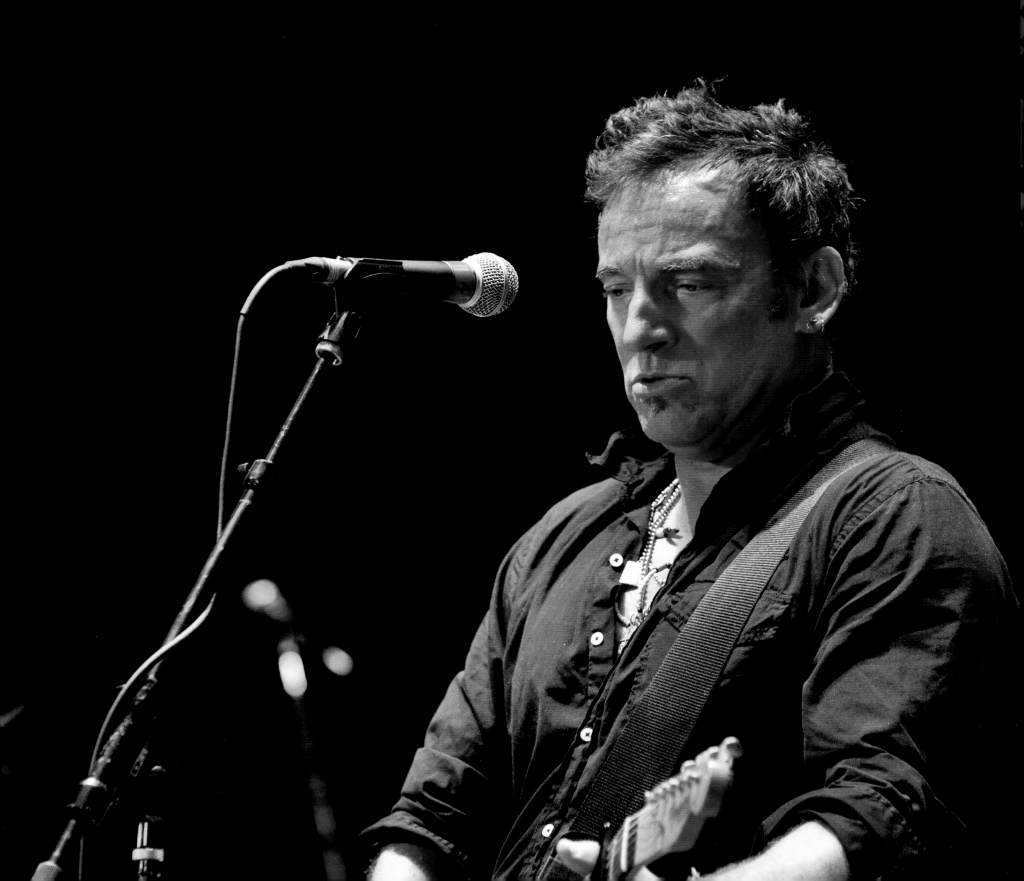

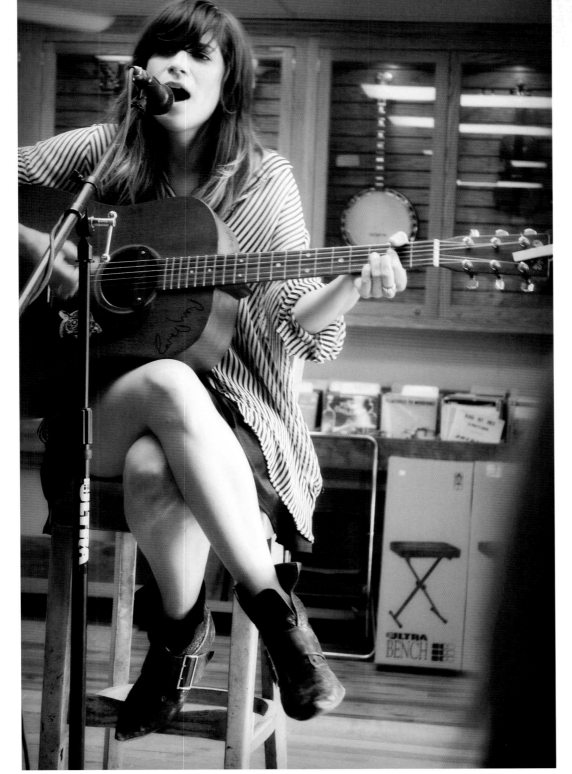

NICOLE ATKTINS BY LORELLE SHEA

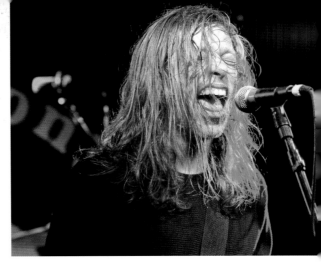

THE I-DRIVE AT THE STONE PONY BY JEFF ROSS

BOARD BEAT BY KIMBERLY BARTOK

ABOVE: A drummer on Asbury Park Board-walk. *(Asbury Park, Monmouth County)*

TOP: Seth Milly of The I-Drive during the 10th annual Light of Day Parkinsons benefit. *(Asbury Park, Monmouth County)*

LEFT: Nicole Atkins plays a set at Jack's Music Shop in Red Bank. *(Red Bank, Monmouth County)*

FAR LEFT: Bruce Springsteen performs at the 10th annual Light of Day Parkinson's fundraiser at the Paramount Theatre in Asbury Park. *(Asbury Park, Monmouth County)*

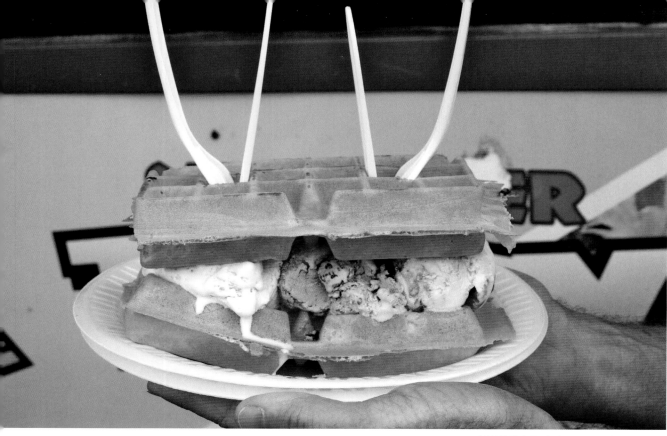

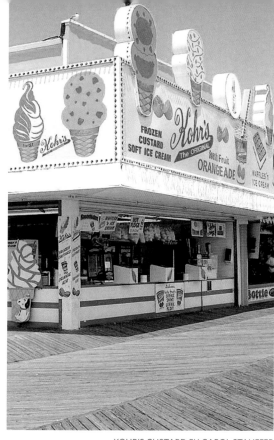

WAFFLES AND ICE CREAM BY ROBIN KREIGER

KOHR'S CUSTARD BY CAROL STAUFFER

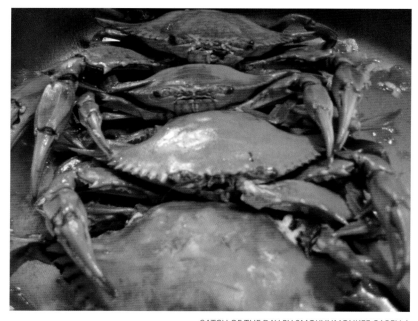

CATCH OF THE DAY BY SMOKYNMONKEE CARELLA

STROLLO'S BY GEORGE GROB

CANDY APPLE RED BY CHARLENE KENNEDY

LEFT: Candy apples — yum!
(Long Branch, Monmouth County)

OPPOSITE TOP LEFT: A boardwalk treat.
(Manalapan, Monmouth County)

OPPOSITE TOP RIGHT: Kohr's is my favorite stop on the boardwalk. I'll look far and wide for a Kohr's chocolate/peanut butter twist. *(Seaside Heights, Ocean County)*

OPPOSITE BOTTOM LEFT: Jersey Shore fresh caught crabs. *(Lavallette, Ocean County)*

OPPOSITE BOTTOM RIGHT: Italian Ice on the Jersey Shore. *(Long Branch, Monmouth County)*

BOTTOM LEFT: When was the last time you had one of these? *(Point Pleasant, Ocean County)*

BOTTOM RIGHT: A classic meal with a view of Cattus Island across Silver Bay. *(Silver Bay, Ocean County)*

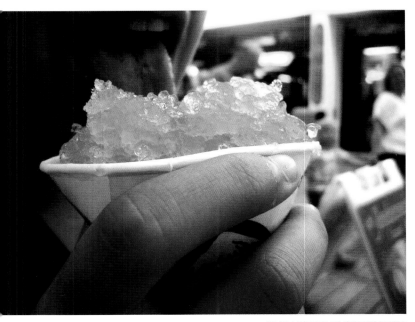

SNOW CONE BY ELISE PETRONZIO

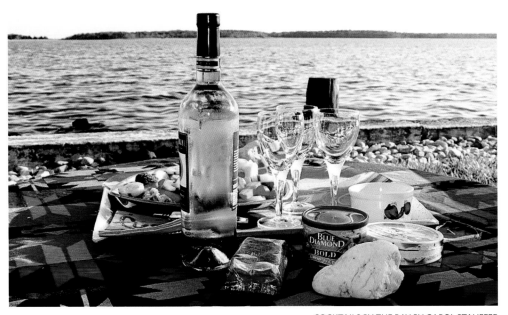

COCKTAILS BY THE BAY BY CAROL STAUFFER

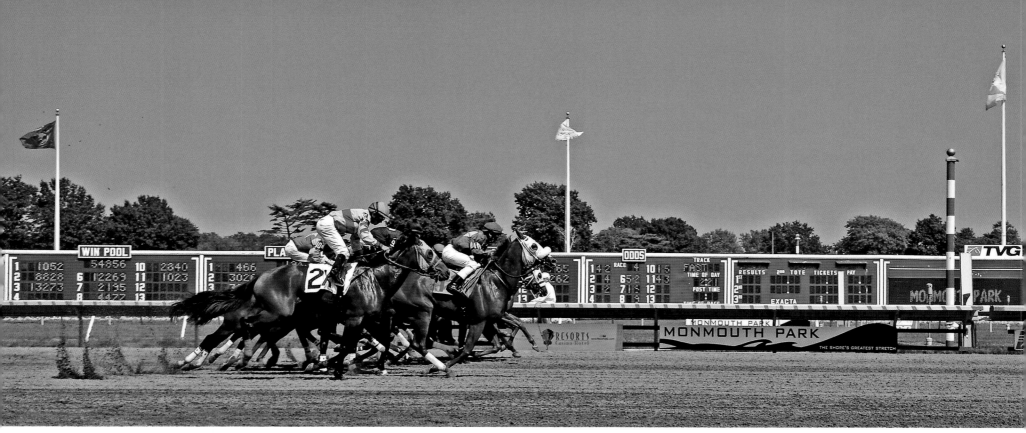

MONMOUTH PARK BY TOM BERG

ABOVE: Although the finish line is right there, they have to go around one more time. *(Oceanport, Monmouth County)*

RIGHT: Horses launch out of the gate at Monmouth Park. *(Oceanport, Monmouth County)*

OPPOSITE TOP: My horse is not even in the picture. I think he's still running. *(Oceanport, Monmouth County)*

OPPOSITE BOTTOM LEFT: Away from all the hoopla by the grandstands, another dynamic plays out as the riders, horses and unheralded supporting cast prepare for the big race. *(Oceanport, Monmouth County)*

OPPOSITE BOTTOM RIGHT: The stable area at Monmouth Park Racetrack where the athletes stand and wait for their chance at fleeting fame. *(Oceanport, Monmouth County)*

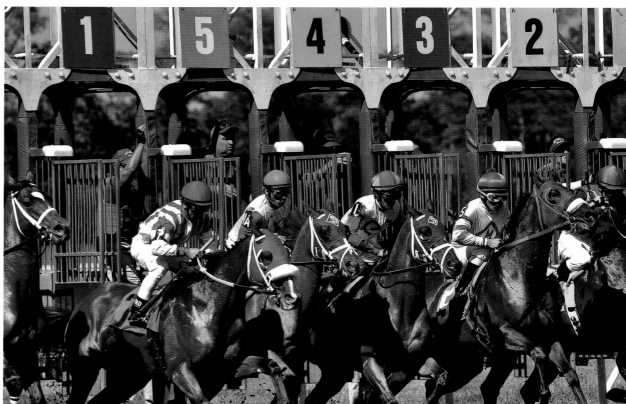

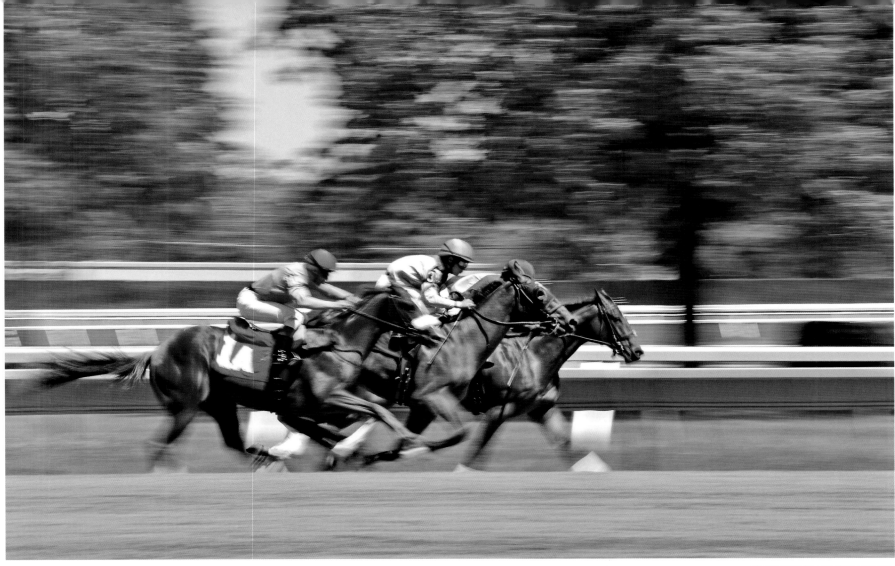

FLYING FEET BY RICHARD CARLINO

BEHIND THE SCENES BY ERIC SAMBOL

BEHIND THE SCENE BY JOHN BELLINGHAM

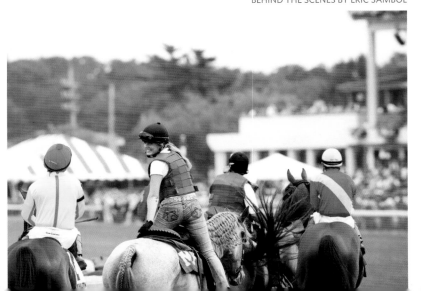

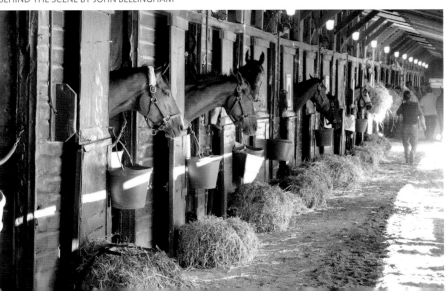

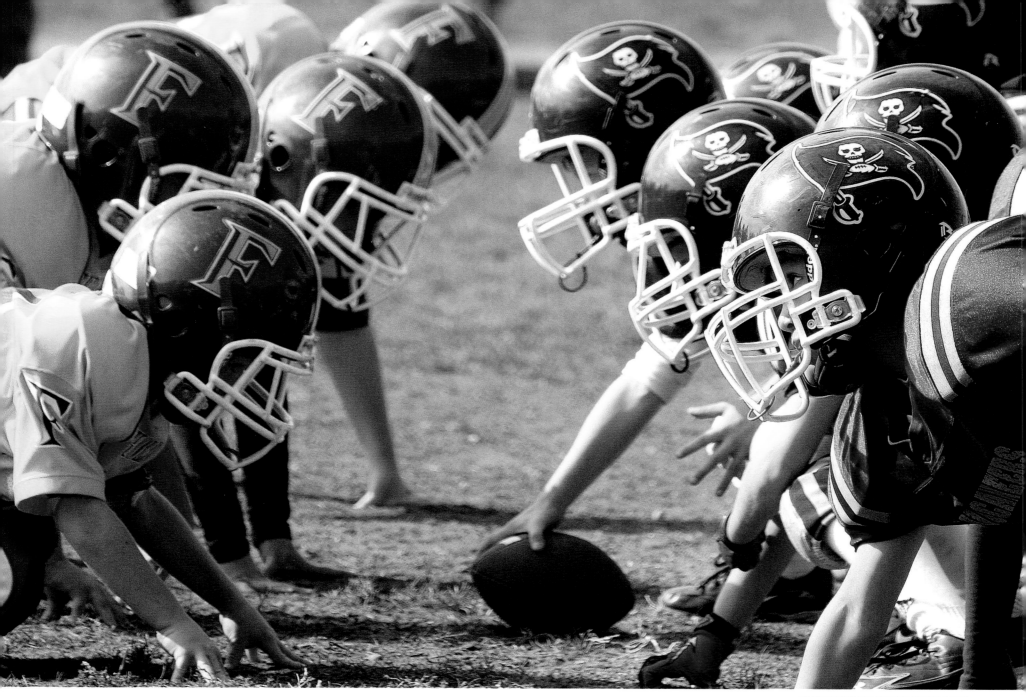

ABOVE: Red Bank vs. Freehold, Pop Warner football. *(Red Bank, Monmouth County)*

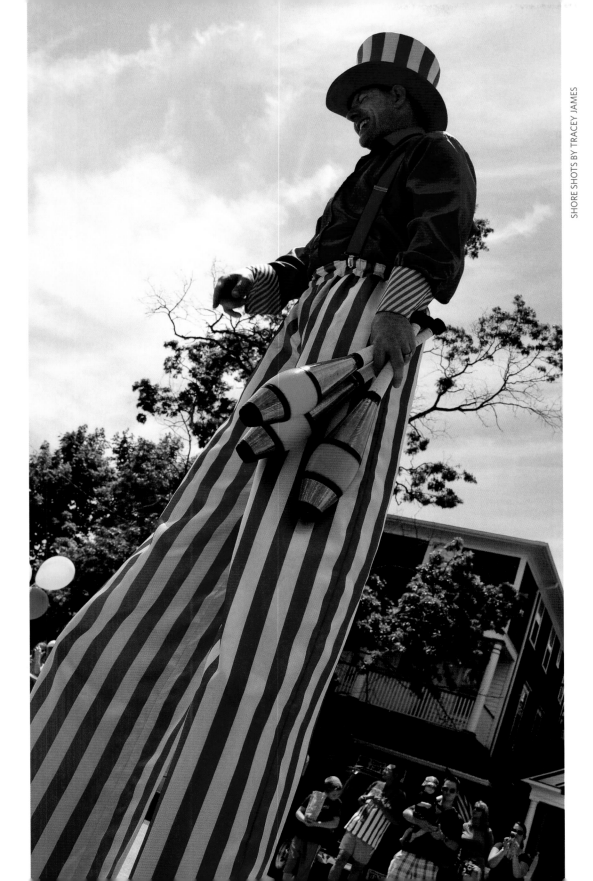

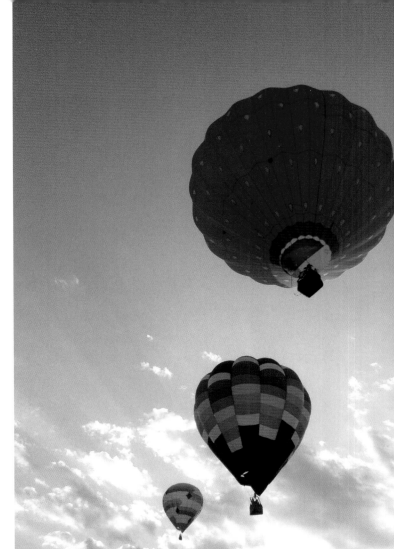

THE CHASE BY TIA NADAL

ABOVE: Hot Air Balloon Festival. *(Keyport, Monmouth County)*

LEFT: Hey shorty! *(Ocean Grove, Monmouth County)*

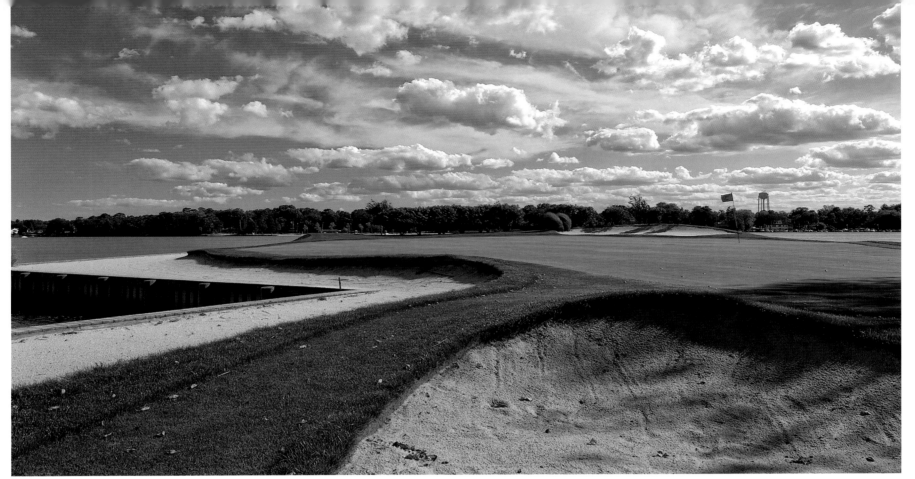

ON THE GREEN BY BRUCE HIMELMAN

BALLOON SKY BY TIA NADAL

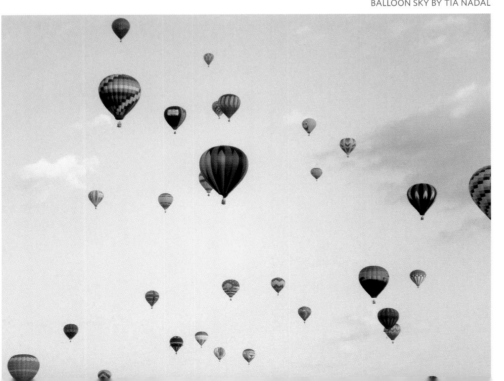

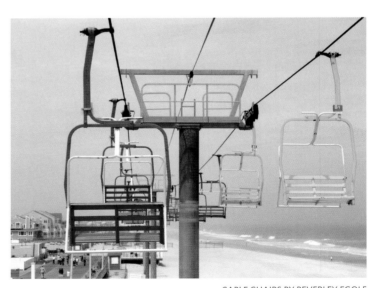

CABLE CHAIRS BY BEVERLEY EGOLF

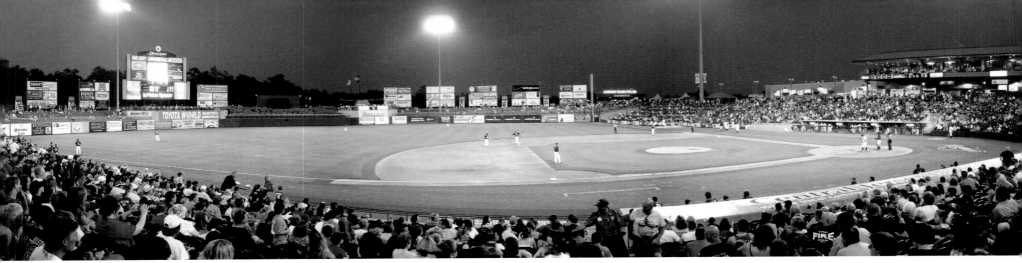

BLUECLAWS GAME BY JOHN FRENCH

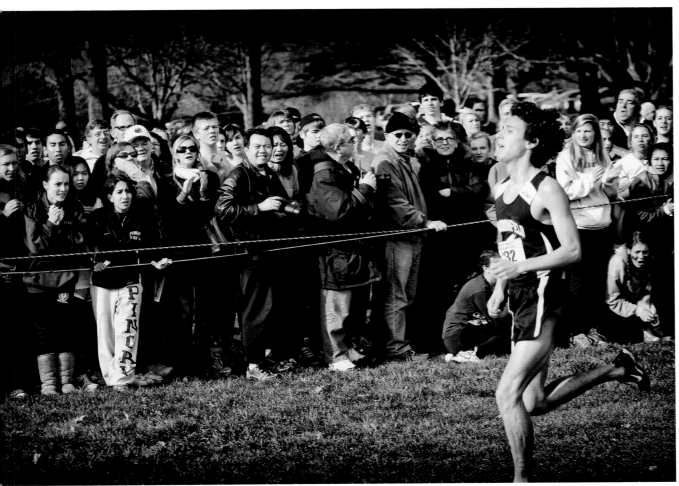

FACES IN THE CROWD BY FRANK COSTELLO

ABOVE: Panoramic of a Blueclaws Game.
(*Lakewood, Ocean County*)

LEFT: The crowd is always into it at the Meet of Champions in Holmdel Park.
(*Holmdel, Monmouth County*)

OPPOSITE TOP: I can't wait to play golf.
(*Toms River, Ocean County*)

OPPOSITE BOTTOM LEFT: Hot Air Balloon Festival. (*Keyport, Monmouth County*)

OPPOSITE BOTTOM RIGHT: A ride on the boardwalk. (*Seaside Heights, Ocean County, NJ*)

Scapes of All Sorts

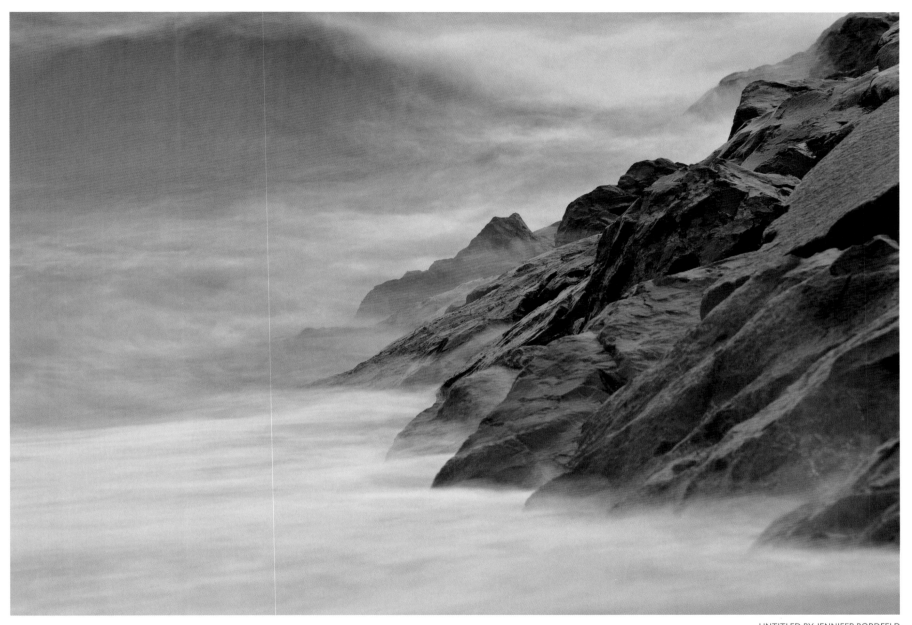

UNTITLED BY JENNIFER BORDFELD

ABOVE: The ocean against rocks on a misty morning. *(Manasquan, Monmouth County)*

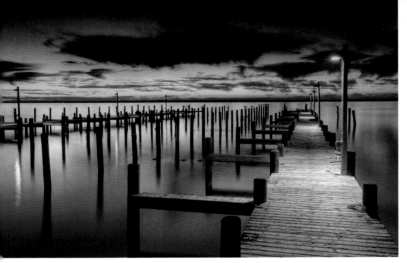

SEASIDE DOCK BY RAY YEAGER

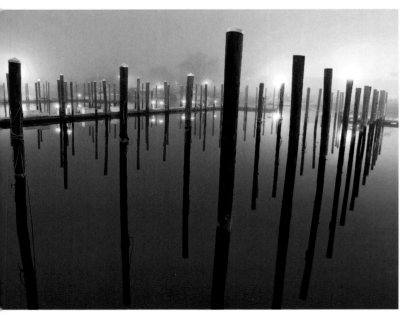

STILLNESS BY MICHAEL YUCIUS

ABOVE: An empty marina in Neptune. *(Neptune, Monmouth County)*

TOP: The Barnegat Bay at dusk. *(Seaside Park, Ocean County)*

RIGHT: A boat on Barnegat Bay as seen from Seaside Park. *(Seaside Park, Ocean County)*

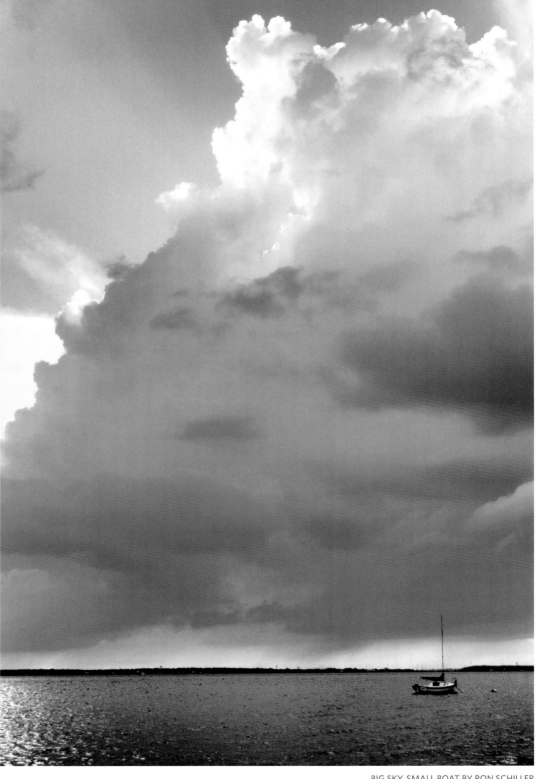

BIG SKY, SMALL BOAT BY RON SCHILLER

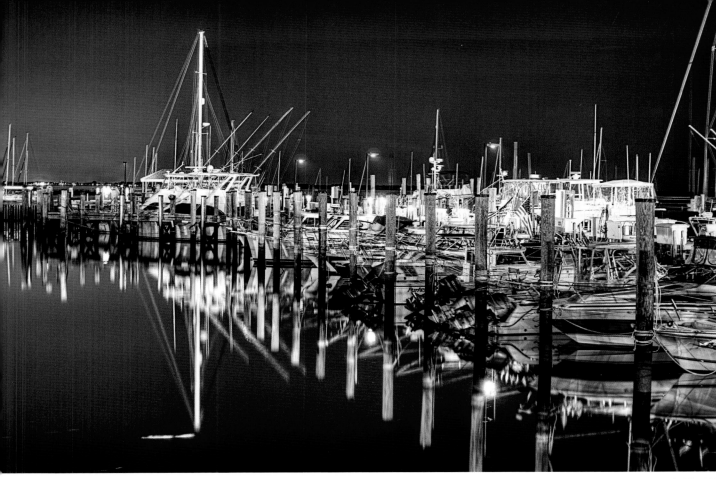

BOATS IN A ROW BY CHASE SCHIEFER

LEFT: Atlantic Highlands Marina.
(Atlantic Highlands, Monmouth County)

BOTTOM LEFT: A calm night.
(Highlands, Monmouth County)

BOTTOM RIGHT: At sunset.
(Shark River Hills, Monmouth County)

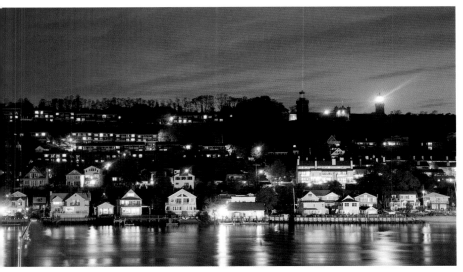

HIGHLANDS AT NIGHT BY GONZALO HERRERA

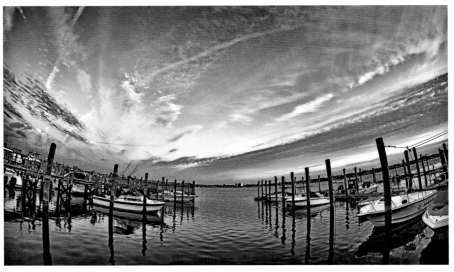

SHARK RIVER BY JAMES ABELS

RIGHT: Viewfinder at the Ocean Grove
Fishing Pier. *(Ocean Grove, Monmouth County)*

BOTTOM LEFT: Sunrise at the beach.
(Lavallette, Ocean County)

BOTTOM RIGHT: Sand shadows.
(Ocean Grove, Monmouth County)

OPPOSITE: Inside a wave, looking out.
(Point Pleasant, Ocean County)

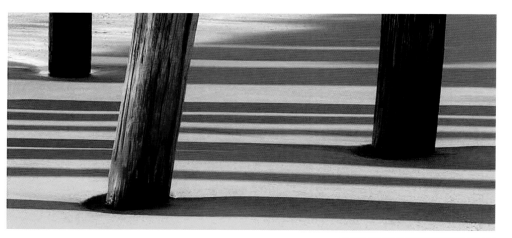

SUNSET VIEW BY RACHEL CARBONE

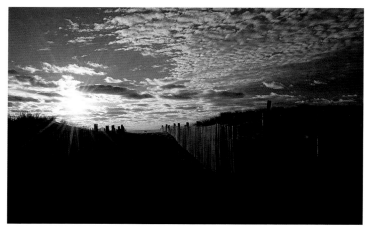

SUNRISE BY DIANE METZ

SAND SHADOWS BY PAT MCCARTHY

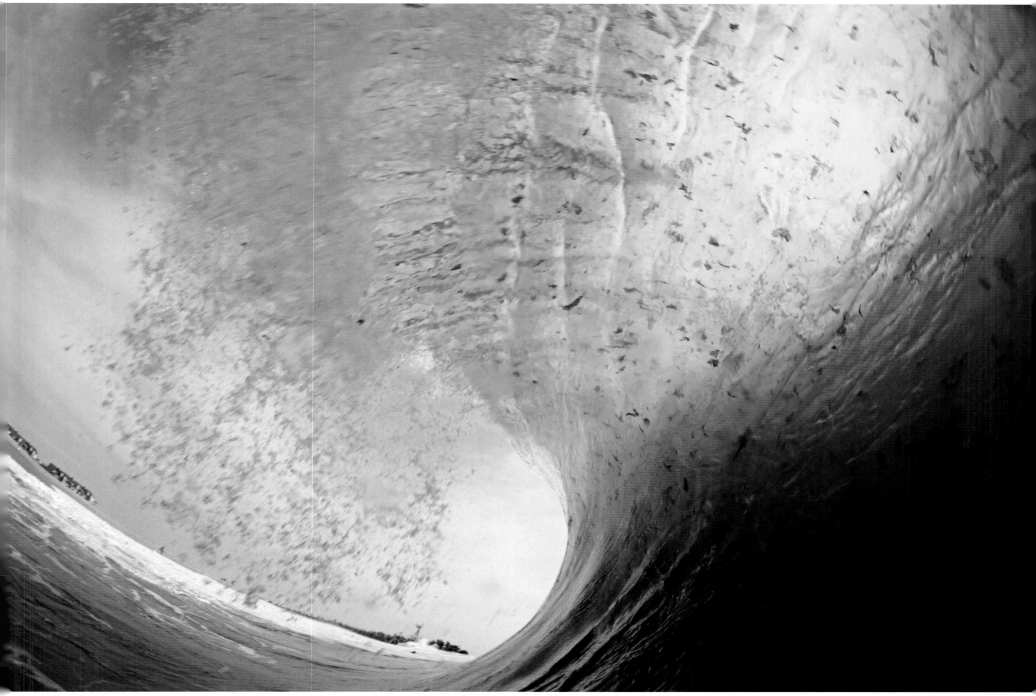

SALAD BY JUSTIN CURTIS

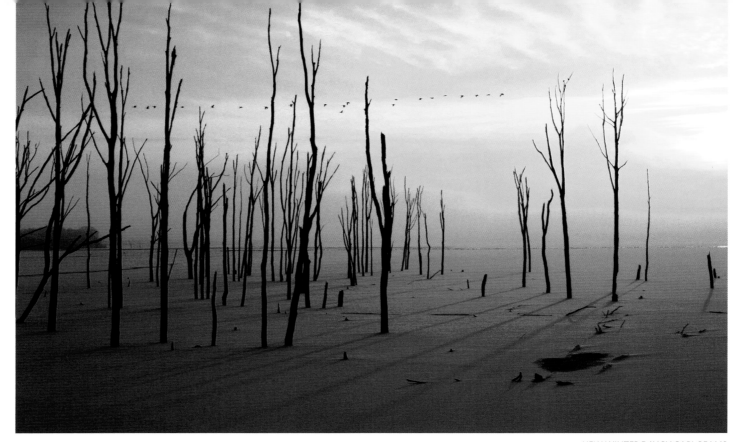

RIGHT: The sun rises on a frozen Manasquan Reservoir, a part of the Monmouth County Parks System. *(Howell, Monmouth County)*

BOTTOM LEFT: Allenhurst in winter.
(Allenhurst, Monmouth County)

BOTTOM RIGHT: Sunset at Seaside Park.
(Seaside Park, Ocean County)

NEW WINTER DAY BY CARL BEAMS

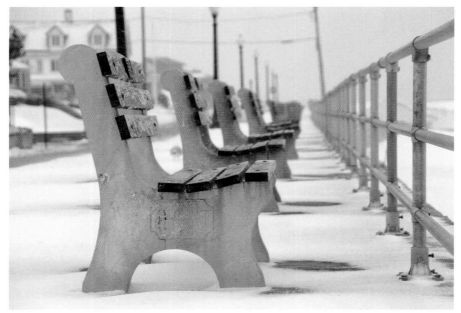

ALLENHURST BY MIKE CARROLL

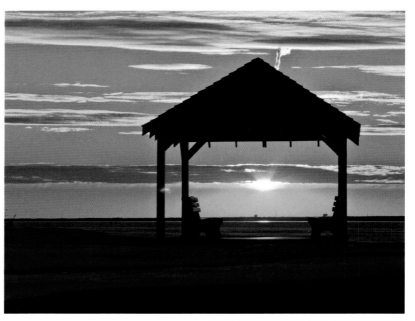

SUNSET AT SEASIDE PARK BY EDWARD HEWITT

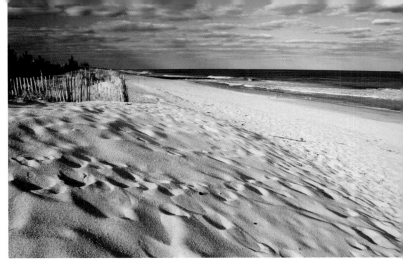

CHERRY BY MARTIN MASTERSON

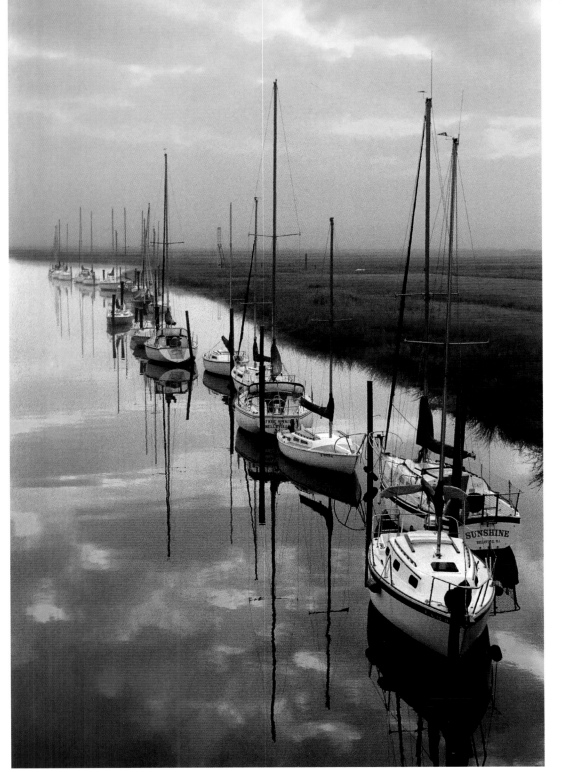

THE SAILBOATS OF MORGAN'S CREEK BY JOSEPH PRUSKY

LET IT SNOW BY HENRY BOSSETT

ABOVE: View of Spring Lake in snow storm. *(Spring Lake, Monmouth County)*

TOP: The quintessential beach day. *(Bay Head, Ocean County)*

LEFT: The sailboats of Morgan's Creek. *(Laurel Harbor, Ocean County)*

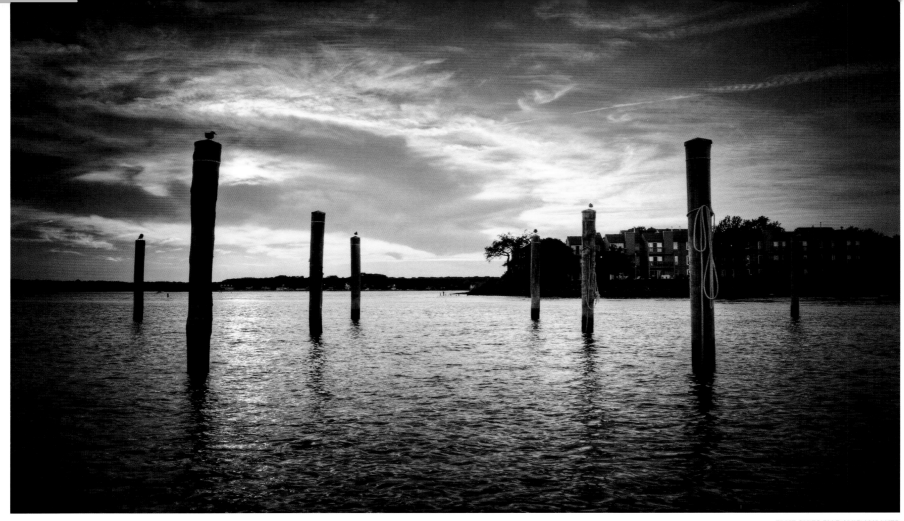

BLUE SKIES BY DAVID WALKER

THE PIER BY STACEY BRUNO

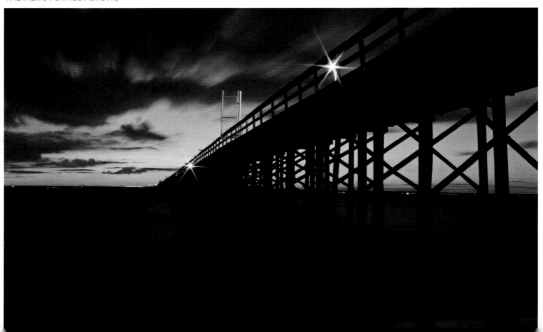

ABOVE: Blue skies rolling in over the Belmar Marina. *(Belmar, Monmouth County)*

RIGHT: Keansburg Pier at dusk. *(Keansburg, Monmouth County)*

OPPOSITE TOP: A long exposure on the beach. *(Ocean Grove, Monmouth County)*

OPPOSITE BOTTOM LEFT: This show was taken after a hurricane in 2010 using a neutral density filer. *(Manasquan, Monmouth County)*

OPPOSITE BOTTOM RIGHT: Frozen Barnegat Bay. *(Surf City, Ocean County)*

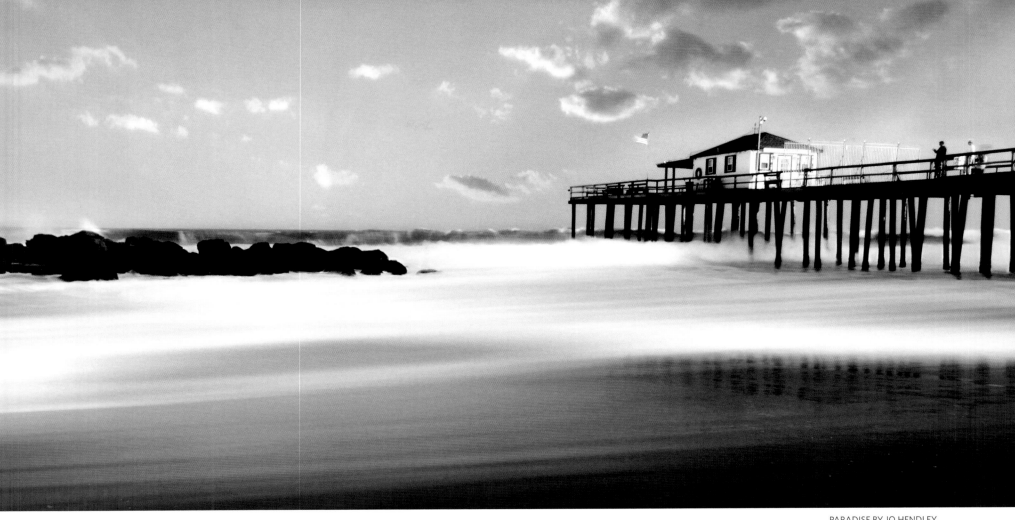

PARADISE BY JO HENDLEY

SILKY STREAMS BY DAVID TURTON

FROZEN BARNEGAT BAY BY JAMES LOESCH

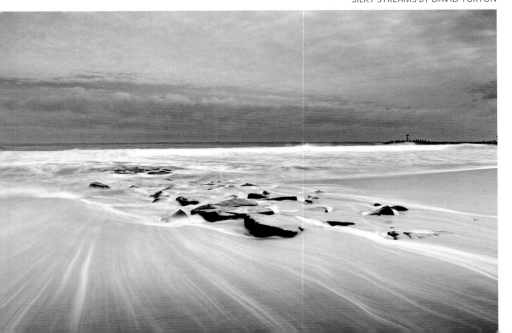

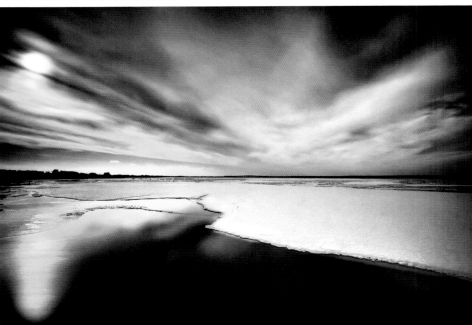

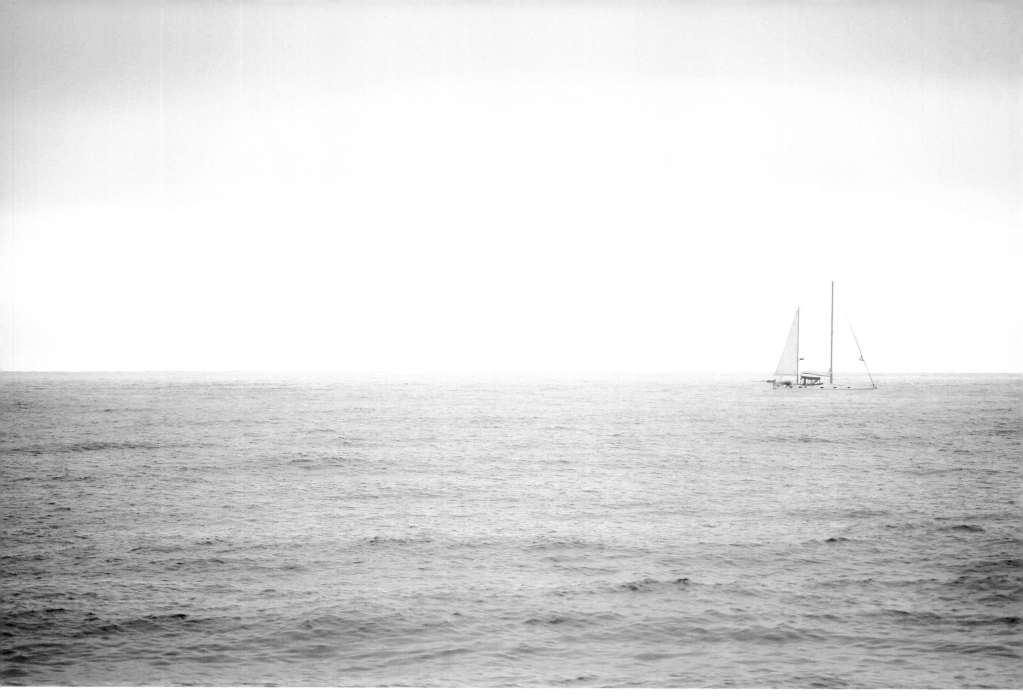

ABOVE: Serenity. *(Bay Head, Ocean County)*

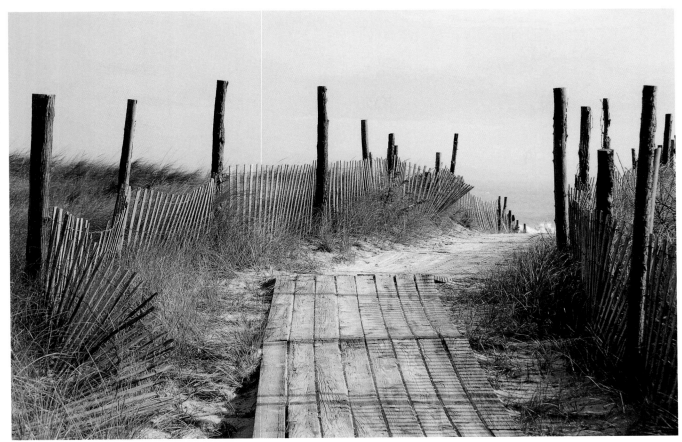

LEFT: A walk to the beach. *(Ship Bottom, Ocean County)*

BOTTOM LEFT: The colors of the dunes are most vivid after a soft summer rain. *(Lavallette, Ocean County)*

BOTTOM RIGHT: Sunset. *(Forked River, Ocean County)*

UNTITLED BY ALEXIS RANK

AFTER A SUMMER SHOWER BY KATIE WISZ

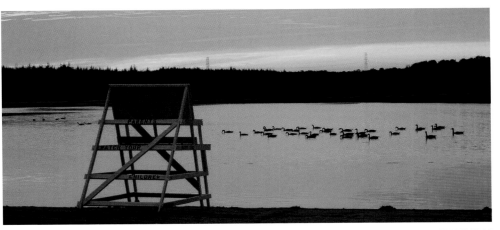

UNTITLED BY SHANNON RUVELAS

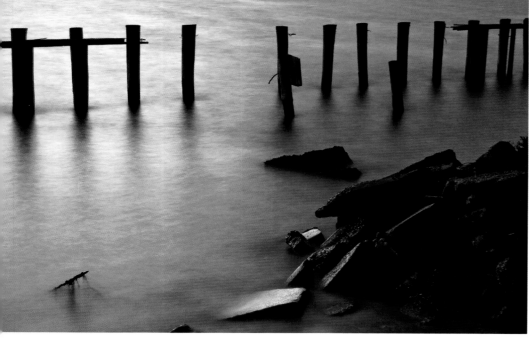

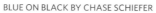

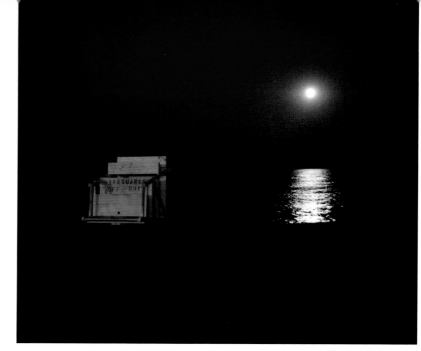

BLUE ON BLACK BY CHASE SCHIEFER

SHORE SHOTS BY TRACEY JAMES

ABOVE: Blue light as the sun sets.
(*Fort Hancock, Monmouth County*)

ABOVE RIGHT: Off duty.
(*Ocean Grove, Monmouth County*)

RIGHT: Two life guard stands on a moonlit
night. (*North Beach, Ocean County*)

OPPOSITE: After hours.
(*Spring Lake, Monmouth County*)

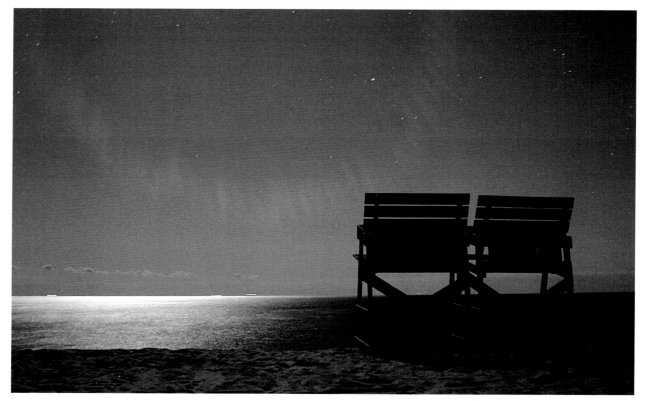

STANDING IN THE SPOTLIGHT BY ALEX SCAVUZZO

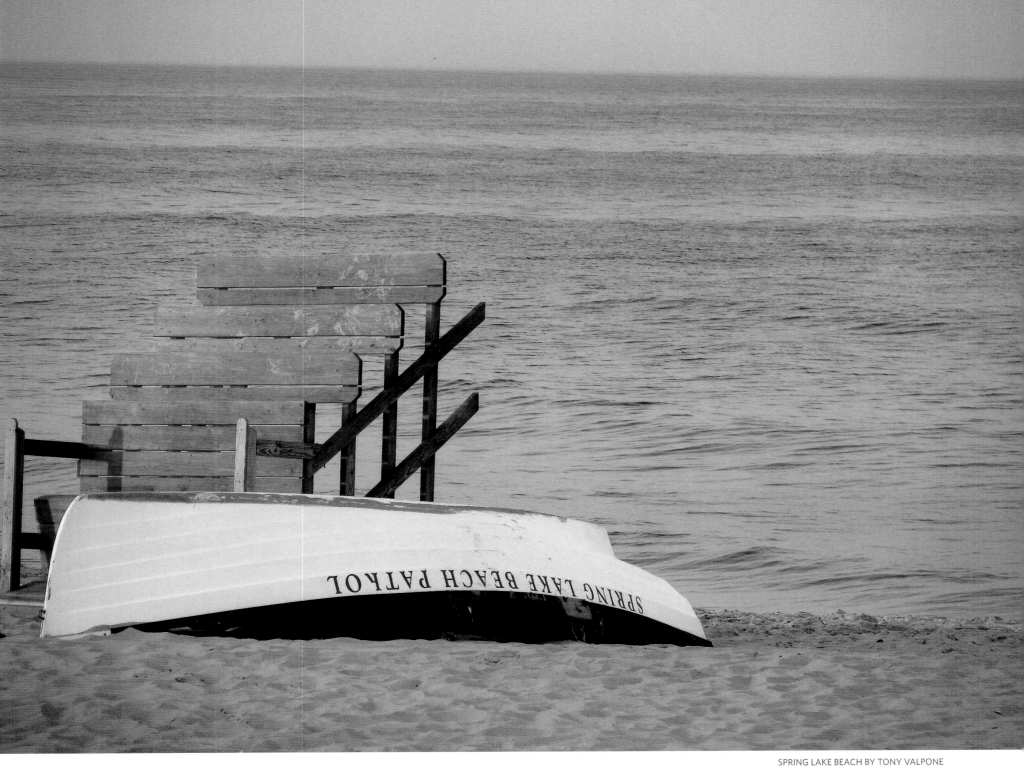

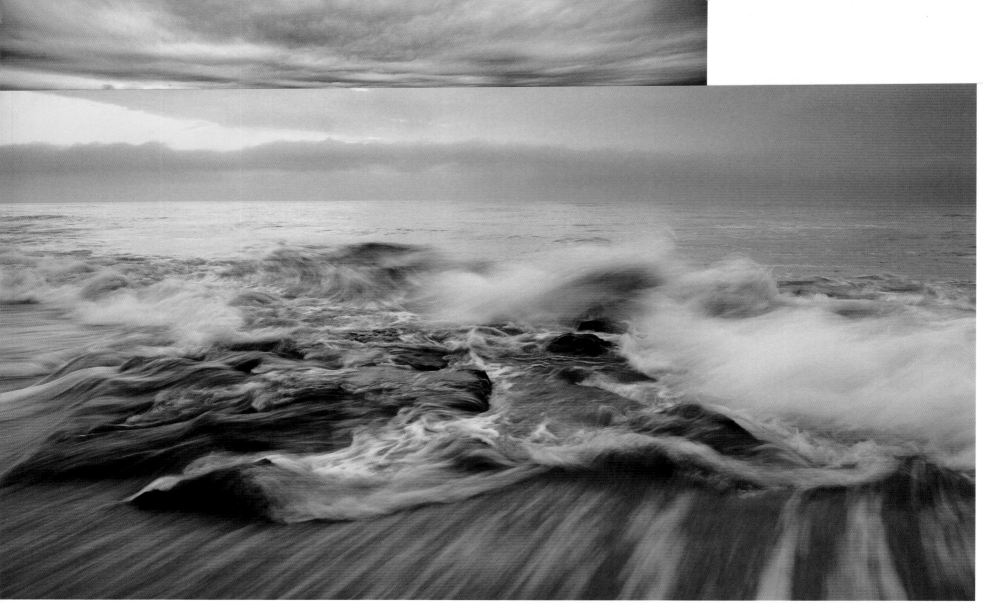

FIRST LIGHT BY JEREMY WOOD

A PIERING MOON BY MATTHEW DATES

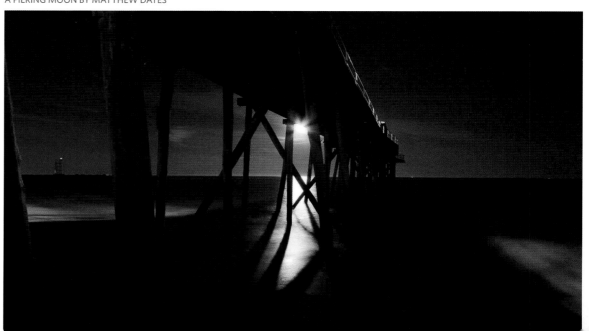

ABOVE: Lavallette beach on an almost-perfect morning. *(Lavallette, Ocean County)*

RIGHT: Belmar Fishing Pier. *(Belmar, Monmouth County)*

OPPOSITE TOP LEFT: Sunrise with Casino Pier. *(Seaside Heights, Ocean County)*

OPPOSITE TOP RIGHT: Sunset under the pier. *(Port Monmouth, Monmouth County)*

OPPOSITE BOTTOM: An interior shot. *(Asbury Park, Monmouth County)*

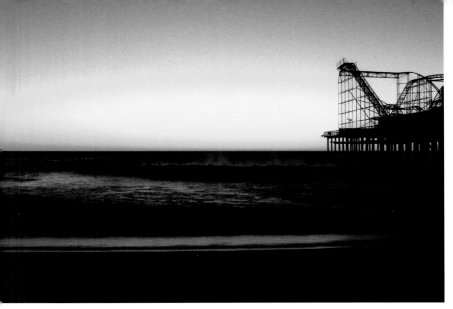

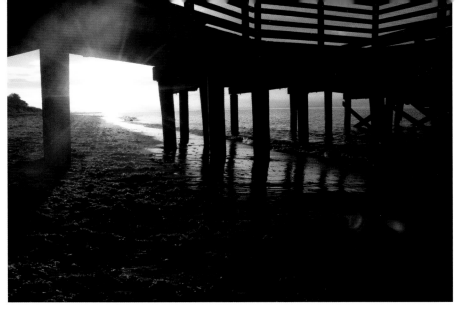

STILL AMUSEMENT BY RAY LINN

UNTITLED BY SAMANTHA DUFFORD

ASBURY PARK BY JACQUELYN SCHENK

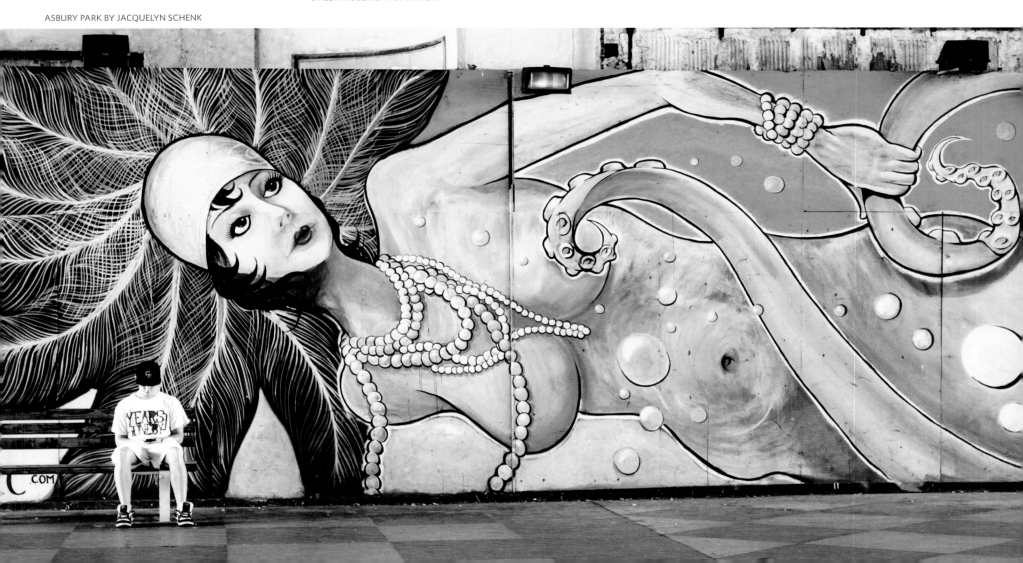

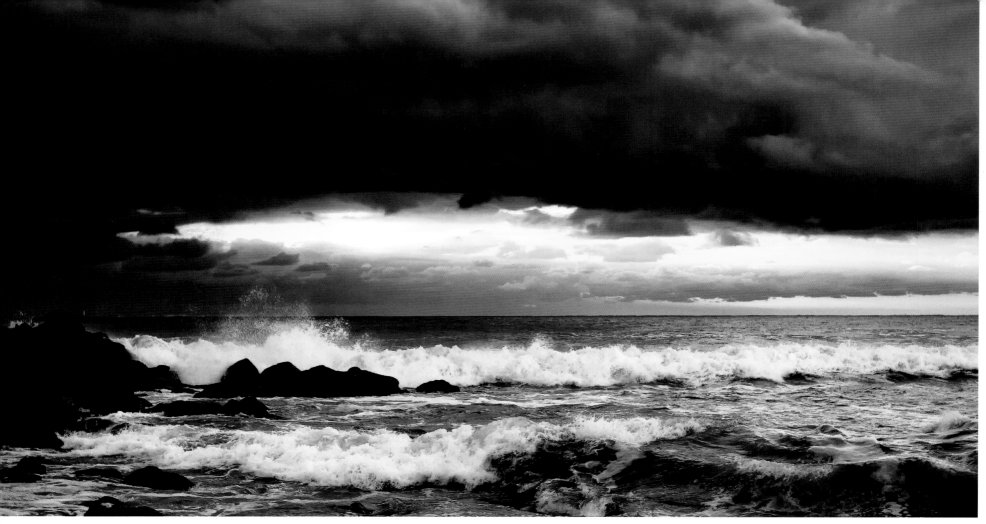

ABOVE: Early-morning light by Shark River Inlet.
(*Belmar, Monmouth County*)

RIGHT: Raritan Bay in spring. (*Keyport, Monmouth County*)

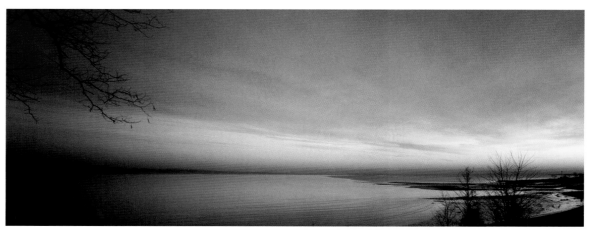

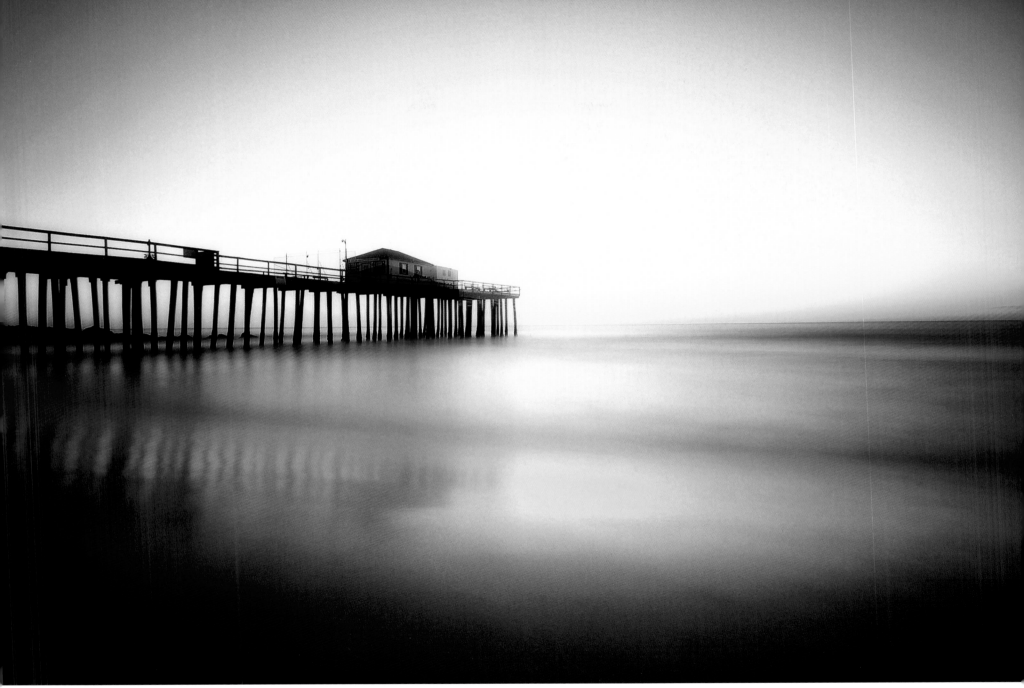

ABOVE: A calm Ocean Grove scene. *(Ocean Grove, Monmouth County)*

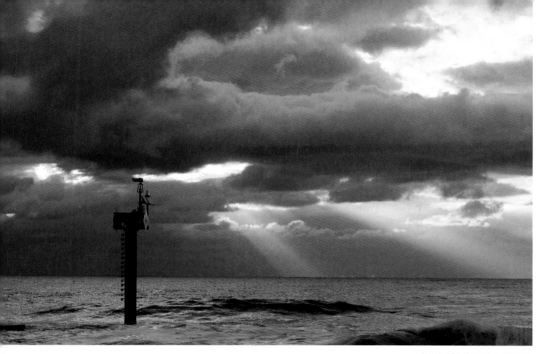

SUNRISE BY MIKE CARROLL

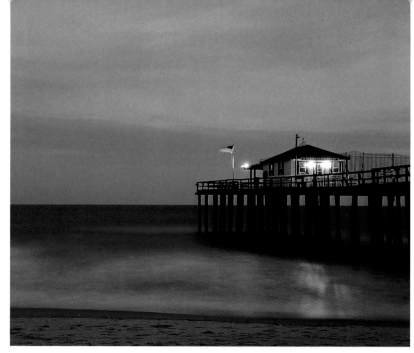

DREAMY PIER BY SCOTT MILLER

SUN RAYS BY HENRY BOSSETT

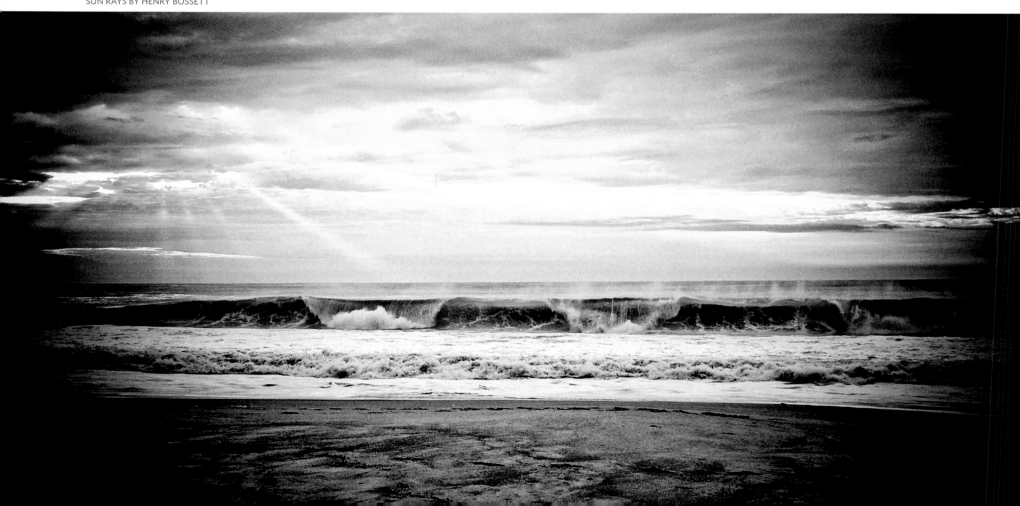

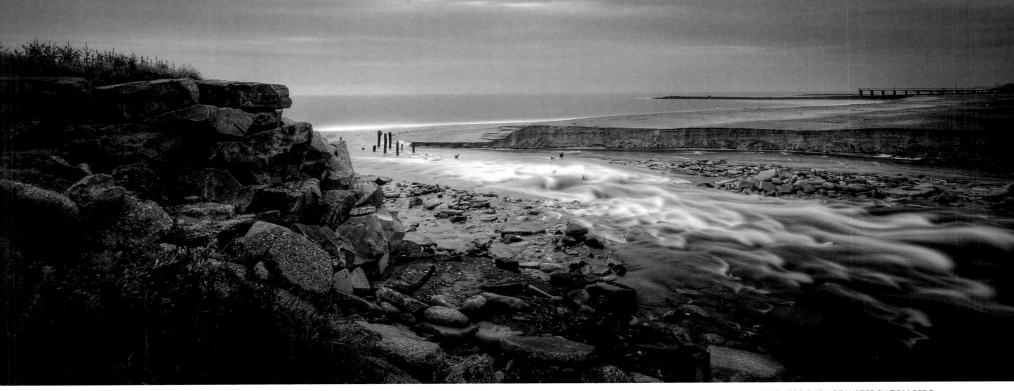

ONSHORE GUSH OF WATER BY TOM BERG

AFTER THE STORM BY KEVIN MICHELSON

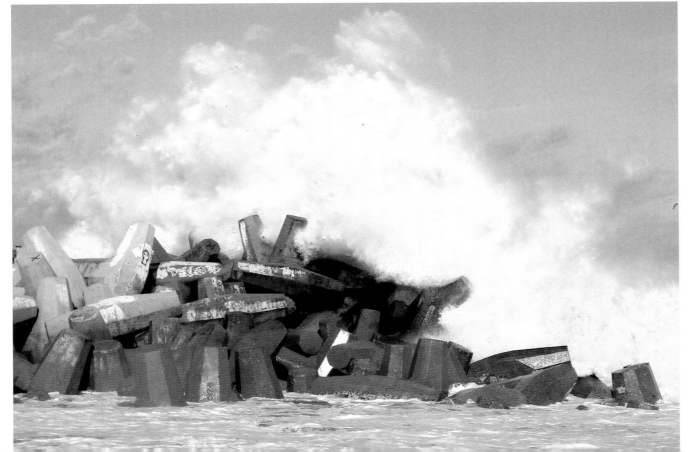

ABOVE: An onshore gush of water. *(Deal, Monmouth County)*

LEFT: Down the shore, everything's alright. *(Point Pleasant Beach, Ocean County)*

OPPOSITE TOP LEFT: Shortly after dawn in Sea Girt. *(Sea Girt, Monmouth County)*

OPPOSITE TOP RIGHT: Dreamy Pier. *(Ocean Grove, Monmouth County)*

OPPOSITE BOTTOM: Clouds breaking up after a storm. *(Sea Girt, Monmouth County)*

FOLLOWING LEFT: Manasquan Beach. *(Manasquan, Monmouth County)*

FOLLOWING RIGHT: Journey into the unknown. *(Belmar, Monmouth County)*

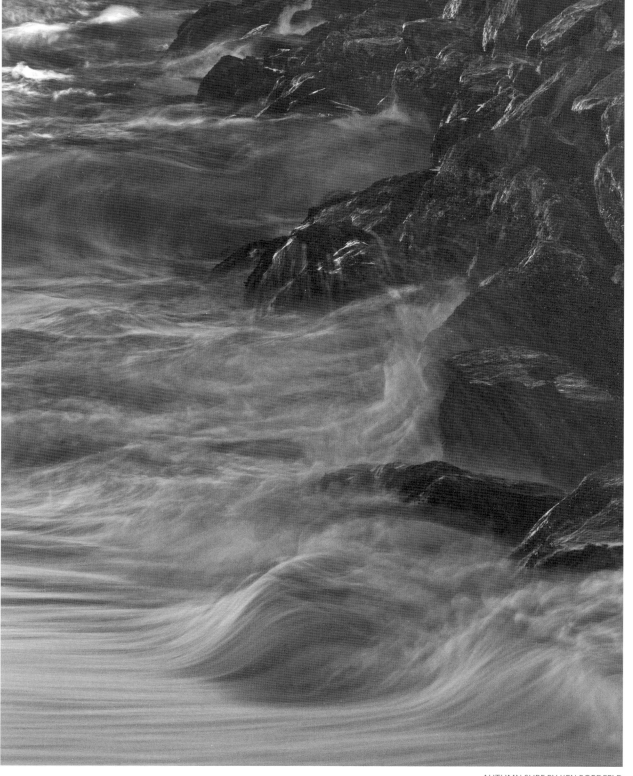

AUTUMN SURF BY KEN BORDFELD

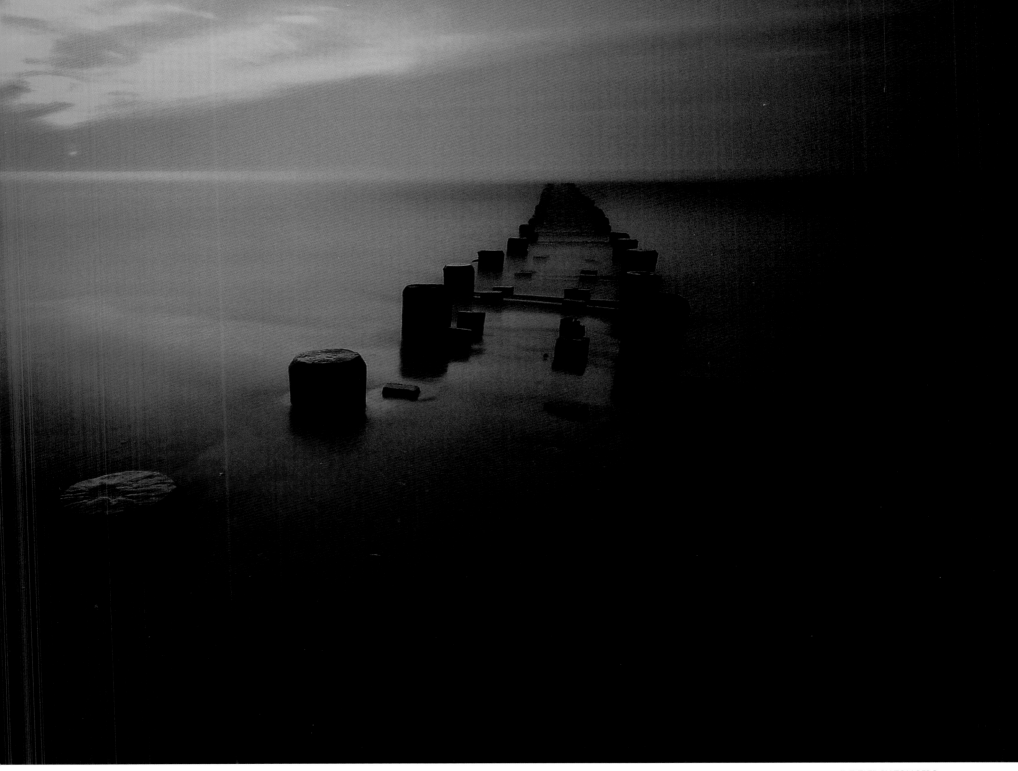

UNTITLED BY TOM BERG

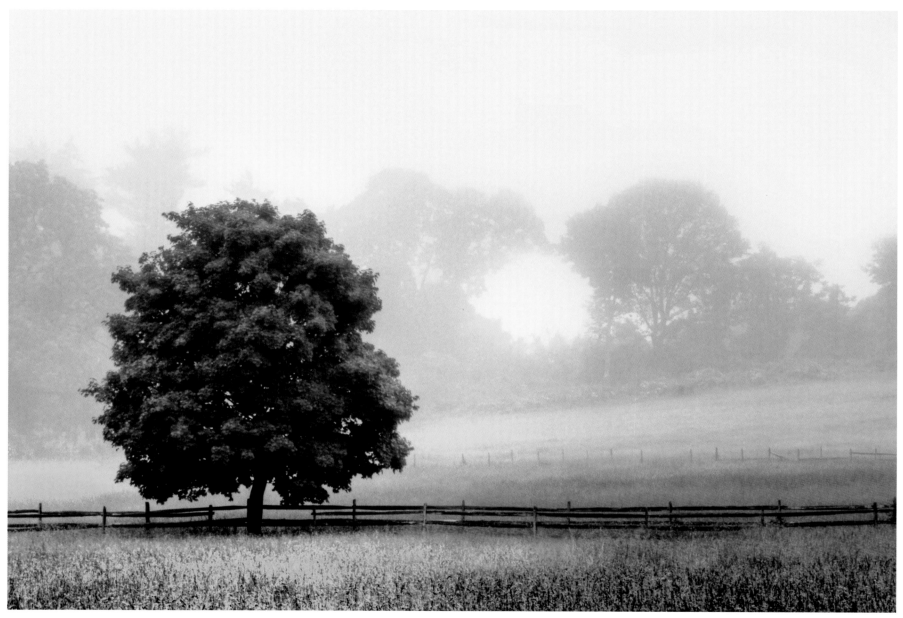

ABOVE: A lone tree on a foggy day. *(Navesink, Monmouth County)*

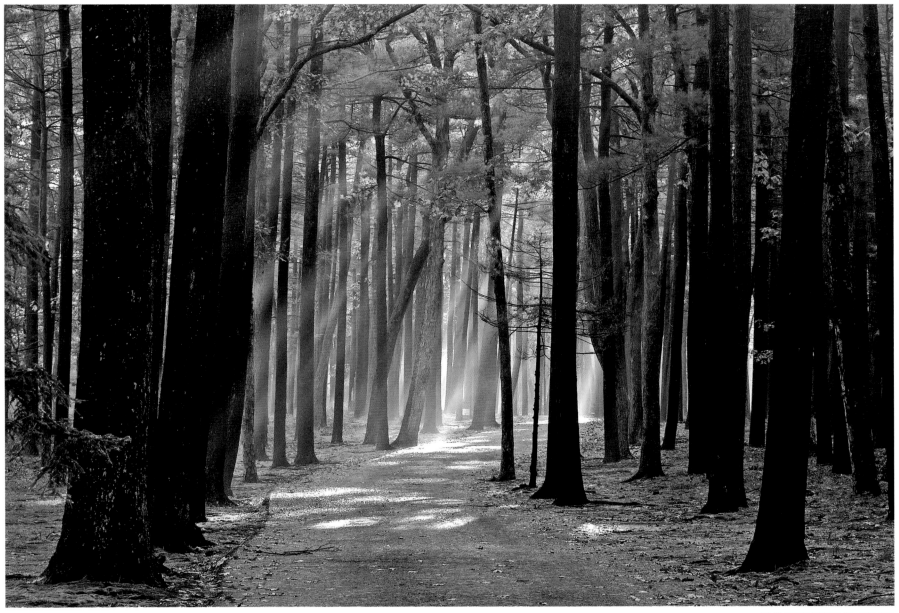

SUNLIGHT BY RICHARD CARLINO

ABOVE: Early-morning sunlight in the trees. *(Lakewood, Ocean County)*

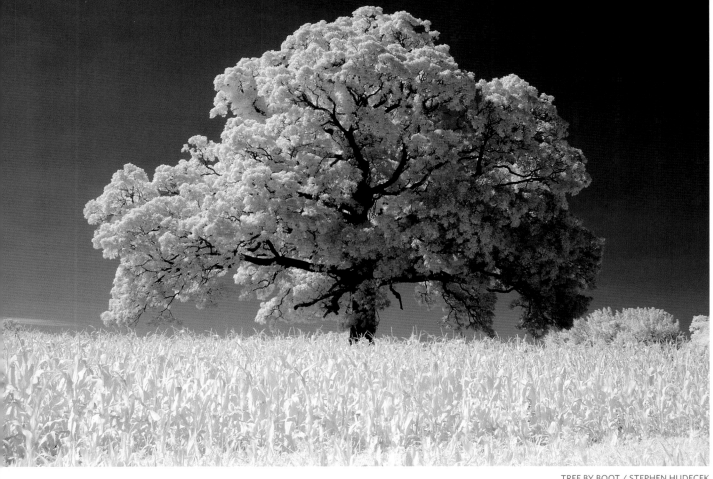

TREE BY BOOT / STEPHEN HUDECEK

AUTUMN BY RAYMOND SALANI III

THE LIVING DEAD BY RYAN MARCHESE

ABOVE: Jersey corn field in infrared. *(Jackson, Ocean County)*

RIGHT: Bridge through the cedar swamps.
(Manahawkin, Ocean County)

FAR RIGHT: Autumn leaves. *(Lincroft, Monmouth County)*

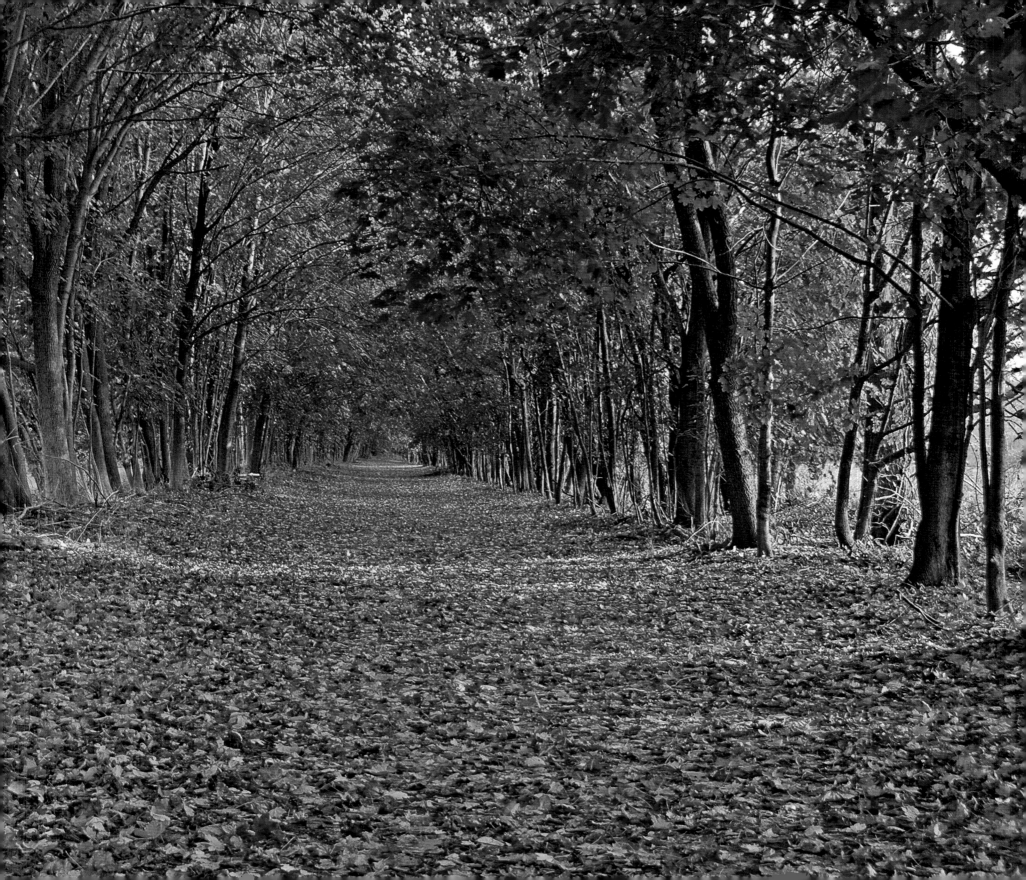

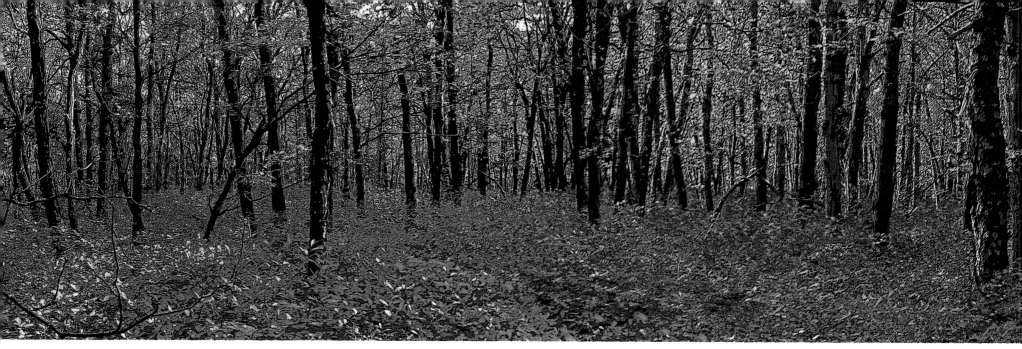

RED FOREST BY KAREN MORGAN

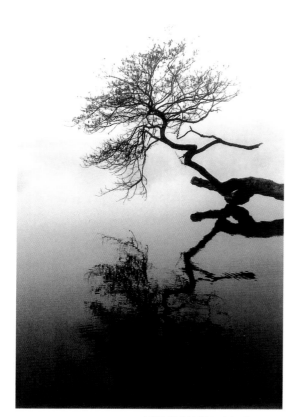

MIRROR IMAGE BY DOUG BENOIT

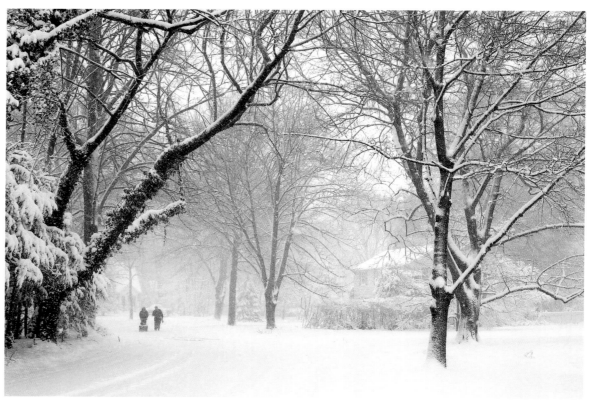

SNOW BY MIKE CARROLL

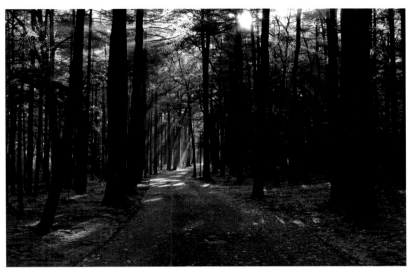

PEACEFUL LIGHT BY RICHARD CARLINO

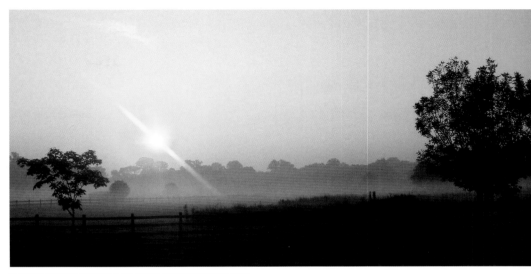

SUNRISE IN MIDDLETOWN BY BOOT / STEPHEN HUDECEK

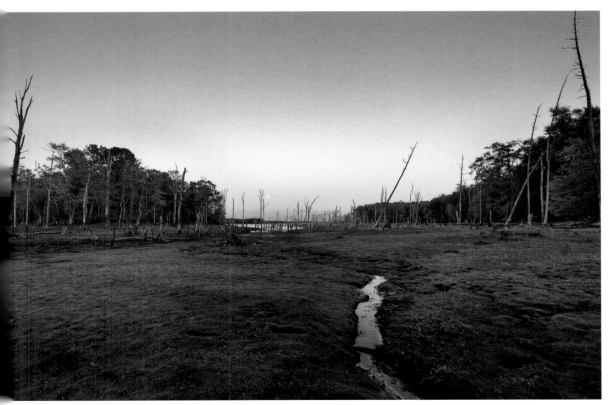

COLORS OF THE RESERVOIR BY MIKE ATTANASIO

ABOVE: Sunrise along Lincroft Road. (*Middletown, Monmouth County*)

ABOVE LEFT: A morning walk in the peaceful light.
(*Lakewood, Ocean County*)

LEFT: Lack of water brings out fabulous colors on this evening at the Manasquan Reservoir. (*Howell, Monmouth County*)

OPPOSITE TOP: I was driving along and passed this forest with the most amazing red foliage. I drove straight home to grab my camera and went back to capture this shot.
(*Lakewood, Ocean County*)

OPPOSITE BOTTOM LEFT: A foggy day with a tree checking itself out. (*Spring Lake, Monmouth County*)

OPPOSITE BOTTOM RIGHT: Fisher Place in Shrewsbury.
(*Shrewsbury, Monmouth County*)

RIGHT: Taking off at sunrise.
(Howell, Monmouth County)

BOTTOM LEFT: Seagulls feeding in the surf with an incoming wave rippling the puddle of a prior wave.
(Sea Bright, Monmouth County)

BOTTOM RIGHT: Reflections of a beautiful place on a beautiful day.
(Bayville, Ocean County)

OPPOSITE: A house along the Navesink River surrounded by the colors of fall. *(Navesink, Monmouth County)*

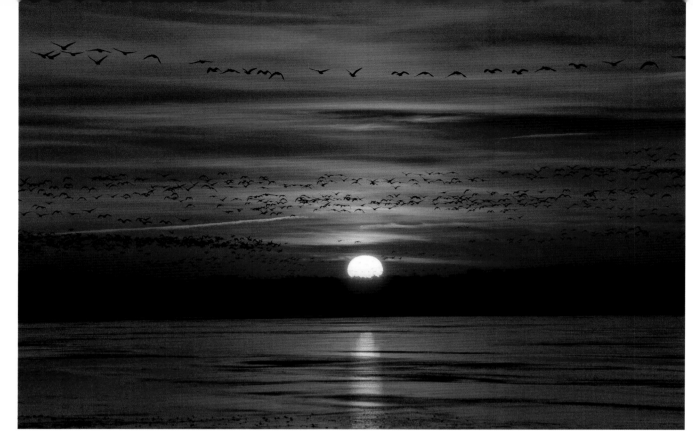

SUNRISE FLIGHT BY GENE ZONIS

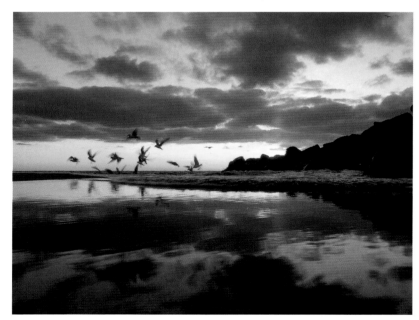

DISTURBING THE PEACE BY STEVE SCANLON

REFLECTIONS BY TERRY DELUCO

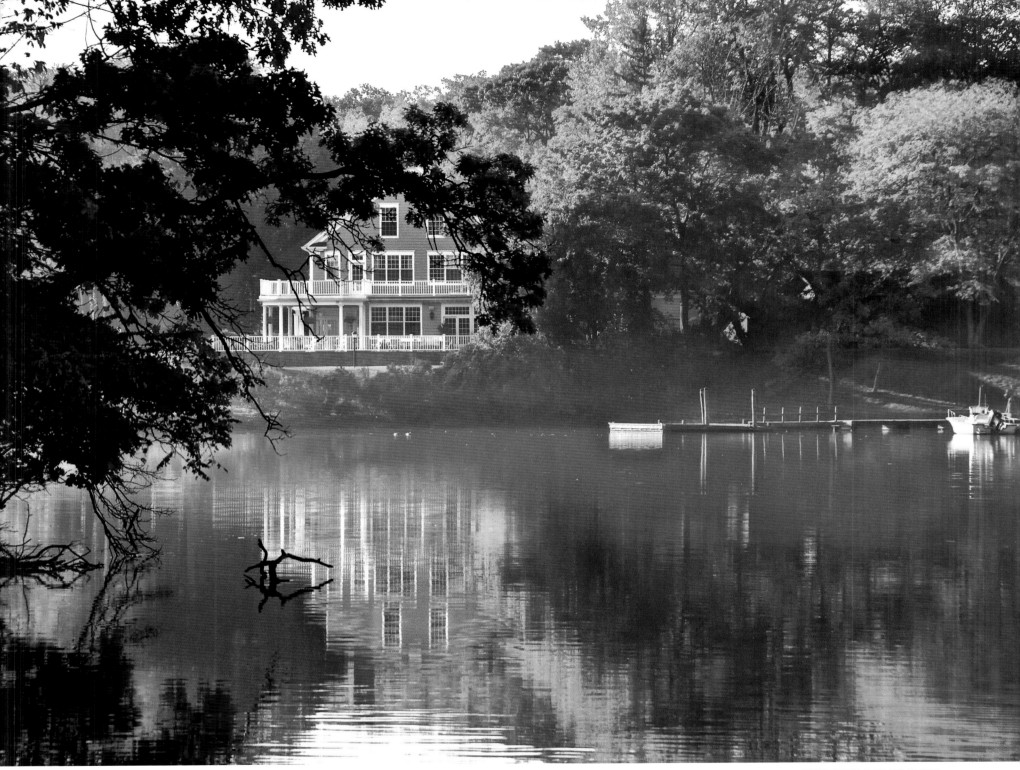

RIVER VIEW BY MICHAEL YUCIUS

Nature and Wildlife

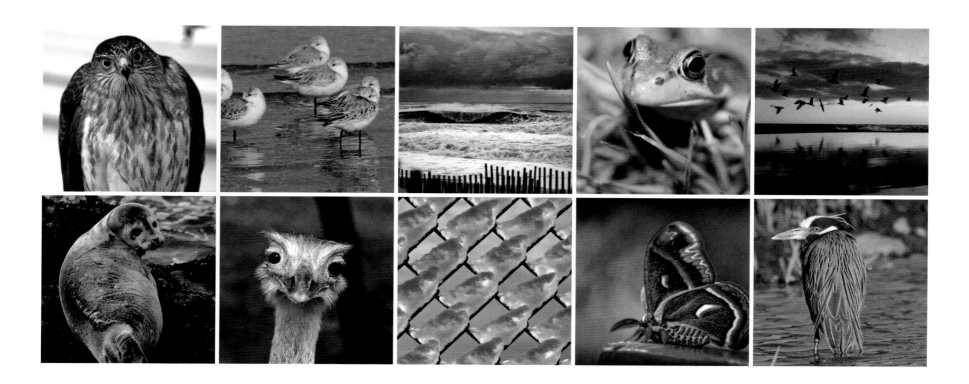

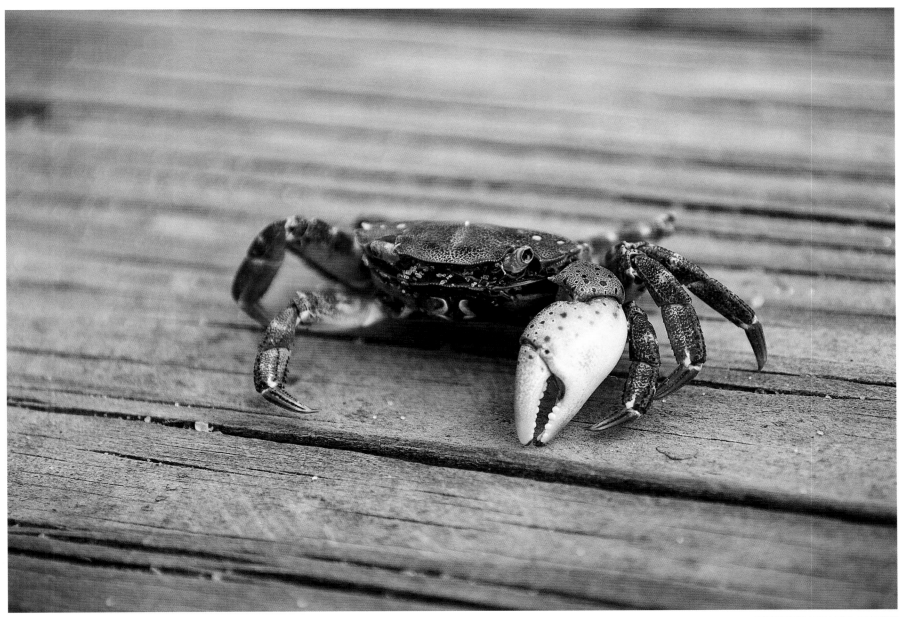

ABOVE: Found this poor little guy sitting on the boardwalk in Asbury Park. *(Asbury Park, Monmouth County)*

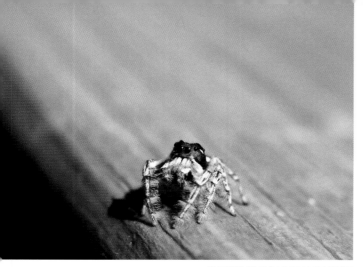

ON THE HUNT BY RYAN MARCHESE

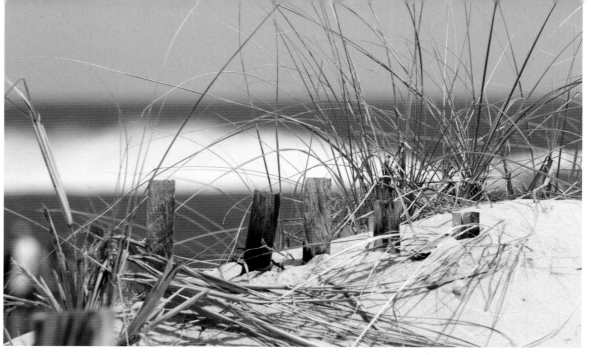

BLOWING IN THE BREEZE BY KATIE WISZ

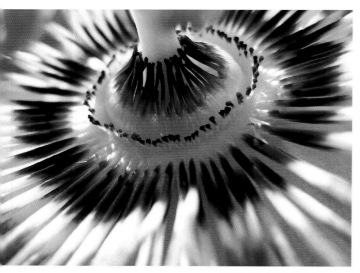

PASSIONFLOWER BY JUDIT PAPP

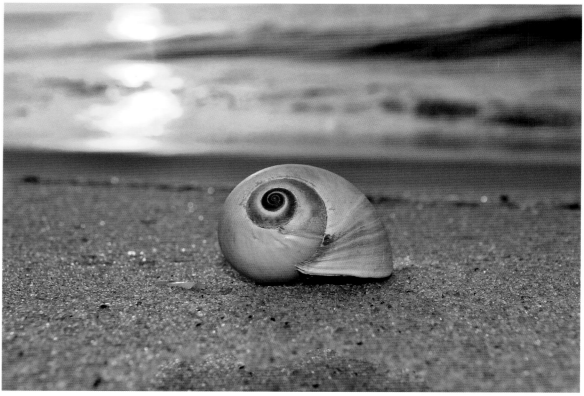

SEASHELL AT SUNRISE BY RAE PEZZOLLA

ABOVE: I could not resist the color and the pattern in this shot. *(Rumson, Monmouth County)*

TOP: A jumping spider. *(Barnegat, Ocean County)*

RIGHT TOP: The dune grass sways in the breeze as the ocean roars in the background. *(Lavallette, Ocean County)*

RIGHT BOTTOM: A seashell found on Ortley Beach. *(Toms River, Ocean County)*

WATER DROPS ARE NATURE'S MAGNIFYING GLASS BY DANA ELYSE

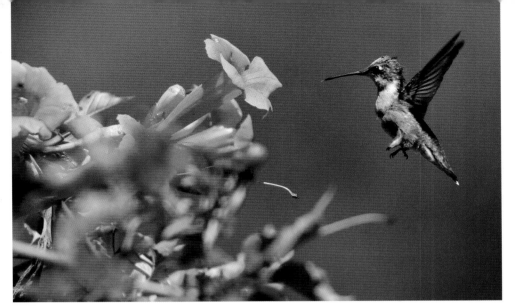

UNTITLED BY DENNIS J RUFFE

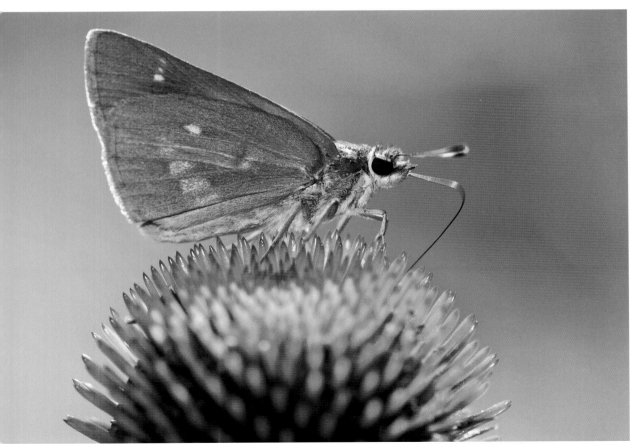

SIGN OF SPRING BY ALEX TUMUSOK

ABOVE: Ruby Throated Hummingbird.
(Wall, Monmouth County)

ABOVE LEFT: Look closely at the lowest water drop-you can see all the grass below it magnified within it.
(Toms River, Ocean County)

LEFT: We know it is spring when they're busy.
(Spring Lake, Monmouth County)

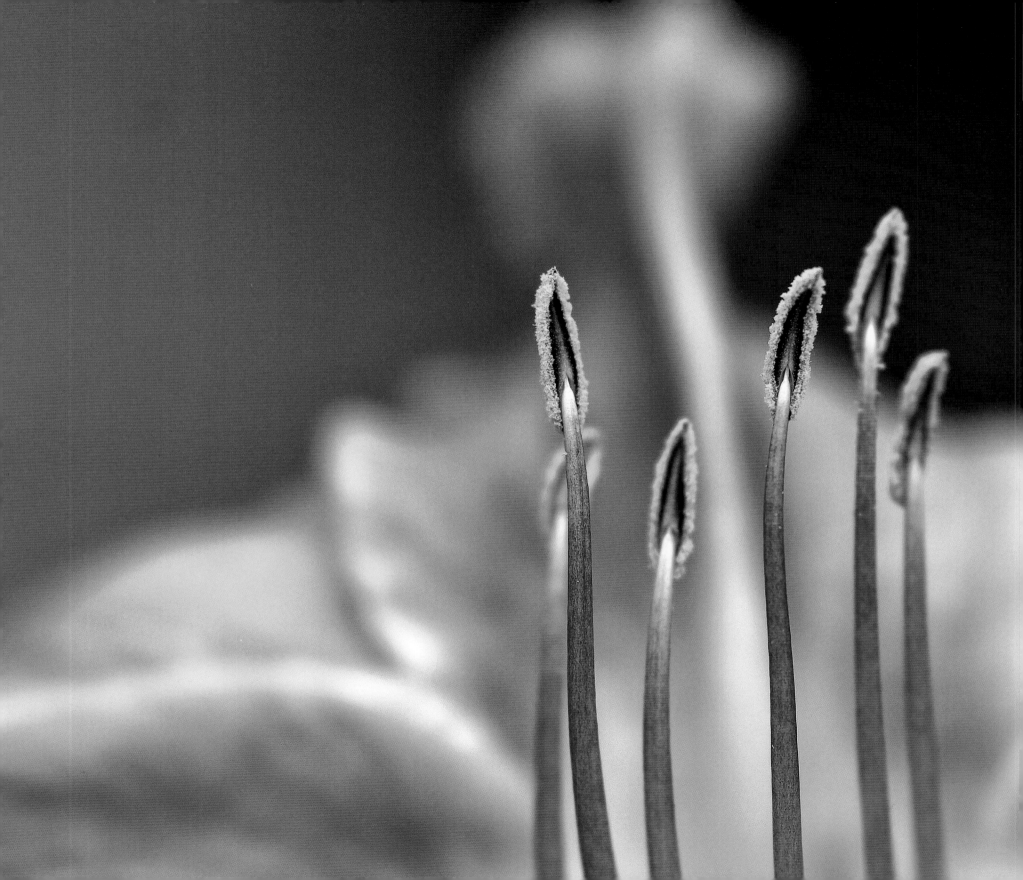

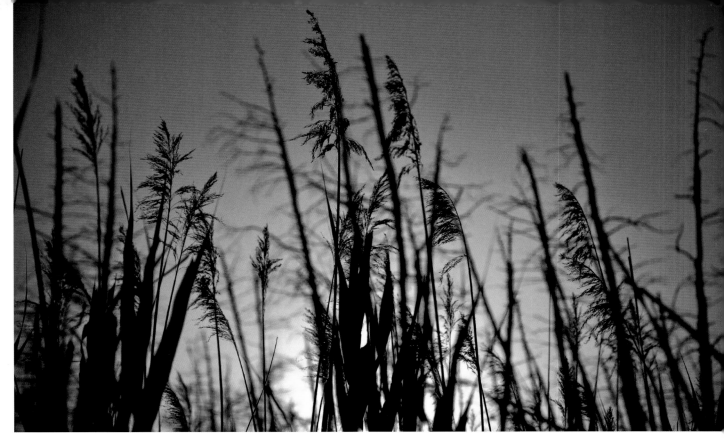

LAST LIGHT BY KRIS SCHOENLEBER

MEMORIES BY ALEX TUMUSOK

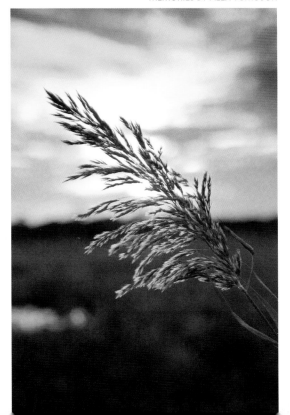

ABOVE: A sunset through the reeds on Cattus Island. *(Toms River, Ocean County)*

LEFT: Another day has gone by. *(Toms River, Ocean County)*

FAR LEFT: An extreme close-up of a day lily. *(Seaside Park, Ocean County)*

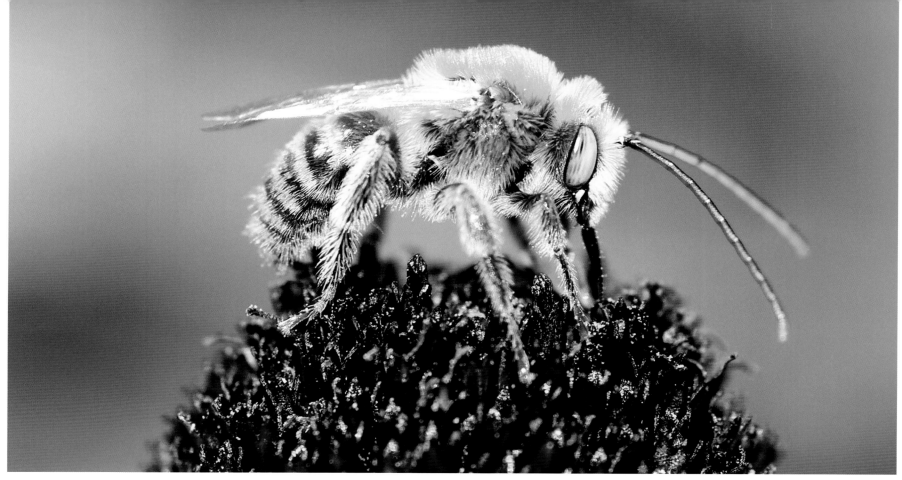

GOLDEN BEE BY RYAN HOSTNIK

FLAMINGO BY DANA ELYSE

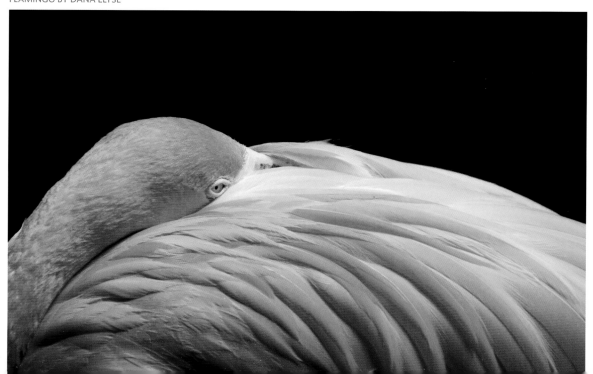

ABOVE: I noticed this bee completely covered in pollen, and he didn't mind me snapping a few pictures before he flew off. *(Colts Neck, Monmouth County)*

RIGHT: A flamingo takes his mid-day nap. *(Forked River, Ocean County)*

OPPOSITE TOP LEFT: Branches shooting everywhere from this old tree in Holmdel. *(Holmdel, Monmouth County)*

OPPOSITE TOP RIGHT: It was a rainy, gloomy day — my favorite kind of day to take pictures. *(Holmdel, Monmouth County)*

OPPOSITE BOTTOM: Two starfish against the wonderful sea and sky. *(Seaside Heights, Ocean County)*

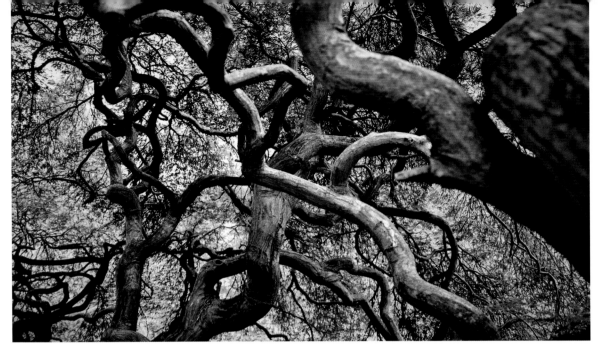

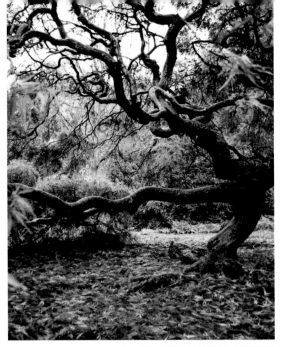

TANGLED BY KRIS SCHOENLEBER

UNTITLED BY SAMANTHA DUFFORD

TOGETHER AGAIN BY J. R. WARNET

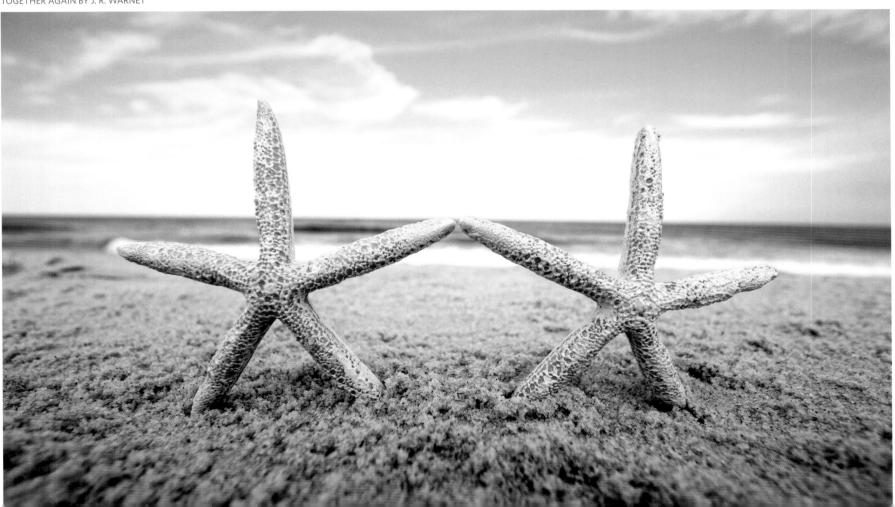

RIGHT: Sparrows.
(Belmar, Monmouth County)

BOTTOM LEFT: Osprey chicks are taught by their parents to play possum when a threat is perceived. Two of three complied while we approached their nest for banding by Conserve Wildlife Foundation of NJ.
(Barnegat Bay, Ocean County)

BOTTOM MIDDLE: Red Tail Hawk.
(Howell, Monmouth County)

BOTTOM RIGHT: Tern flying over the ocean at Sandy Hook.
(Middletown, Monmouth County)

OPPOSITE: I was lucky. These geese flew right into the frame near the 72 bridge to Long Beach Island.
(Manahawkin, Ocean County)

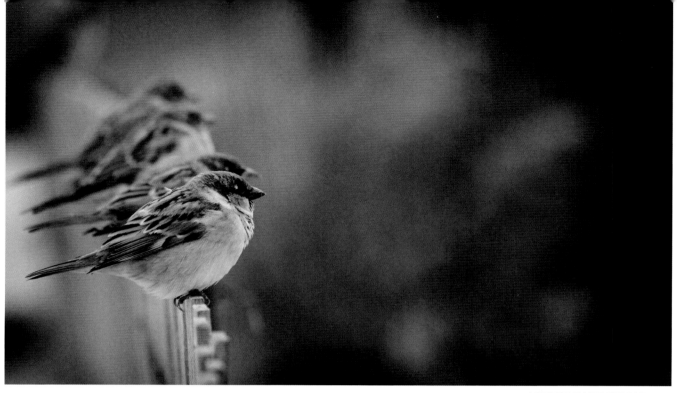

UNTITLED BY JENNIFER BORDFELD

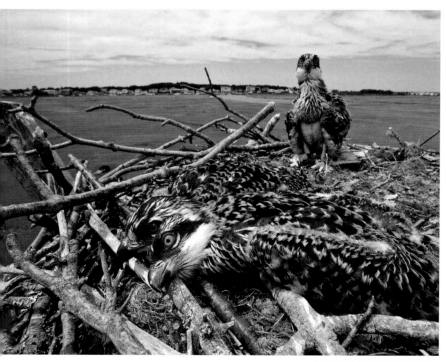

LAST STAND BY ERIC SAMBOL

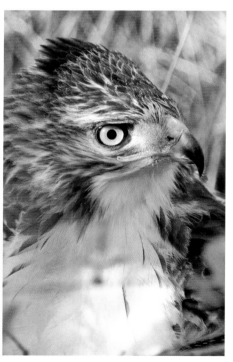

UNTITLED BY DENNIS J RUFFE

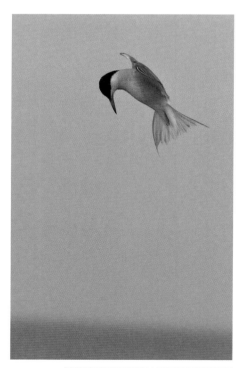

TERN TERN TERN BY ANTHONY BAGILEO

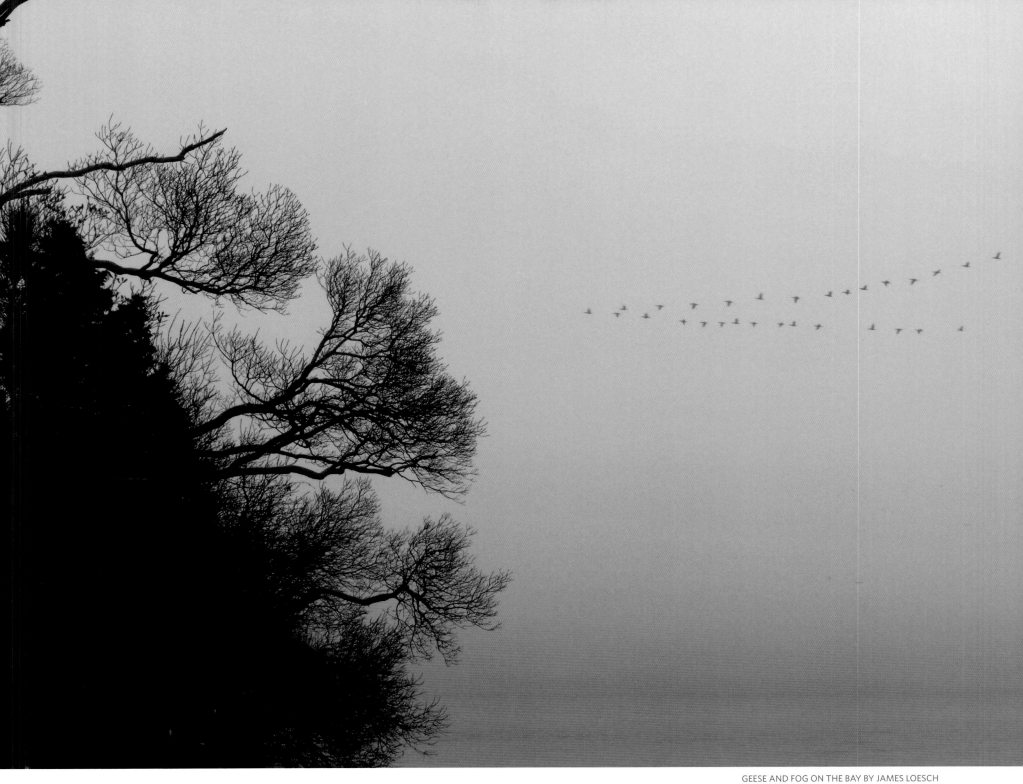

GEESE AND FOG ON THE BAY BY JAMES LOESCH

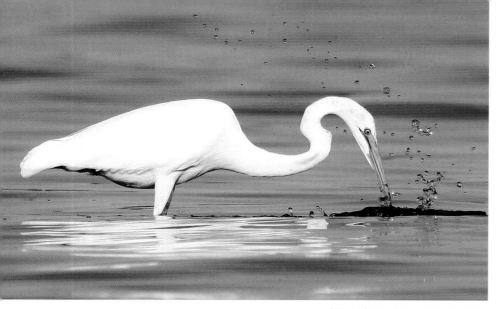

GREAT EGRET BY ANDREA GUGLIELMO

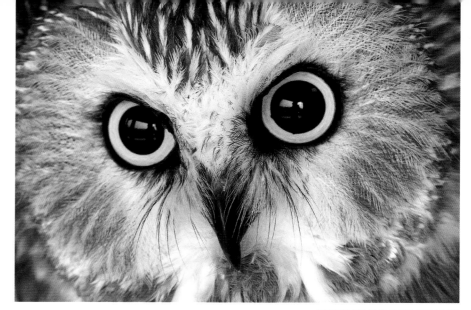

SAW-WHET OWL BY ERIC SAMBOL

ABOVE: Taken off the beach in Cliffwood Beach overlooking Keyport Harbor. *(Cliffwood Beach, Monmouth County)*

ABOVE RIGHT: Only five inches tall or so, this beautiful owl was saved by the Mercer Wildlife Center. *(Bricktown, Ocean County)*

RIGHT: The Least Tern is listed as an endangered species by the NJDEP and is also on the federal threatened and endangered species list. The photo was taken at Belmar, Shark River Inlet. *(Belmar, Monmouth County)*

FAR RIGHT: Feed me, feed me! *(Berkeley, Ocean County)*

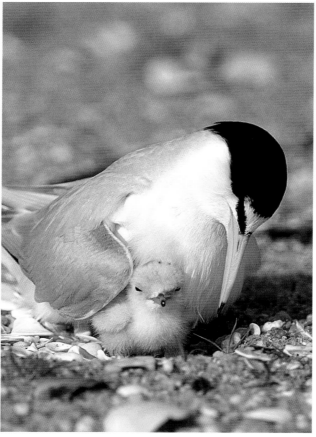

ENDANGERED LEAST TERN WITH CHICK BY BILL DALTON

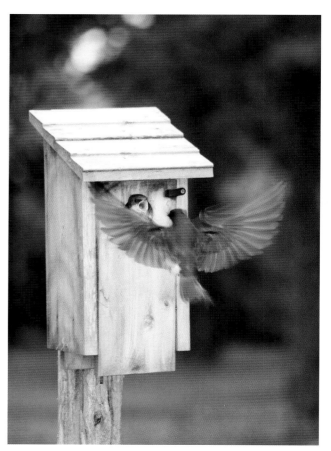

TREE SWALLOW BY EDWARD HEWITT

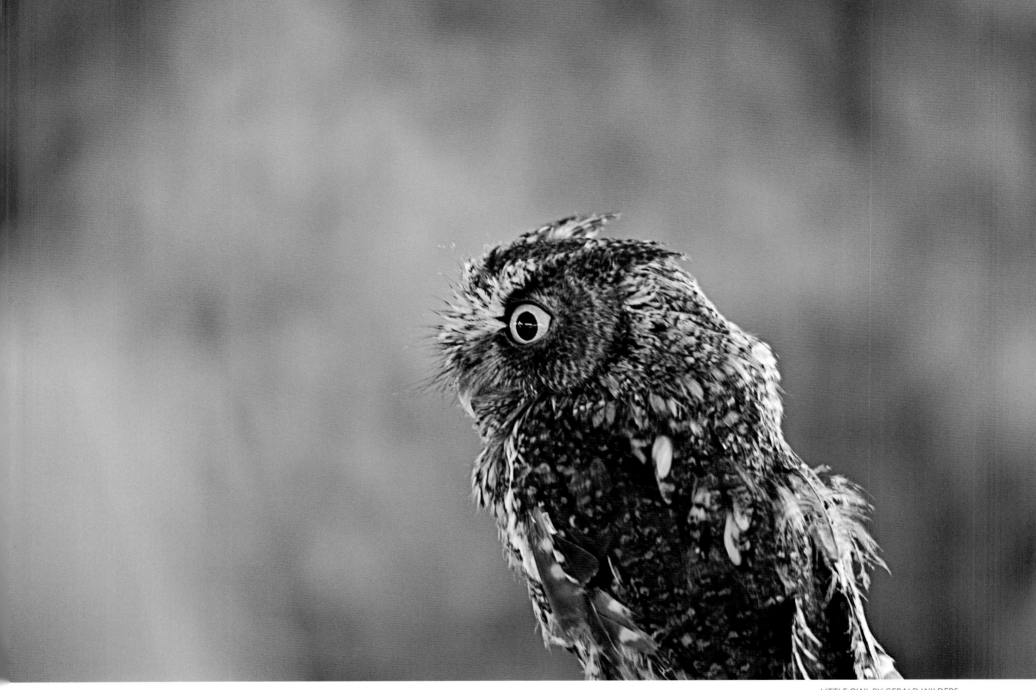

LITTLE OWL BY GERALD WILDERS

ABOVE: An owl at Monmouth County fair. *(Freehold, Monmouth County)*

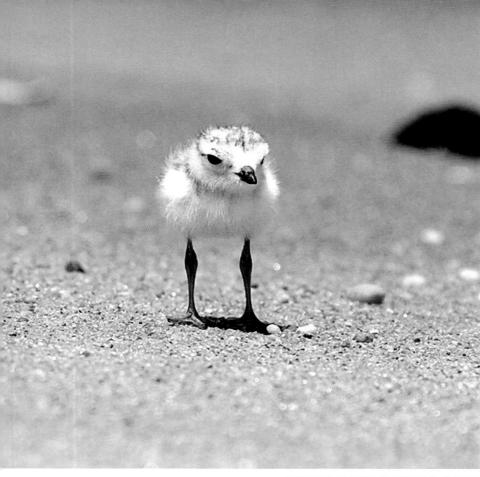

PIPING PLOVER CHICK BY ANDREA GUGLIELMO

ABOVE: Fisherman's Beach Sandy Hook. *(Atlantic Highlands, Monmouth County)*

RIGHT: Great Egret. *(Shark River Hills, Monmouth County)*

OPPOSITE LEFT: The face of this tortoise from Popcorn Park Zoo reflects a wary curiosity. *(Forked River, Ocean County)*

OPPOSITE RIGHT TOP: Gracie, as she came to be known on the beach in Belmar, during the Spring of 2010, was ill and had stranded herself near the boardwalk. Volunteers watched over her while Marine Mammal Rescue was on their way from Brigantine. Gracie was rescued and later released back into the sea to swim again. A happy ending! *(Belmar, Monmouth County)*

OPPOSITE RIGHT MIDDLE: What? *(Island Beach Heights, Ocean County)*

OPPOSITE RIGHT BOTTOM: Hungry Sandpiper. *(Long Beach, Ocean County)*

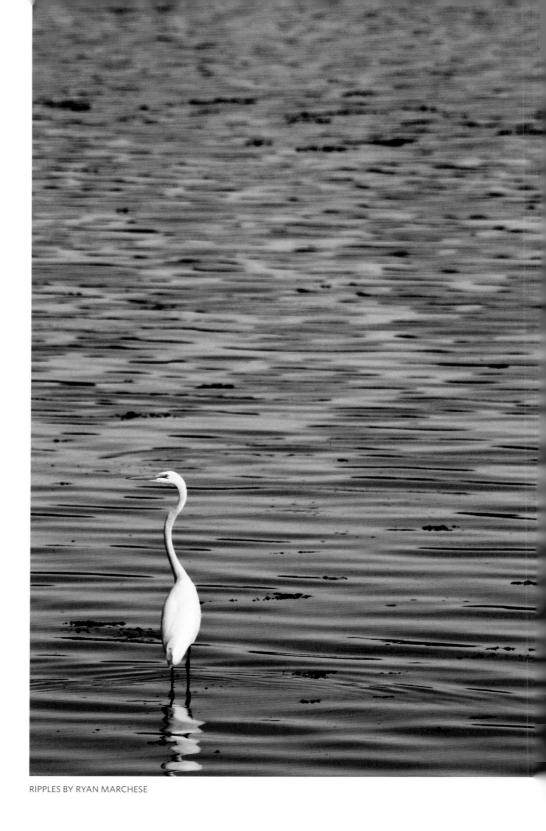

RIPPLES BY RYAN MARCHESE

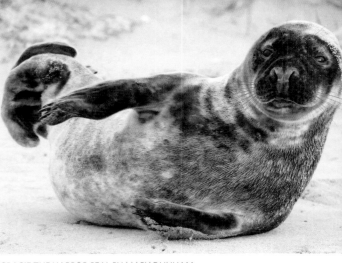

GRACIE THE HARBOR SEAL BY MARY DUNHAM

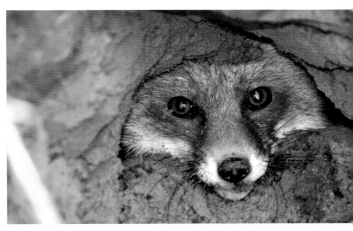

EMERGING FOX BY JO HENDLEY

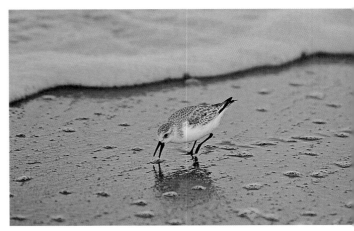

HUNGRY SANDPIPER BY SCOTT MILLER

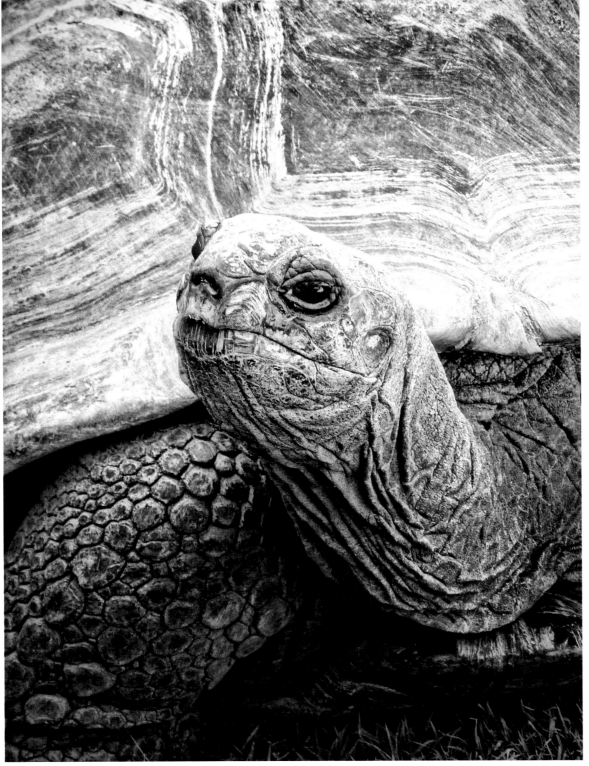

OL' TIMER BY MARY BARAN

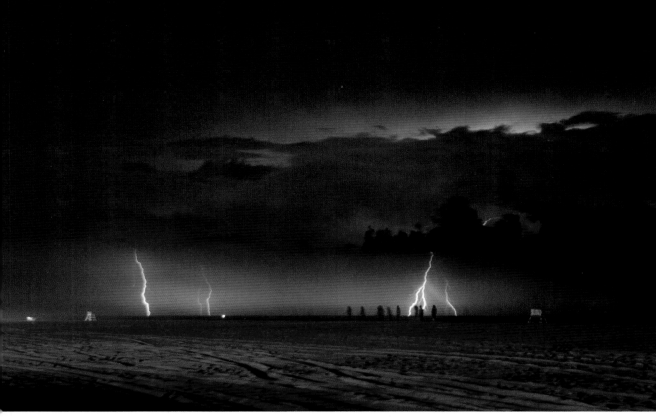

EXTRAORDINARY STORM BY GEORGE GROB

ABOVE: I watched this kind of lightening all night long and caught a series of long exposures. It was amazing. *(Barnegat, Ocean County)*

RIGHT: A storm is coming.
(Bay Head, Ocean County)

FAR RIGHT: Huge waves after the storm.
(Long Branch, Monmouth County)

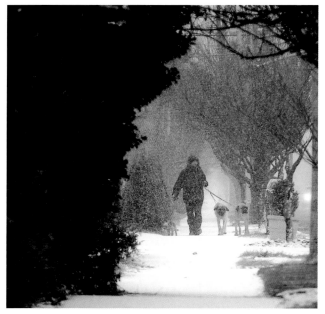

UNTITLED BY SHANNON RUVELAS

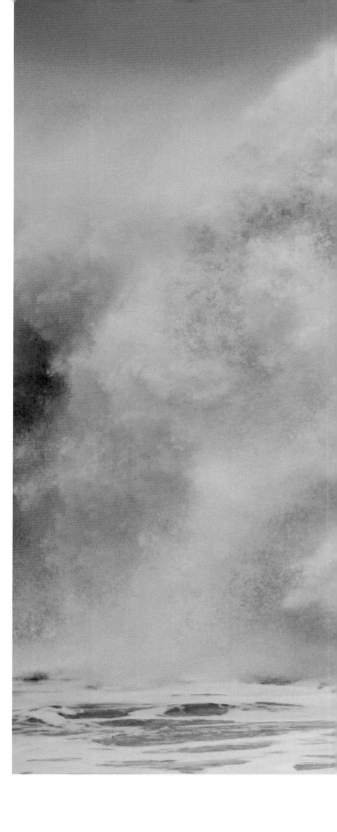

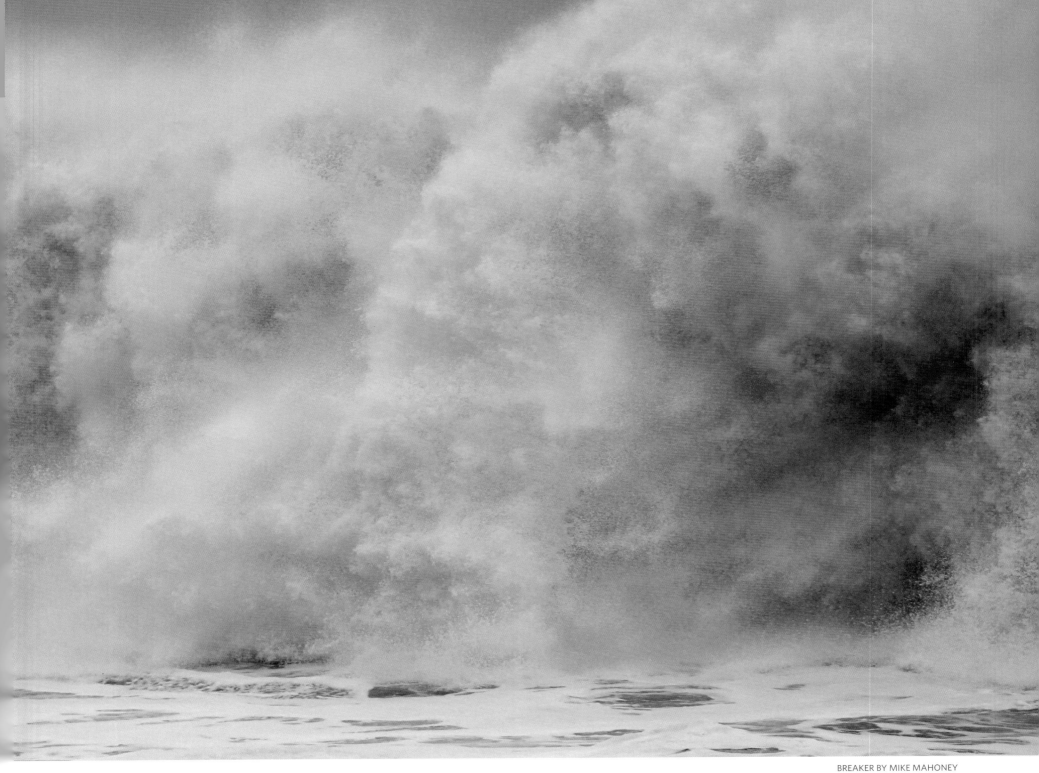

BREAKER BY MIKE MAHONEY

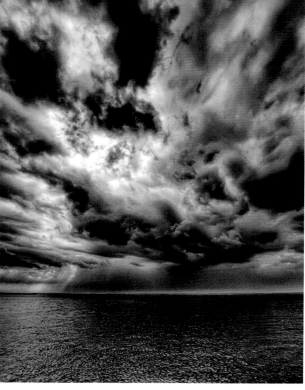

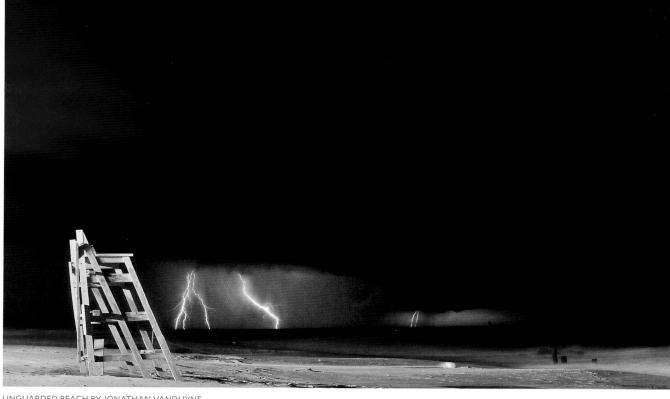

STORM BREWING BY JAMES LOESCH

UNGUARDED BEACH BY JONATHAN VANDUYNE

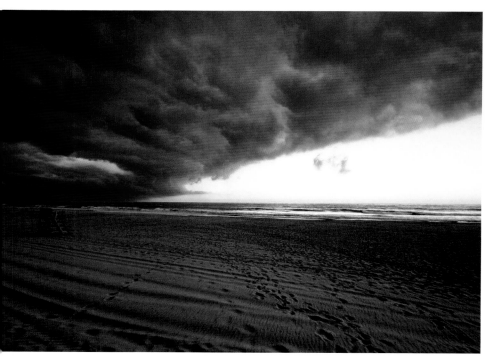

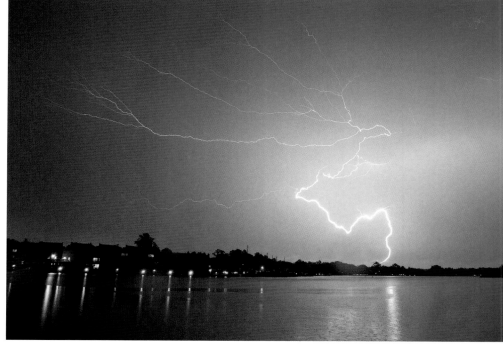

STORM BREWING BY RONNIE PETERS

THE WEATHER FORECAST BY ALEX TUMUSOK

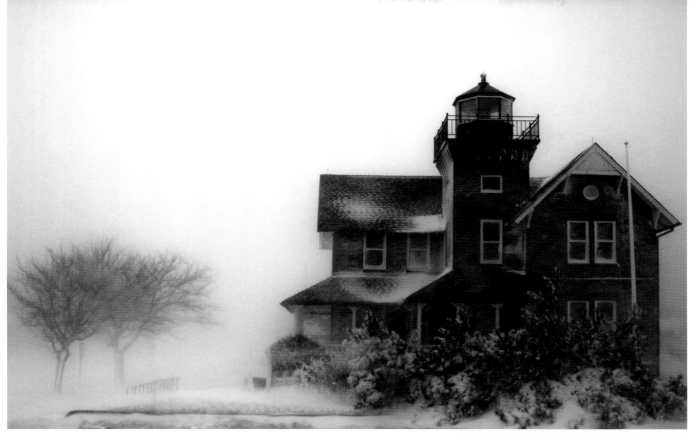

SEA GIRT LIGHTHOUSE IN BLIZZARD BY HENRY BOSSETT

LEFT: The Sea Girt lighthouse in a blizzard. *(Sea Girt, Monmouth County)*

OPPOSITE TOP LEFT: A storm over Manahawkin. *(Harvey Cedars, Ocean County)*

OPPOSITE TOP RIGHT: A mid-August storm. *(Allenhurst, Monmouth County)*

OPPOSITE BOTTOM LEFT: A storm is brewing. *(Spring Lake, Monmouth County)*

OPPOSITE BOTTOM RIGHT: A light show in downtown Toms River. *(Toms River, Ocean County)*

BELOW: A cold day at Sea Girt Beach. *(Sea Girt, Monmouth County)*

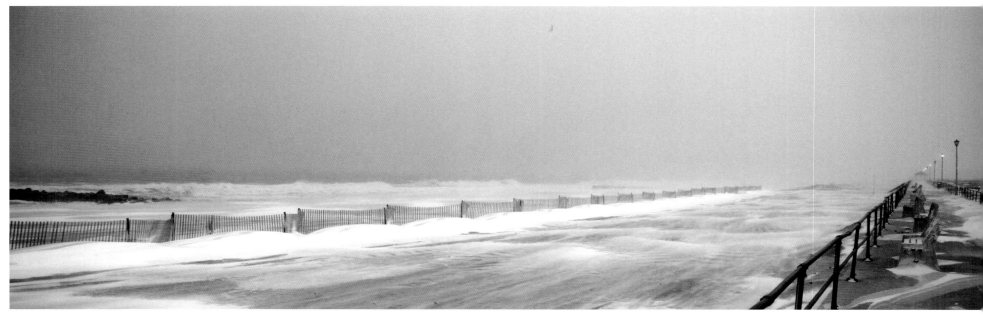

UNTITLED BY CLASON BACON

 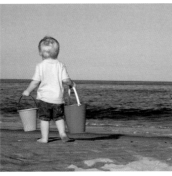 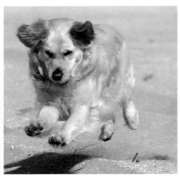 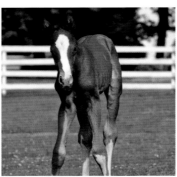 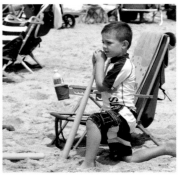

Friends, Family and Pets

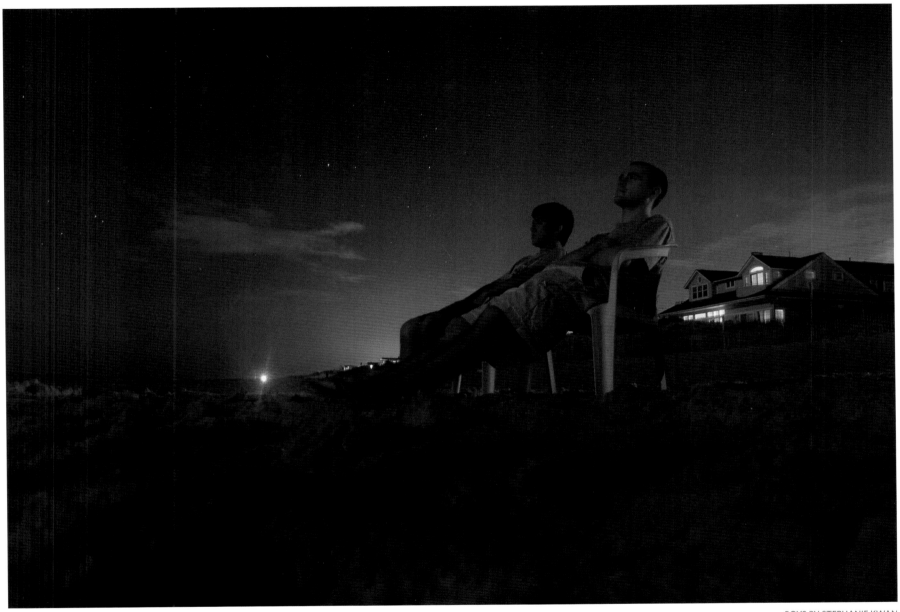

BOYS BY STEPHANIE KWAN

ABOVE: A late night shot of my friends on the beach. They were very patient with me and let me take multiple long exposure shots (15 seconds). I was surprised that they managed to not move the entire time. *(Long Beach, Ocean County)*

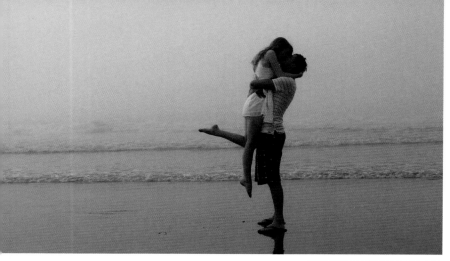

UNTITLED BY KAYLEIGH O'HARA

THINKING IN THE PARK BY ALYSSA EZON

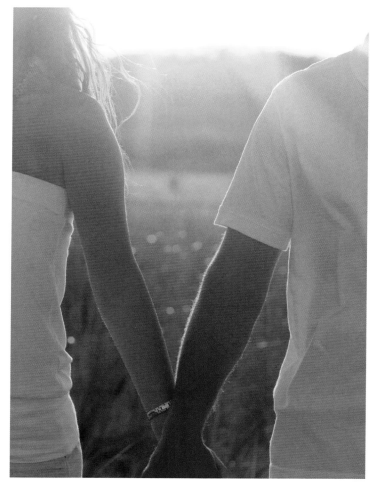

IN LOVE ON THE JERSEY SHORE BY CHRISTIE O'CONNOR

ARABESQUE IN THE AFTERNOON BY MELISSA HERNANDEZ

PRETTY IN PINK BY JENNIFER MALPASS

ABOVE: Pretty in pink on her birthday at the beach. *(Bay Head, Ocean County)*

LEFT: Arabesque in the afternoon: Ashley at Monmouth University. *(West Long Branch, Monmouth County)*

OPPOSITE LEFT TOP: An early-morning photoshoot. *(Lavallette, Ocean County)*

OPPOSITE LEFT BOTTOM: An engagement photo on Sandy Hook. *(Middletown, Monmouth County)*

OPPOSITE RIGHT: Park thoughts. *(Ocean, Ocean County)*

HAROLD BY ROB FISCHER

ABOVE: Norman has been the resident blacksmith at Longstreet Farm for quite a few years. His large and powerful hands tell the story of where his long life has taken him. *(Holmdel, Monmouth County)*

OPPOSITE TOP LEFT: Pleasing the fans. *(Asbury Park, Monmouth County)*

OPPOSITE TOP RIGHT: An amazing relationship between a boy and his dog at the beach. *(Highlands, Monmouth County)*

OPPOSITE BOTTOM LEFT: Portrait of a good friend. *(Port Monmouth, Monmouth County)*

OPPOSITE BOTTOM RIGHT: Alana is happiest when she's at the beach, just like her mother. *(Asbury Park, Monmouth County)*

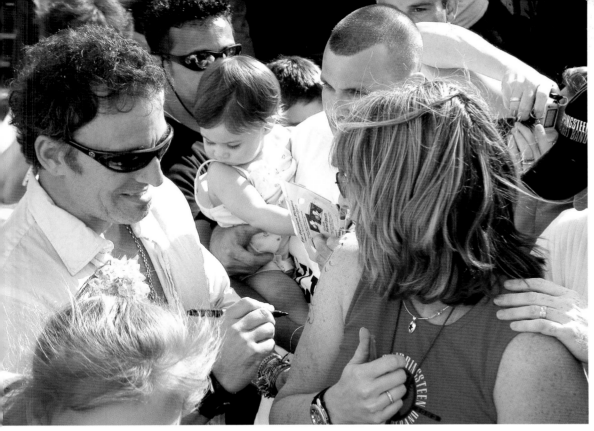

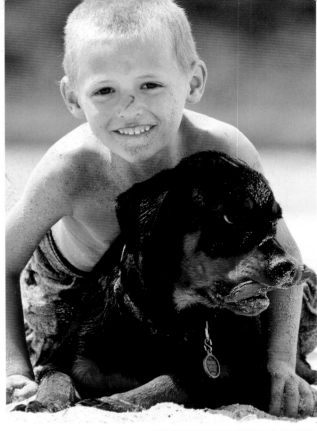

BRUCE BY CARL BEAMS

THE BEACH BOY BY GONZALO HERRERA

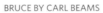STUCK IN GLASS BY CHASE SCHIEFER

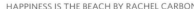HAPPINESS IS THE BEACH BY RACHEL CARBONE

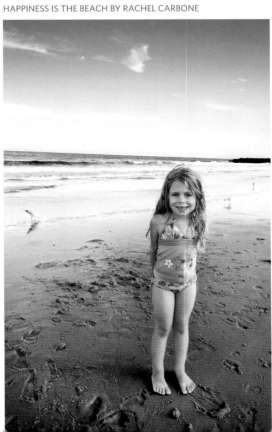

RIGHT: Enjoying the day with friends.
(Sands Point, Monmouth County)

BOTTOM LEFT: Girls on a lifeguard stand.
(Avon-by-the-Sea, Monmouth County)

BOTTOM RIGHT: Pure bliss, I think..
(Deal, Monmouth County)

OPPOSITE TOP LEFT: Enjoying time together.
(Island Heights, Ocean County)

OPPOSITE TOP RIGHT: This gentleman
showed off his just caught bass in Godfrey Lake.
(Bricktown, Ocean County)

OPPOSITE BOTTOM LEFT: Blossoming into a beautiful flower. *(Asbury Park, Monmouth County)*

OPPOSITE BOTTOM RIGHT: Waiting for fireworks
on the Fourth of July. *(Pine Beach, Ocean County)*

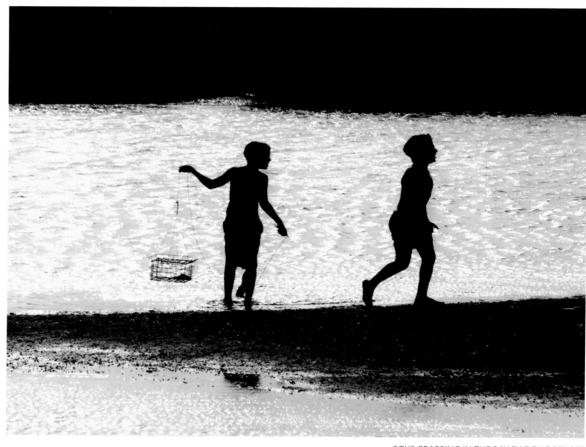

BOYS CRABBING IN THE BAY BY DOUG BENOIT

BATHING BEAUTIES BY EILEEN PETRUCH

JUMPING FOR JOY BY DAVID SUTTON

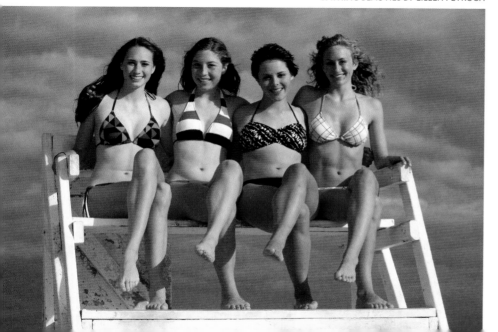

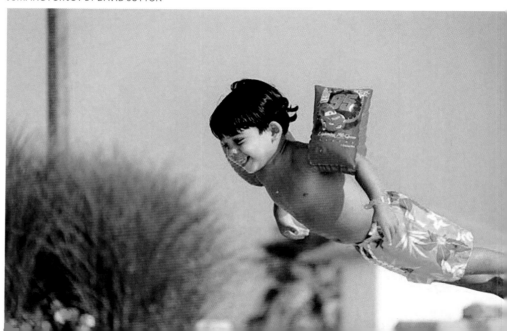

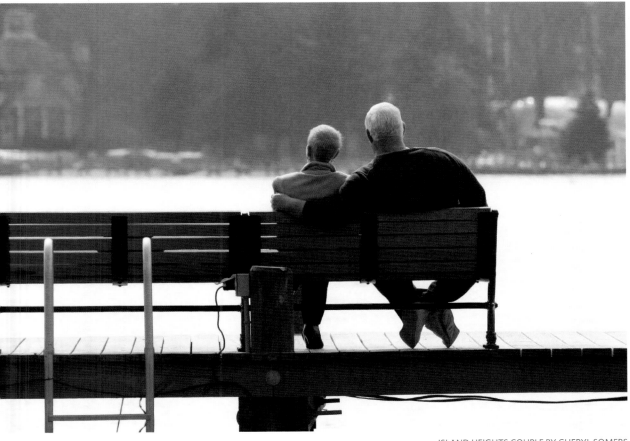

ISLAND HEIGHTS COUPLE BY CHERYL SOMERS

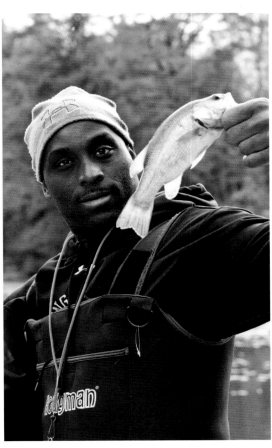

PROUD CATCH BY ERIC SAMBOL

FACE PAINTING BY MATT DENTON

FATHER DAUGHTER MOMENT BY EVA VALENTI

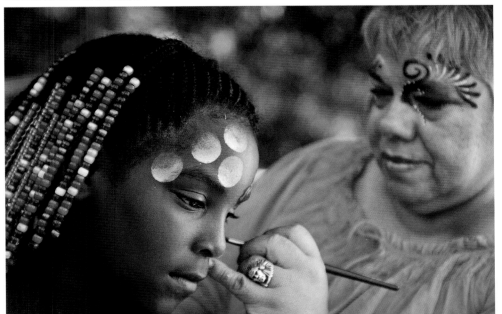

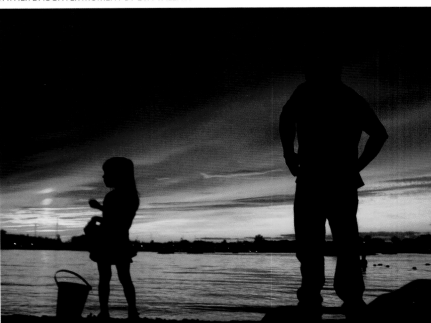

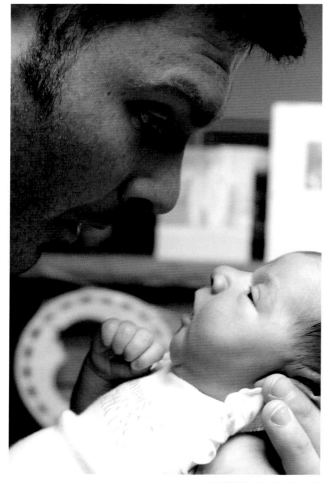

UNTITLED BY AJ SHERMAN

ABOVE: Father and daughter. *(Toms River, Ocean County)*

RIGHT: Headed home with a shell collection.
(Seaside Park, Ocean County)

OPPOSITE: First coaster ride. *(Point Pleasant, Ocean County)*

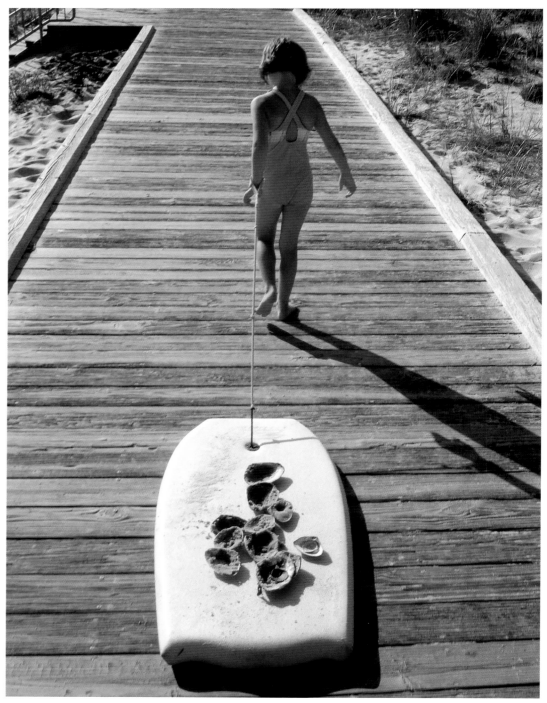

END OF SUMMER BY RW NUNN

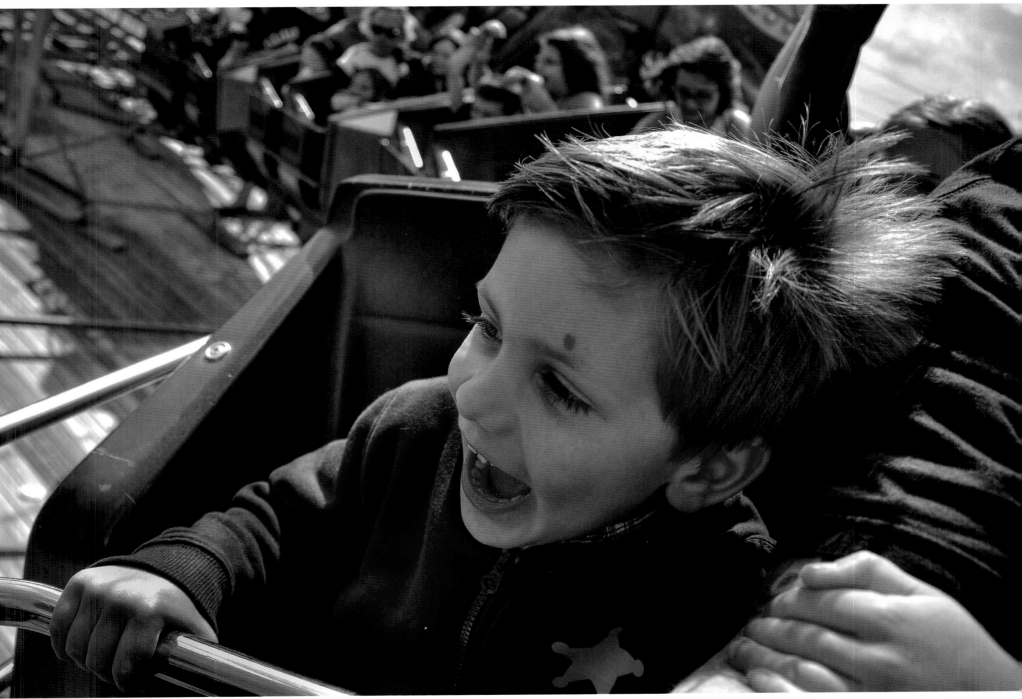

ROLLER COASTER BY TOM BERG

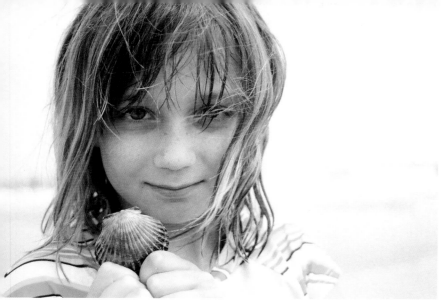

CHILD WITH SEASHELL BY JOLIE JOHNSON

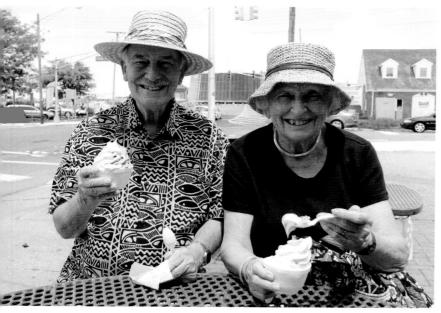

ICE CREAM BY JULIA MENEGHIN

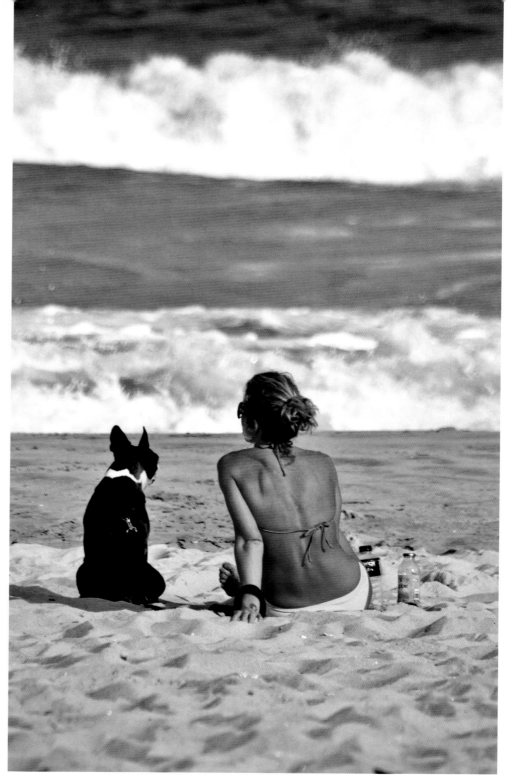

ABOVE: Mimi and Pop enjoying ice cream. *(Belmar, Monmouth County)*

TOP: Collecting seashells. *(Island Beach Heights, Ocean County)*

RIGHT: A woman and her dog relaxing on the beach the day before the hurricane. *(Ship Bottom, Ocean County)*

GOOD COMPANY BY KRIS SCHOENLEBER

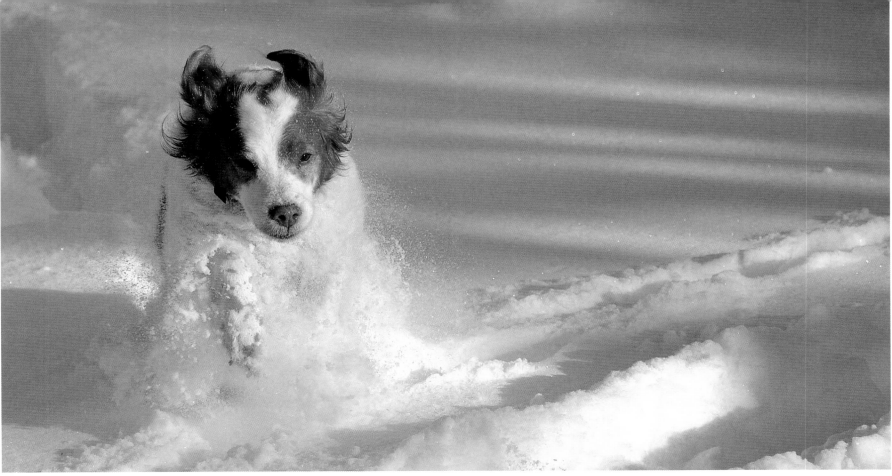

SNOW DOG BY BRUCE MACDONALD

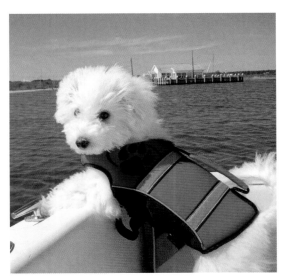

BOAT DOG BY DOTTIE GIBSON

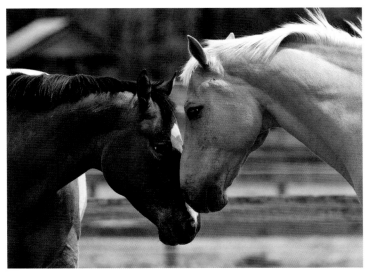

LOVE AFFAIR BY GEORGE BARTLEY

ABOVE: A dog having fun in the snow. *(Spring Lake, Monmouth County)*

LEFT: More than friends. *(Barnegat, Ocean County)*

FAR LEFT: Lexi Gibson enjoying a day on our boat, The Dot. *(Berkeley, Ocean County)*

DANDELIONS BY CORINNE CAVALLO

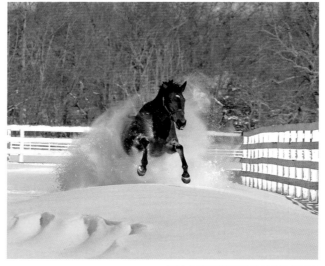

REAL HORSE POWER BY MIKE QUINN

LEFT: This photo was taken at Century Stables in Colts Neck. Private Miracle, our thoroughbred racehorse, jumps through a snow drift. *(Colts Neck, Monmouth County)*

FAR LEFT: I couldn't resist capturing this farm scene. *(Colts Neck, Monmouth County)*

BOTTOM LEFT: Every farm has a resident cat. This one at Longstreet Farm, sitting on the seat of a plow, does not care to be bothered by humans right now. *(Holmdel, Monmouth County)*

BOTTOM RIGHT: The beauty of a horse. *(Howell, Monmouth County)*

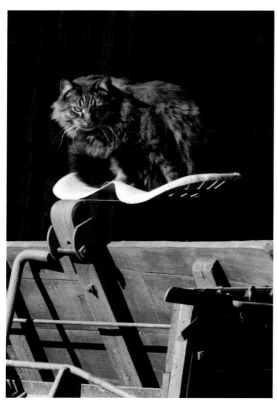

THE FARM CAT BY ROB FISCHER

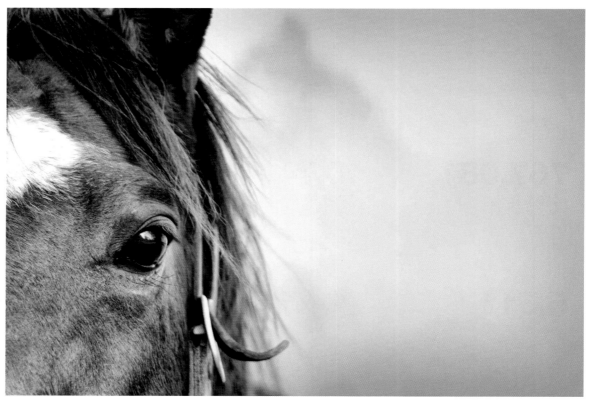

UNTITLED BY JENNIFER BORDFELD

Community Stats

The The Real Jersey Shore book was created by the efforts of Jersey Shore folks who have a passion for their local community and an eye for great photography. The community of users at capturejerseyshore.com spent countless hours shaping this book with their submissions, votes and comments. It is their editing power that determined which photos deserved publication in this book and which photos our editors had to consider for publication. Along the way, users generated some astounding statistics (below) in terms of activity on the Capture Jersey Shore Web site. Our sincere thanks to every user who dedicated their time to shaping the The Real Jersey Shore book.

32,301
photos

1,293
photographers

767,087
votes

8,749
comments

5,511
users

24,166
loves

Community Leaders

The active online community of users at capturejerseyshore.com shaped this book with their submissions, votes, comments, etc. Below you'll find the community leaders in each of four categories: top voter, the user with the most votes cast; top promoter, the user who promoted the contest via email the most; most followed, the user other users followed most; and top commenter, the user who commented on photos the most.

Top voter
Jerrol Hillblom
26,896 votes cast

Top promoter
Raymond Salani III
94 shares

Most followed
Tom Berg
132 followers

Top commenter
Lisa Rass
536 comments

Credits

Photographer credits for chapter intro pages, from left to right, top to bottom:

LIVING: Rob Nagy, Ron Nastasi, Frank Costello, Raymond Salani Iii, Khristi Jacobs, Bruce Macdonald, David Turton, Bob Engelbart, Chase Schiefer, Mike Attanasio, Beverley Egolf, Frank Costello, Mike Galvin Jr, Bob Engelbart, Kelly Schott. LANDMARKS AND ARCHITECTURE: James Loesch, Kristen Vargas, Tracey James, Frank Costello, Michael McElroy, Phil Smith, Michael McElroy, Catherine Conroy, Michael Yucius, Carl Beams, James Abels, Jill Whitley, Alyssa Ezon, Michael Yucius, Khristi Jacobs. SPORTS, RECREATION, FOOD AND FUN: Tia Nadal, Walt Wombough, Ray Yeager, Bob Cuthbert, Josh Jedry, Steve Fitzpatrick, Mike Shanahan, Maryelise Tomczak, Sharon Carone, Debbie Karu, Joanne Peck, Rw Nunn, Marlo Montanaro, Tom Berg, Bob Engelbart. SCAPES OF ALL SORTS: Rory Brogan, Diane Metz, Kris Schoenleber, Mike Attanasio, Allie Meeker, James Abels, James Loesch, Mike Attanasio, Carl Beams, John Basile, Pat McCarthy, James Loesch, Michael Yucius, Anthony Bagileo, Jeremy Wood. NATURE AND WILDLIFE: James Loesch, George Bartley, Madison McIntyre, Alex Tumusok, Michael Gallagher, Rebecca Cramer, Rob Fischer, Ryan Mack, Alyson Shannon, Steve Scanlon, Lj Hepp, Frank Giardina, Bob Engelbart, Tom Berg, Andrea Guglielmo. FRIENDS, FAMILY AND PETS: Chase Schiefer, Rachel Carbone, Gonzalo Herrera, Mike Quinn, Frank Costello, Henry Sonntag, Cheryl Somers, Suzanne Verikios, Matt Denton, Eva Valenti, Bob Engelbart, Jeri Kenney, Patricia Lafferty, Terry Deluco, Andrea Guglielmo.

Sponsors

Special thanks to our sponsors who helped make this book possible.

The Asbury Park Boardwalk offers a mix of modern amenities and soulful authenticity that transcends today's perception of the Jersey shore. The New York Times describes it as a place where "the past stands vigil over the present" and declared that "Black and white, gay and straight, child-ridden and child-free: there's a little of everything and everyone seems to feel at home." A legendary vibrant music scene as well as award winning restaurants, shops, lounges and beaches is just a part of what has recently made the Asbury Park Boardwalk one of the most critically acclaimed destinations in the U.S.

The BlueClaws are the Jersey Shore's top spot for affordable, family entertainment and in early 2012 will welcome their five-millionth fan to FirstEnergy Park. A Phillies affiliate since their 2001 inception, the Blue-Claws have had players like Ryan Howard, Cole Hamels and Carlos Ruiz play in Lakewood on their way to the big leagues, and have won three South Atlantic League championships of their own. The Blue-Claws offer a variety of ticket packages ranging from 7 to 70 games and all include special gifts. Plus, companies routinely host outings in various hospitality areas including picnics, party decks, or SkyBoxes. For more information, please call 732-901-7000 or visit BlueClaws.com.

Gloria Nilson, REALTORS®, Real Living® is one of the preeminent real estate brokerages in central New Jersey. Throughout its 30 years, Gloria Nilson has remained one of New Jersey's prestigious real estate firms and has grown from a single office to 17 offices and over 700 sales professionals across central New Jersey. Gloria Nilson is built on a commitment to redefine personal service and to exceed customer expectations; we have equipped our sales associates with the relevant knowledge to navigate any market condition and to service their clients towards successful results. Visit glorianilson.com to search for your ideal home.

Help Find the Best of the Jersey Shore

★ I DIG IT ✖ I NIX IT

CAPTURE JERSEY SHORE.com

Join the community of Jersey Shore photographers and enthusiasts!

Vote to shape future publications, upload your own take on the Jersey Shore and buy prints at:

capturejerseyshore.com

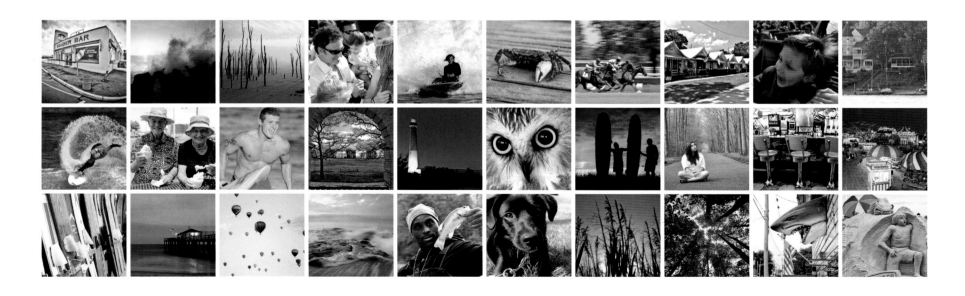

Winners

When picking from 32,301 photos, it's difficult to nail down what separates the best from the rest — especially when so many photos are so good. To help, we enlisted thousands of local folks to vote for their favorite shots. The response was epic: 767,087 votes were cast. The voting helped shape what would eventually be published in this book. Along the way, the votes produced the grand-prize and cover winners below.

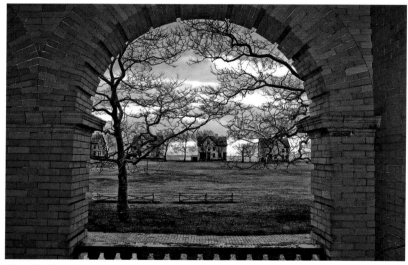

Grand-prize winner
Untitled by Ed Kulback
page 31

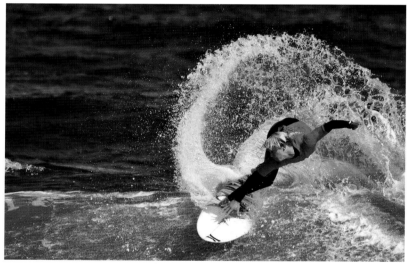

Cover winner
Surfer by Bruce MacDonald
cover

Runners-up
These photos finished just behind the grand-prize photo in total score.